The Life and Times of
Missouri's
Charles Parsons

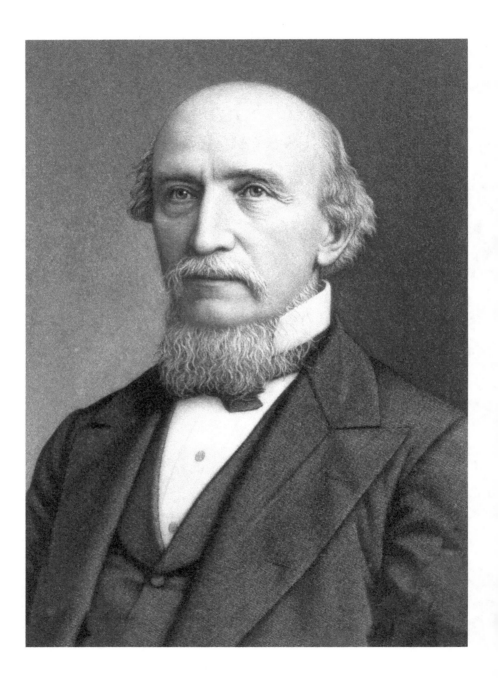

THE LIFE AND TIMES OF
MISSOURI'S
CHARLES PARSONS

Between Art and War

JOHN LAUNIUS

THE
History
PRESS

Published by The History Press
Charleston, SC
www.historypress.com

Copyright © 2020 by John Launius
All rights reserved

Cover image: Charles Parsons. *From Scharf,* History of Saint Louis City and County *(1883). St. Louis Public Library*; St. Louis School and Museum of Fine Arts. *St. Louis Art Museum.*

Frontispiece: Charles Parsons. *From Scharf, 1883. St. Louis Public Library.*

First published 2020

ISBN 9781540242068

Library of Congress Control Number: 2019951835

Notice: The information in this book is true and complete to the best of our knowledge. It is offered without guarantee on the part of the author or The History Press. The author and The History Press disclaim all liability in connection with the use of this book.

To my grandfather Harry Sparks and to my wife, Amy. One provided the perfect model of the Renaissance man to follow and the other the perfect partner to dance through the ages, totally and completely, forever and always.

CONTENTS

PREFACE

In the spring of 2007, the director of the Mildred Lane Kemper Art Museum, Sabine Eckmann, stood observing a room full of valuable things in a secure area of the museum. Fine art and sculpture were displayed next to archaeological discoveries, polished swords and artifacts from cultures around the world. Sabine, other curators and select staff wanted to review these objects for possible inclusion in future exhibitions at the museum. These items had once composed the private collection of Charles Parsons (1824–1905). As described in his 1905 obituary in the *St. Louis Republic*, Charles was a "distinguished citizen, venerable banker, art connoisseur, author and philanthropist."[1] At the center of this collection—valued at what would be equivalent to more than $1 million today—sat a piece of Japanese pottery incorrectly identified as a "bowl"—a labeling mistake that occurred in 1923 when the university officially accepted the full collection into their care.

I joined the staff of the Kemper in June 2006 to oversee the security operations of the museum. Having just come from a five-year journey as a counterterrorism security contractor in the post-9/11 era, working with the U.S. Department of Homeland Security and other intelligence agencies, my first task was to coordinate with all the departments of the museum a worldwide operation to return many of the most valuable pieces of art owned by Washington University in St. Louis that were on loan to museums around the world, as well as to receive the traveling show that would inaugurate the newly completed Mildred Lane Kemper Art Museum.

In August 2006, trucks carrying millions of dollars' worth of art began to arrive on campus under cover of night with layers of security from the Washington University campus police, with assistance from local, state, federal and international authorities. It was an exciting time to begin a new era of world-class art display and education with an institution whose commitment to arts education goes back to 1879, with the formation of the St. Louis School and Museum of Fine Arts, the first art museum west of the Mississippi.

By the spring of 2007, the fanfare surrounding the museum's public opening in October 2006 had waned, and it was time to begin a review of objects that had arrived as the museum was opening; many items had been in storage for years, with little to no opportunity for display due to the size of exhibition space prior to the completion of the Kemper. This review was pursuant to the museum's mission to preserve and develop its collection, as well as "continuing its legacy of collecting significant art of the time; providing excellence in art historical scholarship, education, and exhibition; inspiring social and intellectual inquiry into the connections between art and contemporary life; and engaging audiences on campus, in the local community, across the nation, and worldwide."[2]

As the head of security operations at that time, it was my job to inspect the objects before and after review by the staff, along with the museum registrars, to ensure that what came out of the secure storage areas went back in exactly as it had been found. When it was time to inspect the Parsons collection, one object immediately caught my eye. From across the secure area, among the Japanese swords, Buddhist statues, *netsuke* and *okimono*, as well as numerous examples of Satsuma, Makuzu, Kutani and Old Kyoto wares, furs and many other objects that Parsons had collected on his world travels in the mid- to late nineteenth century, I saw a "bowl"—a beautiful piece of Japanese Satsuma pottery depicting the Buddha and his disciples in the Tang Dynasty (618–906 CE) style of China. This Satsuma pottery was topped with a perforated bronze lid.

At this time, Sabine Eckmann, the William T. Kemper Director and Chief Curator of the museum, was not aware that I had spent the past twenty-five (now thirty-eight) years studying martial arts and world incense traditions. In my early teens, my primary interest focused on the Japanese incense traditions, which began to develop around 600 CE.[3] Having taken formal instruction in the Japanese tradition of *Koh-do* (literally "the way of incense" and frequently translated as "the incense ceremony")[4] and having been approved to share this path of refinement and spiritual practice by

my original incense teacher, I was well acquainted with the object and its iconography that was now before me.

I recognized the vessel immediately as a Japanese incense burner connected with Japanese nobility due to the presence of a *mon* (crest) of the Tokugawa shogunate, the ruling family of Japan in the Edo period (1603–1868 CE), and I approached the object for closer inspection. Eckmann joined me, and I explained that the accession card from 1923 was incorrect and shared with her what the object truly was. Her response to my explanation can only be described as quintessentially German. Eckmann shrugged and smirked at me, and with her signature German American accent, she simply said, "Prove it. Write an essay." I did just that.

In the essay that followed, I demonstrated that the Tokugawa incense burner portrayed the tale of enlightenment through incense and the teachings of the Buddha, blessed by the ruling Tokugawa regime and specifically linked to the casting out of evil as part of the Japanese festival of *Setsubun* (festival of seasonal division). Soon after, the title of the object in the official museum accession record was changed from "Bowl" to "Incense Burner." Today, you may visit the Mildred Lane Kemper Art Museum's online database to see inv. no. WU99, a Tokugawa incense burner, which will be discussed in greater detail in chapter 9.[5]

Writing the essay on the Tokugawa incense burner brought me face to face with Charles Parsons and his fascinating life and times. In addition to the burner, I found other incense-related objects during the first viewing of his artifacts—or, as Parsons would say, "curios"—in the spring of 2007. Given my training and background in the mysterious and fragrant art of *Koh-do*, I was perfectly suited to recognize these other objects related to the incense culture of Japan. Two such works, a porcelain cup and a curious *okimono* (置物), a carved ornament for display similar to but larger than a *netsuke* (根付), will be discussed in chapter 9 as well. The writing and research for the essay on the Tokugawa incense burner had powerfully connected me to a man who seemed to have similar esoteric interests as myself, but who was he publicly? Who was Charles Parsons as a businessman, war veteran, author, political activist, philanthropist and art collector? I had to know more.

Piecing together the interesting life of Charles Parsons and his successful siblings has been a journey of nearly a decade. What started in the collection of the Mildred Lane Kemper Art Museum has grown into an extensive collection of documents from historical archives in the United States and around the world.

In this account of Charles Parsons's life, archaeologists, enthusiasts of ancient culture and historians will enjoy Parsons's twenty-two-year relationship with Homeric archaeologist Heinrich Schliemann. Of interest to art lovers and historians are the artworks Parsons collected and the relationships he cultivated with artists like Corot, Church, Gifford, Inness and celebrated female sculptor Harriet Hosmer. Further, the Egyptian mummies he collected in 1896, now on permanent display at the St. Louis Art Museum, provide insight into and understanding of nineteenth-century collecting practices and the ancient culture of Egypt.

Civil War enthusiasts will appreciate Parsons's service and adventures in St. Louis as the assistant general quartermaster for the Union army, under the command of his brother, General Lewis B. Parsons, as well as Generals William T. Sherman and Ulysses S. Grant. American history buffs will take interest in stories of Charles's personal relationship with Sherman and extended connections with Grant.

In this account, you will glimpse the world travels of Charles Parsons; the rise and fall of Keokuk, a metropolis in Iowa once destined to be a great city; the creation of the first art museum west of the Mississippi; world's fairs in Chicago and St. Louis; and the creation of institutions that still thrive today. Readers with an interest in St. Louis and the surrounding region will learn that the hospital for children that Charles Parsons endowed in the nineteenth century to honor his late wife, Martha Parsons Pettus, would become St. Louis Children's Hospital in the twentieth century.

Cruelties of the nineteenth century—the practice of slavery and the treatment of women as having little more value than bearing children— shifted during the lifetime of Charles Parsons. He was active as president of the Humane Society of Missouri,[6] contributing to changes in society that would not fully come to fruition until the late twentieth and twenty-first centuries, but they began with the actions of this man.

From the surviving documents, not easily compiled and which are presented as is, and a review of his immense collection of art and artifacts, Charles Parsons emerges as a man who loved God with all his heart and artistic expression in all of its traditions and languages. He loved his country as a patriot and lived as an example that would be well followed today. He fought for the end of slavery, contributed to education with endowments at Washington University in St. Louis and the formation of Parsons College in Iowa (1875–1973). He was esteemed by his peers, collected great art of the time, thrived in business and was a paramount example of a Renaissance man in the nineteenth century.

Preface

Charles Parsons, who was born in rural New York and eventually settled in St. Louis, Missouri, contributed greatly to our nation. Fueled by stories of his family's participation in the Revolutionary War, he was a true patriot and worked to see the country's successful growth. His integrity, fidelity, courage, compassion, profound desire to contribute and sense of responsibility and justice in all matters are clearly evident. What follows is an account of the past that can inform our present and, hopefully, through the reader, affect the future by taking to heart his example of a life well lived in the service of God and his fellow man.

It is exciting to report that, as this manuscript was in its final stages, the Mildred Lane Kemper Art Museum reopened in September 2019, after a short period of remodeling, doubling its exhibition space and featuring a thirty-foot-tall polished, stainless-steel façade and a "soaring glass-lined lobby featuring an installation by artist Tomás Saraceno."[7] The Gertrude Bernoudy Gallery for display of the permanent collection provides a whole new viewing experience for the works of nineteenth- and twentieth-century American and European artists, many of which were collected by Charles Parsons for the enjoyment of generations to come.

ACKNOWLEDGEMENTS

I owe a debt of gratitude to the Missouri Historical Society and its excellent staff for hours of visits, especially the support of archivists Molly Kodner and Jaime Ellyn Bourassa. Acknowledgements must also be extended to photographers and videographers Levi Kirby and Andrew Shryock, as well as graphic designer Kara Hoganson; Sonya Rooney, University Archivist, Julian Edison Department of Special Collections at Washington University Libraries; archivist Marie E. Gurevitz and Amy C. Vedra, director of reference services, Indiana Historical Society; the Olivet College Library; the Missouri State Archives; the St. Charles County Historical Society; the State Historical Society of Missouri; the St. Louis Public Library, namely Amanda Bahr-Evola, manager of Special Collections and Digital Archives; the Heinrich Schliemann Museum, in Ankershagen, Germany; Watertown Free Public Library; the Missouri Humanities Council, namely Executive Director William "Steve" Belko; the staff of the St. Louis Art Museum, namely Head of Digital Assets Cathryn Gowan, Head Librarian Keli Rylance and Image Rights Manager Jessica Rahmer; John L. Maurath of the Missouri Civil War Museum; and the staff of the American Bankers Association (ABA), namely paralegal Andrew Doersam, General Counsel Dawn Causey and President and CEO Rob Nichols for their efforts to locate long-forgotten proceedings of the ABA, of which Parsons was an early founder.

I am grateful to the staff of international auction house Bonhams, namely Takako O'Grady, Karina Choy, Suzannah Yip, Yoko Chino and Global CEO Matthew Girling, for their assistance with the works of Yabu Meizan.

I appreciate the opportunities that Bellefontaine Cemetery has afforded me to present the lecture that has become this book, specifically Event and Volunteer Coordinator Dan Fuller and President and CEO Sherry Smith. The Carnegie Historical Museum in Fairfield, Iowa, and its director, Mark Schaefer, provided access to remaining artifacts of the Parsons family in its collection and connections to the last remaining class of Parsons College, who I was able to address directly in October 2018 with a lecture about the life of Charles Parsons. In that class is John Braidwood, who has engaged in hours of conversation over our shared love of the life of Charles Parsons and has been an unceasing advocate of this work.

Without the urging of Terry Cooper to present a public lecture on the life of Charles Parsons at Webster University, this book may have been in the works for two decades instead of just over one. Cooper's supportive coaching and interest led to many discussions and visits to the Parsons family plot.

Most special to this work is the untiring efforts and coaching of Theresa Huntsman to edit my essays and talks on Charles Parsons as she moved from Washington University in St. Louis to Harvard University and now to Yale University. Our mutual interest in the life and times of Charles Parsons has created a friendship that will last a lifetime.

Most recently, I am grateful for the assistance and friendship of T.J. DiFrancesco, whose connection and commitment to Parsons occurred following his attendance of a talk I gave in summer 2018 on the Tokugawa incense burner. His professional insights as a writer and poet have proved invaluable to the creation of this work.

Vikki Cosner, coauthor of *Missouri's Mad Doctor McDowell*, was the person who first suggested The History Press as a home for this book.

I would also like to thank the Mildred Lane Kemper Art Museum at Washington University in St. Louis for its assistance with Parsons's collection of art, artifacts and images. The museum has been the home of Parsons's collection since 1923, when, after the death of Charles Parsons Pettus, Charles's nephew, the collection was accepted into the university's care. Although the collection was bequeathed in 1905, immediately after Charles Parsons's death, there was a stipulation that the collection would not become the university's until after the death of Pettus.

I thank Carmon Colangelo, Dean of the Sam Fox School of Design and Visual Arts, and the entire Kemper staff of museum professionals. Specifically, I wish to acknowledge Director and Chief Curator Sabine Eckmann, who was supportive of my early efforts with Charles Parsons and his art collection when I was a member of her staff. Eckmann has ensured

that many paintings from Parsons's collection are maintained on view in the impressive permanent collection installation and that his endowment, the Parsons Fund, continues to fund new acquisitions. Registrars Rachel Keith, Sarah Hignite, Kimberly Broker and Kristin Good were kind and patient with my numerous requests to view not only Parsons's collection but also remaining records, as well as for approvals for image rights. Head of Publications Jane Neidhardt was generous with her time to share her thoughts on Parsons and directed me to the work of the museum's former director, Graham W.J. Beal, who authored *Charles Parsons Collection of Paintings* (1977). In this work, Beal wrote that Charles Parsons's gift "vastly expanded" the university collection of paintings.[8] Also, I wish to acknowledge Jan Hessel, former facilities manager and art preparator, who first found the image of Charles Parsons sitting in his parlor surrounded by his paintings, as well as Dave Smith, facilities assistant, for photographing the image. In all, Parsons would be very pleased with how Washington University and the Mildred Lane Kemper Art Museum have cared for his prized possessions.

Chapter 1

BEGINNINGS IN NEW YORK STATE

O n January 24, 1824, Charles Parsons was born as the third son and sixth child of Lewis B. Parsons Sr. and Lucina Parsons in Homer, in Cortland County, New York.[9] The man, who would be remembered by the *St. Louis Republic* as a "distinguished citizen, venerable banker, art connoisseur, author and philanthropist" after his death in 1905 was at the beginning of an incredible journey that would take him across the United States, through the American Civil War and around the world.[10]

Charles Parsons's birth was one of ten for his mother and father. His other siblings, in birth order, were Octavia, Philo, Lewis, Lucy Ann, Harriet Matilda, Levi, Emily, George and Helen.[11] Based on surviving letters and other documents, the Parsons family were close-knit and supportive. The following short glimpse of Charles Parsons's siblings and his mother and father informs us of his connections and relationships with those who raised him and stayed with him for much of his life through business, war and success.

HIS FAMILY

Octavia Parsons Sterling

The first child of Lucina and Lewis Baldwin Parsons Sr., Octavia was born in Scipio, New York, on October 27, 1815. She was Charles's oldest

sister, nine years his senior. Her beauty and goodness were well known, and in 1838, when Charles was fourteen years of age, she married William Erastus Sterling.

Sterling was a successful merchant who dealt in the cattle and produce businesses. He became prominent in Gouverneur, New York, where he served as the town supervisor numerous times in the 1840s. Sterling was a man of education, religion and morals. William and Octavia enjoyed six children during their marriage. On March 5, 1861, Sterling passed away. Octavia survived until 1881 and was well loved by her younger brother Charles.[12]

Philo Parsons

Charles's eldest brother, Philo, was born on February 6, 1817. When he came of age, he joined Lewis Baldwin Parsons Sr. in business as L.B. Parsons & Son. This was when the family was settled in Perry, New York. In 1843, he married the lovely Ann Eliza Barnum. Their marriage was long, happy and prosperous, producing eight children. Miraculous for the time, seven of them survived. A year after their wedding, Philo and Ann moved to Detroit, Michigan, and saw great success with his grocery business, Parsons & James. After many years of growth, and with Charles's counsel, Philo established a private bank. Philo and Ann enjoyed a beautiful and successful life together. It was Ann who was first to depart this world, suddenly, in 1893. Philo followed her three years later, in 1896.[13]

Lewis Baldwin Parsons Jr.

Lewis was born on April 5, 1818. Later in life, he added "Baldwin" as a middle name after the death of Lewis Sr. At the request of his father, Lewis Jr. was educated in the local schoolhouses, and he was the next to work in the business of L.B. Parsons & Son after Philo, but not for long.

Lewis Sr. thought it best that Lewis Jr. obtain a college education, and he enrolled at Yale University in 1837, becoming the first in his family to attend university. His letters describe how unprepared he was for this institution of higher learning, but he worked diligently to prove his worth. The courses were hard on him, and for a period of time, he was so ill that the family thought he would not be able to continue and would disgrace

the family name. Although he had not fully recovered at the time, he did complete his studies.

After graduating from Yale, he took some time to recover his health and then entered Harvard Law School. He graduated in 1844 and moved to Alton, Illinois, to begin practicing law. His first law partner was Newton D. Strong (1809–1866), a fellow graduate of Yale and member of the Illinois state legislature, before moving permanently to Reading, Pennsylvania.[14] Later on in that town by the river, he partnered with Judge Henry W. Billings, a "leading lawyer of the Illinois State bar," who became the mayor of Alton in 1852.[15]

In 1847, Charles was joyfully present at his brother's wedding to Sarah Green Edwards, the daughter of St. Louis doctor Benjamin F. Edwards and the niece of Illinois's first governor, Ninian Edwards. The Parsons family was completely pleased with this union. Sadly, shortly after giving birth to their daughter, whom they named Sarah, Lewis's wife passed away. Two years later, Lewis married her younger sister, Julia, and in this union, two more children, Charles and Julia, were born. Sadness struck Lewis's heart once again, however, with the passing of his new wife in 1857.[16]

Chapter 3 will reveal more of the life of Lewis Baldwin Parsons Jr. as a businessman, lawyer and Civil War general, as well as the reason why Charles joined the Union army as assistant general quartermaster in the city of St. Louis.

Lucy Ann Parsons

Lucy Ann Parsons was the fourth child born to Lucina and Lewis, on January 11, 1820. She was four years older than Charles and was reportedly most fond of him as they were growing up.[17] Her passing in 1859 was devastating to Charles, and it took him many months to recover. She had married successful merchant Charles S. Cone; their marriage was happy but brought no children before her untimely passing.[18]

Harriet Matilda Parsons

Born fifth was Harriet Matilda on March 22, 1822. She was sickly and struggled during her short life, passing away on August 22, 1823. Lucina Parsons was already pregnant with Charles at the time of Harriet's death.

Levi Parsons

Exactly two years later, on January 24, 1826, Levi was born. Charles felt that their shared birthday gave them a kindred connection. Levi moved to St. Louis to pursue business interests. His mercantile success was much applauded by the family; he prospered as a partner in the thriving wholesale grocery house of Smith Brothers & Company. The cursed cholera epidemic that claimed the lives of so many took Levi on April 9, 1850. Levi's death deeply affected Charles. Later in life, after Charles married Martha Pettus, her work with the Sanitation Commission in St. Louis was influenced by the loss of this younger brother.[19]

Emily Parsons

Emily Parsons was born the eighth child on June 11, 1828. She was described as a sweet and lovely girl who was called home on December 17, 1833. Emily brought wonderful happiness to Charles's mother, Lucina, who grieved long and deeply after her passing, when Charles was only nine years old.[20]

George Parsons

George Parsons was born on January 2, 1830, the ninth child. Charles was often tasked with watching young George, and this may have contributed to George's acumen for business, which he was early to show. George found success in Chicago as a banker and merchant. He married the elegant Emily Lycett Barnum in 1855. Emily passed away in 1904, and George followed on October 9, 1911.[21]

Helen Maria Parsons

Helen Maria was the tenth child born to the Parsons family, on July 19, 1834. As Lucina's final child, there was a special bond between them. Charles felt Helen was brilliant and loving in all manners befitting her station. They were fond of each other and often kept in contact by letter. On November 16, 1858, she was married to George B. Boardman. While Charles was fulfilling his duties in the Union army, he learned of her passing on August 6, 1863. The hardships of national strife were felt much deeper by Charles upon learning of her death.[22]

Lucina Hoar Parsons

Charles's mother, Lucina Hoar, was a New York woman of education and breeding, born on October 31, 1790.[23] She took pride in being seventh in descent from Charles Hoar, sheriff of the "Cittie of Gloster," England; his widow, Joanna, immigrated with her children to Massachusetts around 1640 and settled in Concord and the vicinity. Lucina worked diligently to encourage her children to be good citizens and was tireless in her family responsibilities. She was known as the enforcer of the rules and teachings that Charles's father bestowed on the family. Charles's brother Lewis wrote that his mother was "in the full vigor of her intellect and retaining to the last a deep interest in all matters of moment, both of Church and State, of which she was well advised by the constant and wide reading. Possessing with uncommon energy a rarely calm and equable temperament, a most active and earnest Christian from my early youth, she was an admirable balance for my father's more sanguine and nervous character, and wisely advised and aided his plans and action in life."[24] Charles remarked, "She was a mother in Israel, indeed, full of piety, of a most intelligent nature, loving and affectionate; she was a woman to be loved, had friends wherever known and not an enemy ever."[25] To the great sadness of Charles and his surviving brothers and sisters, Lucina passed from this world on October 3, 1873.[26]

Lewis Baldwin Parsons Sr.

Charles's father, Lewis Baldwin Parsons Sr., was born on April 30, 1793.[27] He had been a very successful merchant until the War of 1812, when his fortune was lost to the economic chaos of the time. Lewis resolved that he would thrive again, and through persistent effort, conservative practices and pure will, he maintained the family and prospered once again.[28]

Before the War of 1812, Lewis Baldwin Parsons had aspirations of becoming a clergyman and securing a formal education, but due to a serious bout of dyspepsia, he had to resign from these intentions.[29] Undeterred in his commitment to education, however, Lewis taught himself, reading voraciously and speaking with anyone on nearly any subject of interest. He enjoyed teaching his children the wonders of the world, and Charles learned his love of art from the stories his father told from the books he read.[30]

Lewis could trace his family lineage to the first Parsonses in America, who came from England in 1636. He was the son of Lieutenant Charles Parsons,

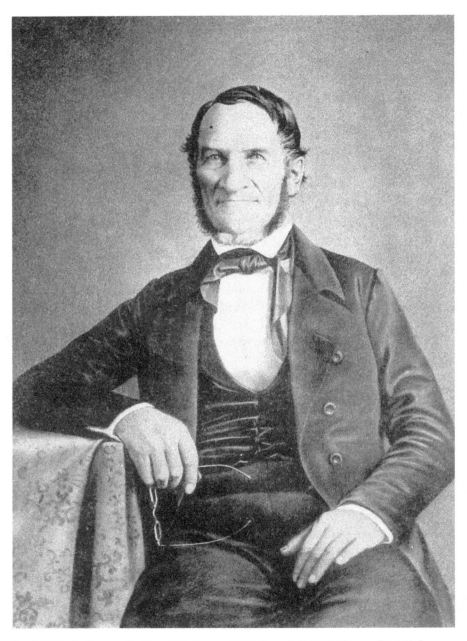

Lewis Baldwin Parsons Sr. *From W.E. Parsons, 1925. Carnegie Fairfield Museum, Fairfield, Iowa.*

a soldier of the American Revolution under General George Washington. Lewis Baldwin Parsons ensured that the family were well acquainted with stories of the Revolutionary War and how Charles's grandfather had been stationed with his company at Ticonderoga and up the Mohawk River at Fort Schuyler during the summer of 1780, as well as how he suffered with his troops at Valley Forge, was wounded at the Battle of Monmouth and was present at the surrender of Lord Cornwallis at Yorktown.[31]

In manners and morals, Lewis Baldwin Parsons was most strict. He was of liberal disposition, though, when it came to his faith. Charles wrote, "In religion my father was a Puritan of an enlightened stamp."[32] He was a Calvinist and a devout and liberal Presbyterian. Charles wrote, "I recall his paying for a long period one-tenth of the salary of the minister. In fact, long before that time, and for the rest of his life, he made it a sacred duty to contribute at least one-tenth of his income to Church and charitable purposes."[33] Religion was of paramount importance to Lewis Baldwin Parsons in the education and training of his children. Charles wrote:

> It was my father's custom at morning family worship to have each read a verse in turn from the Bible, which was read in course from Genesis to Revelation. In those days, Sunday began at sunset on Saturday, when all worked ceased. Sabbath evening prayers were always prefaced by an inquiry of the children as to what they could recollect of the two sermons they had heard. We were allowed to take pencils and paper to church, to aid our memories, but were always expected to give some account of what had to be said. Generally my father made some remarks on the subjects treated of at the church service, in all of which he was well versed, and being a fluent talker, of fine conversational power, even as children we were generally quite interested. At other times, at our meals, he would entertain and instruct us upon various subjects, and as there were then in the country no daily newspapers, and as books were more rare than now, his lessons in a conversational way were full of interest, and as he remembered well what he read, and had a ready, apt and ample supply of anecdotes, were very instructive and entertaining.[34]

Charles's brother Lewis provided us with insight beyond their father's religious contributions, here relating how Parsons Sr. contributed to the family in other ways:

Deeply regretting his limited advantages for education in early life, my father improved every opportunity for self-culture until there were few men in business life at that day of more varied and accurate knowledge, and the same cause made him ever an ardent advocate of general education. For history and poetry my father had a decided taste, and often quoted to his children the fine sentiments of the best authors. For art and nature in its varied forms his love arose to enthusiasm.[35]

When providing charity to others, Charles was often reminded by his father that "the true use of wealth, at least to a reasonable amount, was for the public good."[36]

Although he was not a formally educated man, Lewis Baldwin Parsons imparted most of Charles's early guidance in business. With Charles clerking since the age of twelve under his father's guidance, he developed a strong foundation for future success in business. Charles wrote:

As a business man I think my father possessed rare sagacity, combined with a fine sense of right, as is shown in his rules to us, as applicable to business and as general maxims of life, some of which I recall, as, for example:

- *Don't try to get the last dollar of gain in a trade; you may miss the first one.*
- *Let the man you are dealing with have a little chance; he has a right to live as well as you.*
- *Never tell the good of your trades; it is undignified: and, further, it will make people indisposed to deal with you, as every man wants a chance to profit.*
- *Be careful about making promises, but always keep them.*
- *Never be a speculator; they are sometimes rich, then poor, but generally die poor.*
- *Some people think their prayers are surely answered, forgetting that others may be praying for the same good result; forgetting also the story of the soldier, who seven times aiming at those of the enemy, and each time seeing them fall, would have sworn he had killed them all; but finally discovering that the seven charges were all in his gun, said: "It was well to remember that other men might be firing at the same mark."*
- *Be courteous to all from the principle and kindly feeling. Besides, "it is better to have the good will of even a dog than his ill will."*[37]

It appears as though the influence of Lewis Baldwin Parsons Sr. assisted Charles later in life when he joined to fight in the Civil War on the side of the Union. Charles recounted an experience with his father:

> *I well recollect, when I was quite young, his reading to us the then famous Jack Downing letters, during Jackson's administration, and his enjoyment of the humorous account of the "Kitchen Cabinet" at the White House. During the agitation of the Kansas-Nebraska Bill, introduced by Douglas, he took great interest in the subject and denounced it as a breach of faith and honor on the part of the South, as the Missouri Compromise was regarded as a settlement forever of the question of taking slavery north of the south line of Missouri. Still, he was not an abolitionist, standing firmly on the compromise of the Constitution, so long as abided by on the part of the South. While regarding all slavery with abhorrence, he considered the whole country as responsible for its origin, and as only to got rid of by the gradual emancipation or colonization by the consent and the expense of the whole country.*[38]

These sentiments were echoed by Philo Parsons when he wrote of his father's legacy: "He predicted the civil war and its cause, and felt that not the South alone, but the whole country was involved in the great wrong of human slavery."[39] Additionally, Charles wrote of his father:

> *The ruling principle of his life was to do good; first in the proper raising and education of his family, and second, in efforts for the progress of truth within the sphere of influence, and in giving of his means to spread the knowledge of God through the world; and as one of the great mean to such an end he was ever a most devoted friend and contributor to Home and Foreign Missions. His faith in the ultimate triumph of right over wrong, of the good over the bad, of God over the devil was absolute.*[40]

In 1845, Lewis Baldwin Parsons retired from business, and in 1848, he moved to Buffalo, New York. A short time before this, however, his health had begun to decline. He spent the winter in Texas hoping to recuperate. On his way to Texas, he visited St. Louis and the lower Mississippi. Then he purchased a horse and set to ride a reported eight hundred miles through Texas. Texas had recently been admitted into the Union, and any information about the new state was of great interest to people. While in Texas, Lewis wrote letters that were full of fascinating incidents. They

attracted so much attention that they were published in newspapers and enjoyed with great interest.[41]

While residing in Buffalo, New York, Parsons Sr. traveled to visit Charles, who had settled in Keokuk, Iowa, and he stayed for several months. During his extended visit, Lewis became greatly interested in the state. Charles wrote, "Foreseeing the greatness of its future and the influence and power it was to exert on the destinies of the country, he decided to do what he could to aid in giving a wise direction to its moral and educational development, and hence arose his decision to devote a large share of his property to the cause of education there."[42] The property that Lewis Baldwin Parsons Sr. purchased became the grounds for Parsons College, in Fairfield, Iowa (to be covered in more detail in chapter 11).

After his time with Charles in Keokuk, Lewis Sr. continued his travels across the country. Charles reported that in the fall of 1851, Lewis was extensively exploring Michigan. Charles wrote that "he contracted malarial disease so strongly that he never recovered from its effects, and in fact then planted the seeds of the complaint from which he suffered greatly until he died at Detroit" on December 21, 1855.[43]

It is clear that Charles deeply loved and respected his father. In the closing thoughts of *Recollections of Lewis B. Parsons*, which Lewis Jr. wrote and sent to Reverend Dr. Craig, president of Parsons College, in 1893, he said:

> *I am sure no man had more perfectly the respect and love of his children (of whom eight arrived at maturity) than our father. In telling an anecdote he never repeated an expression having in it the least profanity, or that would have been improper to relate before ladies. His high sense of honor and the dignity of manhood were a good example to all and placed him on a high plane commanding unusual respect.*[44]

THE JOURNEY WEST

Before Charles began his travels west, he received a basic education in his father's store as a clerk. In 1846, he was ready to venture out beyond the family business. He was initially hired as a clerk and then became a partner in a commission and transportation house in Buffalo, New York, under the financier Gains B. Rich. Between 1846 and 1850, Charles was based in Buffalo and traveled often to Ohio, Indiana, Illinois and even the

town that would become his permanent home after 1864, St. Louis. From a letter during this earlier period, Charles did not seem too impressed with St. Louis: "I found Cincinnati had grown beyond my expectations, it is indeed a city of great resources, I think St. Louis can't come up with its 110,000 inhabitants."[45]

Later in life, Charles Parsons became a strong Republican, occupying prominent positions in the party and contributing generously to its success. However, we see Charles's interest in politics developing much earlier, evident in the following letter. While attending a political convention in Cincinnati in 1848, he sent a letter home to his father. This rare glimpse of Charles's young and intelligent twenty-four-year-old mind is revealing:

> *We have just passed through the great Wilmot Proviso Free Soil Convention which has just nominated Martin van Buren, the hero of 1840 for the Presidency...with Ohio delegates to the number 2—or 3,000 but such a motley gathering as the Buckeyes presented—there was the greatest quantity of homely-green looking-men [sic] you ever heard of. A young man of my acquaintance...saw a large number of Ohio looking into a bawdy hour [and] he sung out "Hurra for the Ohio delegation," a wag took a number of them to a noted bawdy house to get supper and of course they made the acquaintance of the damsels much to their chagrin.... There has been some tall talking from one man, that is Joseph L. White, the Whig orator of 1840 and '44 who in '40 made the houses and hills of Indiana vocal with loud and bitter denunciations of M.v.B but who now supports him strongly and ardently and going still further speaks of Hy Clay as the best and greatest of men...but you must read his speech for it is a beautiful and much more so coming from his own lips...his enunciation full and distinct and he is full of life in soul-bathing eloquence—how has fallen to spend his breath for so great a magician as Martin it is too bad....Yet ranking in my heart is the soul sickening remembrance that in 1844 the same conscience tender abolitionists and revenge seeking Barnburners...stood up to malign, to abuse and vilify to assist in blackening...the fair fame of the greatest and the best—Oh how it rankles in my bosom, it festers in my heart and I might sooner lie down with hyenas or become a companion with screech owls than throw myself into the arms of such a party.[46]*

Though politically influenced in his youth, Charles was not influenced by the unfounded ventures. With only a few months to gain working knowledge and guidance directly from the most respected and able financier at this time

in history, Gains B. Rich, Charles could have bought into the fever of the California Gold Rush.

Charles never seemed destined to try his hand in the gold rush. Commenting on Charles's early successes and failures in his first business, Charles and Company, and in relation to his developing business sense, his father wrote, "He is, I think, pretty well cured of the notion of making money by speculation, not so much by his losses (which have been small) as by seeing numerous and heavy failures...here. I doubt much whether even the California mania will have much effect on him."[47] Parsons Sr. went on to say, "I am pleased that our children have energy in business but they should remember that a moral life consists not in the abundance of things."[48]

By 1849, Charles's brothers Lewis and Levi had become established in St. Louis. This was also the year when Lewis B. Parsons Sr. decided to move to Buffalo, seeking new opportunities.[49] In 1849, Charles was hired by the Bank of Attica in Buffalo. This year brought tragedy to the Parsons family in St. Louis.[50] In 1849, Levi lost his business due to the great fire that left many devastated. He and his business partners were saved by being "perfect insured,"[51] meaning that the insurance covered all losses and damage. But a far more serious situation was before Levi. He had been ill with cholera, and in letters to his father, the talk of searching for a final "monument"[52] seemed to foretell the future—Levi died of cholera on April 9, 1850. Charles was deeply saddened, as was the family, but he was instrumental in choosing Levi's final resting place and the monument, which would reveal his appreciation of art and the love for his brother. Graham W.J. Beal, author of *Charles Parsons Collection of Paintings* (1977), wrote:

> [Charles] *was particularly struck by an impressive tomb made for the wife of Byron Sherman and gives a detailed description of it, providing a first glimpse of his interest in the arts. He described various stones, the quality of the carving and the fancy iron gates. He suggests that the Sherman tomb would make a good model for a Parsons' family tomb, but that "less fancy gates would half the cost of the iron work." An early paragraph in this letter brings together in a few lines the major concerns that are to be found in all of his later personal correspondence—nature, business, religion, and art.*[53]

Charles wrote, "A more lovely spot [Greenwoods] I never saw for the last final resting of mortality, Hill and Dale [*sic*] forest and lawn, still lake and

running fountains and afar off of the busy city with its heaven towering spires, its forests and masts before us in the most magnificent of harbours, around us the pious memorials raised by the living for the dead."[54] If one were to visit the family plot of Charles Parsons at Bellefontaine Cemetery, in North St. Louis, one could not help but imagine that he chose it based on his experience of laying to rest his brother in such an idyllic location.

Charles had worked for the bank in Buffalo for more than a year when it sent him to St. Louis. On his way there, by way of Alton, Illinois, he met up with his brother and father on Monday, October 3, 1850. Charles described his father as "very well indeed"[55] but that he had gained weight with the imaginative phrase, "[He] has burst off all the buttons of his overcoat."[56]

He only stayed in St. Louis until October 1851; he wrote home explaining that business in St. Louis was dreadful and that many financial houses were closing. It was time for Charles Parsons to head north to Keokuk, Iowa, to seek his fortune in the growing river boomtown.

Chapter 2

KEOKUK, IOWA

First Gateway to the West

Stories of success and failure in California's gold rush regularly appeared in newspapers across the country in 1851. While some men and families were still packing up from St. Louis, Missouri, to head west to seek their fortune, Charles Parsons was about to head 180 miles north from St. Louis to the town of Keokuk, Iowa. With opportunities dwindling in St. Louis and too much competition for Charles and Company to make a significant impact, he accepted, at the urging of H.D. Bacon (of Page and Bacon, bankers in St. Louis), a proposal to open a bank in Keokuk. By October 1851, Charles was established in this emerging river boomtown.[57]

Keokuk was an extremely important town on the Mississippi River in the early nineteenth century. At one point in time, it was projected to take over St. Louis in size and national significance. Keokuk is the southernmost city in the state of Iowa, and it was named after the Sauk chief Keokuk.[58] It sits at the confluence of the Des Moines and Mississippi Rivers, a location that gave early settlers access to expansive hunting grounds, trading areas and the means to easily transport their goods as boating technology advanced. This location also earned it the nickname "Gate City."[59]

At the turn of the nineteenth century, the U.S. Army knew the area that eventually became Keokuk only by its original Indian name: Pinch-e-chut-tech.[60] The first Caucasian settler to the area was Dr. Samuel C. Muir, a surgeon and graduate of the University of Edinburgh, Scotland. He joined the army early in the nineteenth century and was stationed with a command at Fort Edwards, Illinois (now the town of Warsaw), a mere

seven miles from Keokuk. Between 1815 and 1820, Dr. Muir married a woman from the Sauk Nation. In 1820, the U.S. Army issued an order requiring officers to renounce their indigenous wives. Refusing to comply with the order, Muir resigned his commission and settled across the river with his wife at the mouth of the Des Moines, exactly where Keokuk is now located. Muir died in 1832 of complications of cholera, leaving his wife and five children.[61]

From 1820 on, Keokuk grew quickly from increasing traffic on the Mississippi River, which brought an influx of European settlers in search of new homes on the American frontier. The development of significant business infrastructure began in the town around 1827 with the establishment of what was known locally as "Rat Row,"[62] due to the infestation of rats. "Rat Row" was the creation of John Jacob Astor, who established his American Fur Company below the bluffs and erected five buildings to accommodate the business and the workers needed to see its success.

Historian, early archaeologist and politician Caleb Atwater (1778–1867) provided one of the earliest accounts of the area in and around Keokuk, Iowa. In 1829, he wrote, "The settlement was part of the land designated in 1824 as a half-breed tract by the United States Government for allotting land to mixed-race descendants of the Sauk and Fox tribes. Typically children of European or British men (fur traders and trappers) and Native women, they were often excluded from tribal communal lands because their fathers were not tribal members. Native Americans considered the settlement a neutral ground. Rules for the tract prohibited individual sale of the land, but the US Congress ended this provision in 1837, creating a land rush and instability."[63]

The name change from Pinch-e-chut-tech to Keokuk did not occur until after the Blackhawk War in 1832.[64] This war was a short conflict between a band of diverse tribes of Native Americans led by the Sauk chief Black Hawk. Black Hawk commanded a force numbering 1,500, with members of his tribe alongside men, women and children from the Kickapoo, Fox, Meskwaki, Potawatomi, Ho-chunk and Ottawa Nations across the Mississippi River and into the state of Illinois from the Iowa Indian Territory. This force was known as the "British Band" due to a British alliance that dated back to the War of 1812.[65]

The force's crossing of the river from Indian Territory into the state of Illinois in order to reclaim their homeland was in violation of numerous treaties. The U.S. government considered this an act of war and activated the Illinois and Michigan Territory militias, beginning the conflict. Although the "British Band" was victorious at the Battle of Stillman's Run and other

skirmishes, it was finally defeated at the Battle of Wisconsin Heights and the Bad Axe Massacre.[66]

The Black Hawk War is where Abraham Lincoln became a captain in the Illinois militia. Although he served as a volunteer from April 21 to July 10, 1832, he never saw combat. His primary contribution was to bury the militia's dead, and he finished his service under the command of Captain Jacob Early, who was leading a company of independent spies. For his military service, Lincoln received a large land grant from the government and created lasting political connections that served him in the years to come.[67]

Following the Black Hawk War, the "British Band" members were either imprisoned or returned to Indian Territory. Black Hawk was transported east and, along with other warriors, was toured to other cities under the "hospitality" of the U.S. government. In 1883, he became the first Native American to publish his autobiography.[68]

Also after the war, the town known as Pinch-e-chut-tech was renamed Keokuk after the Sauk chief, not to be confused with Black Hawk. To date, there is no surviving record or explanation as to why this occurred. Keokuk was incorporated on December 13, 1847, following the grant of statehood to Iowa.

Keokuk was on its way to becoming a large population center in the mid-nineteenth century. In late 1850, the College of Physicians and Surgeons opened a seven-story building downtown at Third and Palean Streets, which marked Keokuk as a premier medical center in the Midwest until the early twentieth century.[69] In 1851, Charles Parsons established his bank in Keokuk, and between 1851 and 1857, he was witness to one of the biggest frontier success stories to date—that is, until the Panic of 1857 and his bank's failure.[70]

In 1853, Keokuk was a primary staging and outfitting center for more than two thousand Mormons, who passed through the town on their westward journey.[71] It is not clear if Charles profited directly from the travelers, but if he did, it was only through the merchants who secured loans for the supplies that they sold to the Mormons for their trek. Between the residents of Keokuk and the travelers who passed through it, there was no shortage of potential customers, but business was still extremely challenging.

In 1855, the *Keokuk Post* reported that nearly seven hundred buildings of all types of use and purpose had been erected in the year prior, and already in 1856, "431 businesses lined Keokuk's streets. Lawyers, doctors, insurers, notaries, and customs collectors occupied another hundred or so offices."[72]

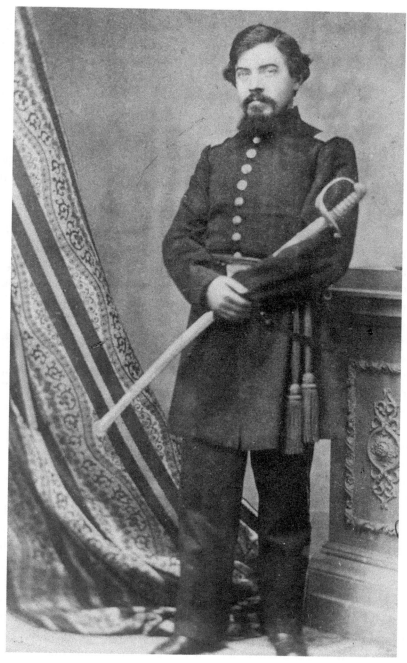

John W. Noble. *Missouri Historical Society, St. Louis.*

In his surviving letters, Charles related to his father the time-consuming and demanding experience of owning a bank in a growing river town. The majority of Charles's complaints related to the larger local banking houses and the fact that they could offer better interest rates than he could.[73]

Although business was challenging for Charles Parsons, he created powerful friendships and alliances in Iowa that served him the remainder of his life. His friends included John W. Noble (1831–1912), who became the U.S. district attorney for the eastern district of Missouri, secretary of the interior under President Harrison and prosecutor of the infamous "Whiskey Ring" but was most notably remembered as one of the proponents of the Forest Reserve Act of 1891, which allowed presidents to set aside forested lands as national parks.[74] Samuel F. Miller (1816–1890), also a close friend of Parsons's, moved to Keokuk because the state of Iowa aligned with his views on slavery: to abolish the abomination. After supporting Lincoln in the 1860 election, Miller was nominated to the Supreme Court in 1862 and rose to national prominence.[75] Samuel Ryan Curtis (1805–1866), mayor of Keokuk in 1856 and then congressman, was a close confidant of Parsons's. Curtis is remembered as an engineer to whom St. Louis is indebted, largely for the preservation of its harbor and improvements to the river, such as deepening the shoreline so all manner of boats could dock in St. Louis. He successfully commanded the Union army at the Battle of Pea Ridge, and he was an early advocate for the Union Pacific Railway. Federal judge John Forrest Dillon (1831–1914), author of the influential *Municipal Corporations* (1872), was also a friend and confidant,[76] as was George W. McCrary (1835–1890), who was a federal judge and a distinguished member of Congress and served as secretary of war under President Rutherford B. Hayes.[77]

Although no evidence exists to show that Charles Parsons interacted with Samuel Clemens (1835–1910), more famously known as Mark Twain, in Keokuk, it is interesting to note the author's ties to the area. Clemens's older brother, Orion (1825–1897), moved to Muscatine, Iowa, about ninety miles north of Keokuk, and purchased the *Muscatine Journal* in 1853. Clemens joined him in 1854 and later recounted his experiences in his book *Life on the Mississippi*.[78] In 1855, Samuel moved to Keokuk, and while working for Orion at his printing press, he made his debut as a public speaker.[79] On January 17, 1856, the *Keokuk Post* noted with enthusiasm his wit and humor at a banquet to honor printers. In a letter to his mother in 1886, Twain remembered Keokuk's hot weather—heat so extreme it could make a person cry, he said. In his autobiography he recalled the bitter winter of late 1856, when he found a $50 bill blowing on the snowy pavement. Twain sold his

first written material to the *Keokuk Post*. He also corresponded regularly with a young woman, Annie Taylor, who was a student at Iowa Wesleyan College at Mount Pleasant.[80] If Samuel Clemens met Charles Parsons during their shared time in Keokuk, it is unlikely they would have aligned politically. It is often forgotten today, but Clemens joined the Confederacy briefly early in the Civil War, which in 1856 was only a few years away.[81]

Although competition in the banking industry made his life difficult, Charles Parsons was still succeeding in his enterprise before the panic. As was the case with other banks, farmers and merchants, he had been enjoying prosperity in Keokuk, which gave entrepreneurs a level of confidence and the opportunity to take risks. The timing could not have been worse. Charles's bank and many other businesses failed in the Panic of 1857.[82] This was caused by a decline in the international economy, coupled with the domestic economy expanding too quickly. Some of the blame was attributed to the California Gold Rush. With large amounts of gold being mined, this greatly expanded the money supply in the early 1850s. When the influx of mined gold began to decline by the mid-1850s, eastern banks and investors became wary of the loans they had extended to developing settlers out west. Some banks even went so far as to refuse to accept currency issued by western banks. Eastern bankers and businesses called on Europe to deliver gold to back the paper money in circulation. The Palmerston government in Britain circumvented the requirements of the Bank Charter Act of 1844, which ensured that the amount of money in circulation was physically backed by gold and silver; when this surfaced in public awareness, the panic spread from Britain to America.[83] The interconnectedness of the world's economies caused a worldwide financial crisis for the first time. This crisis hit Keokuk particularly hard, as railroads, associated companies and financial institutions began to fail.[84]

In Keokuk specifically, the price of grain in 1855 was very high.[85] As a result, farmers sought loans to purchase additional land to expand their crop yields and increase their profits. Charles Parsons saw the direct benefit of this to his bank. Two years later, though, when the price of grain and other crops dramatically decreased, the immediate loss of revenue caused a chain reaction of failures across numerous industries and businesses, with an emphasis on the railroad industry.[86]

The Panic of 1857 is believed to have stopped the skyrocketing growth of Keokuk, as land sales declined and westward expansion slowed. The dream of the town dubbed an "infant Hercules" that would someday "eclipse both Chicago and St. Louis" was fading quickly, and Keokuk did

not recover until 1861.[87] It is interesting to note that the southern, mostly agrarian economy suffered little in comparison to the northern economy during the panic. This was due to fewer railroads and greater maturity in landholding, requiring far fewer loans.[88]

The Panic of 1857 caused a number of things to change in the life of Charles Parsons. Upon closing the bank, he immediately paid his debts. It is unknown how Charles emerged so quickly from the panic and how he came to be engaged to a woman living in St. Louis, but Charles managed to reopen the bank after restructuring and was joyfully engaged to be married to Martha, "a young lady of the Pettus family, and at that date, one of the oldest names in St. Louis."[89] Parsons may have been able to recover so quickly because the Pettus family was one of the most powerful and wealthy in the region, and a deal may have been made through this union. The Pettus family represented the most refined of classes at the time in St. Louis, owing much to the efforts of their patriarch, Martha's father, William Grymes Pettus.[90]

William Grymes Pettus (1794–1867) was a Missouri politician who settled in St. Louis in 1818 after serving in the War of 1812. A mere office clerk in St. Louis, he found himself elected secretary of the convention to bring Missouri into the Union. This convention also wrote the Missouri state constitution upon admission into the Union in 1821 as the twenty-fourth state. Pettus went on to become secretary of state in the administration of Alexander McNair, served as a probate judge in St. Louis County and was elected a member of the Missouri Senate to represent the St. Charles District in 1832.[91] Although recognized as the man who wrote the constitution that entered Missouri into the Union, Pettus had southern leanings that caused tensions with Charles at the breakout of the Civil War.[92]

Charles Parsons and Martha Pettus were married on June 11, 1857, in St. Louis.[93] Unfortunately, "the ceremony was overshadowed by another family tragedy for the Parsonses. Julia, the wife of his brother Levi, had died a few days earlier. Charles wanted to postpone the wedding, but plans were too far along to reschedule. Instead, in brother George's words, the "wedding [was] an extremely solemn affair....I never saw Charles so much affected."[94]

Charles and Martha arrived five days later in Boston by train and embarked on a nearly five-month honeymoon in Europe, sailing first to England on June 17, 1857.[95] Their honeymoon marked the first of many travels to Europe. The art and architecture, museums and artists' studios that they visited influenced Charles's tastes and motivation to collect works

of art, building one of the finest collections of paintings in nineteenth-century America.

Although Martha and Charles were often apart while Charles was traveling for business, they stayed in regular communication through letters. Martha appears to have experienced fulfilment with each letter that Charles wrote to her, saying that "every line [is] fraught with love."[96] In this same letter, she asked him "not to chide her for writing of their human passion so freely." For his part, Charles rarely wrote of their mutual love without a reference to the superior love of God, a telling comment on the mores of that time and, more particularly, the influence of his Puritan father.[97]

At the end of 1857, Charles found temporary residence at Astor House in New York City to conduct business.[98] He penned Martha a letter expressing his admiration and gratitude for the support he had received from his brother Philo and "our kind heavenly father."[99] In this letter, we also see Charles's fascination with the possibilities of the business world and the presence of the Divine at work. He wrote, "Let us submit, for it is most evident that His hand is in the great disorganization of the business world."[100] Charles, feeling self-conscious, wrote to Martha, "You will think I am selfish to be constantly talking and thinking about my business. I hope to soon give up the subject and let my mind run on more cheerful [terms]. New York looks terribly dull now owning to the entire suspension of business yet there is a more cheerful feeling in the money market."[101]

Even though Charles Parsons continued to travel frequently for business following their honeymoon, his heart was still very much in Keokuk. Throughout his surviving letters, there is the sentiment that Charles believed he would remain in Keokuk for the rest of life, but that was not his fate. The Panic of 1857 changed the dynamic between the economies of the North and the South. It encouraged southerners to believe that the North needed the South to ensure the stability of both their economies. This belief gave southerners confidence that the North was open to expanding slavery and ensuring its continuance.[102]

When the Civil War began in 1861, Keokuk emerged as a point of embarkation for Union soldiers ready to fight in the South. Although the town saw no action during the war, several hospitals were established, and soldiers were transported there for surgeries and other treatments. With so many Iowans fighting for the Union, a national cemetery was established for those who lost their lives.

For Charles Parsons, Keokuk had been a place where he grew as a businessman and expanded his circle of friends in personal and business

matters that served him later in life. When the repeal of the Missouri Compromise and the Dred Scott decision took place in St. Louis, the ripple effects raised political tensions in the country; Iowa, which shares a border with Missouri, became vocal through its citizens and elected officials of its disapproval of slavery.

Charles and his friend John Noble participated in political campaigns and torchlight processions as members of the "Wide Awakes," a paramilitary organization cultivated by the Republican Party prior to the Civil War.[103] Parsons and Noble debated the issues of the coming war with those who opposed them, but war could not be avoided through such efforts. John Noble recalled that the "reverberations of thought and debate" were followed "by those of the cannon." Charles saw firsthand the steamers on the Mississippi filled with men from Iowa and states above, flowing south to the great battle.[104] He saw "thousands enlisted to defend the flag and the constitution" and "regiments on the march, camping, and drillings on" on the bluffs above Keokuk.[105] Thus Charles Parsons and John Noble obeyed the call of their country. John Noble closed his law practice and joined the Union army. He was commissioned a lieutenant in the Third Iowa Cavalry Regiment, rising eventually to the rank of brevet brigadier general.[106] Charles closed his bank and accepted the request of his brother Lewis to join the Union army under his command in St. Louis.[107] Charles's next great adventure awaited him there. He said goodbye to the river town in Iowa that, for the remainder of his life, he referred to as "my dear old Keokuk."[108]

Chapter 3

U.S. CIVIL WAR QUARTERMASTER

W hen hostilities broke out between the states in 1861, Charles and Martha Parsons were living in Keokuk. They had survived the Panic of 1857, when Charles was forced to shut down his bank due to the recession. Now a much larger panic was gripping the country: the Civil War. Charles and his brother Lewis, along with attorney John Noble, were called into service to protect the U.S. Constitution. Lewis Parsons and John Noble had attended Yale University, and in the early 1850s, both had moved to St. Louis, where Lewis introduced Charles to John. Due to their shared interests and the economic downturn in St. Louis, Charles and John traveled to Keokuk to seek their fortunes. Their businesses and friendship mixed well for early success and mutual support during the 1857 panic.

Although their friendship started in St. Louis and grew in Keokuk, the Civil War forced them to part ways until after the conflict. Before being mustered into the service of the Union army, Charles and John watched the great Mississippi River and the mounting tensions of the impending war from the river cliffs in Iowa. Speaking at Charles Parsons's memorial in 1905, Noble recounted the early moments of the war from Keokuk:

> [W]e saw that great river [the Mississippi] freighted with men and the might west, all in arms, flowing southward to the sea of conflict. The drums beat and down the river came the regiments of the march, camping and drilling on our high hills. From Keokuk itself and from the plains and prairies around about, came thousands enlisted to defend the flag and the constitution, and on towards the south went the forces to contend for

mastery over that river as part of this Union, and determined that it should run unvexed to the sea. Our friend [Charles Parsons] and I with many of our fellows went with the flag. The bank was closed. The law office deserted. The call of our country was obeyed.[109]

Because John Noble played an interesting role in the life of Charles Parsons following the war, it is important to understand his history as well. Noble was commissioned as a lieutenant in the Third Iowa Cavalry Regiment in September 1861.[110] By 1864, he was the regiment's commander, holding the rank of lieutenant colonel, and he was mustered out of service in 1865. Noble ultimately earned the rank of brevet brigadier general. He became a member, along with Charles Parsons, of the Missouri Commandery of the Military Order of the Loyal Legion of the United States (MOLLUS) and settled in St. Louis. He was appointed United States attorney for the Eastern District of Missouri from 1867 to 1870 before returning to law. In 1880, he was the founding member of the St. Louis Mining and Stock Exchange before serving as secretary of the interior between 1889 and 1893. Noble is best remembered as a pioneer of the conservation movement through his support of the Forest Reserve Act of 1891.[111] His Interior work created forest conservation policies that lead to the establishment of federally protected national parks in the decades to come.

The Civil War caused the Lincoln administration to call thousands of men into military service between 1861 and 1865, and they were utilized in two military areas. In the east, Union troops waged battles unsuccessfully for a long time against the Confederate capital of Richmond, Virginia. In the west, Union troops worked to drive Southern troops out of the states of Missouri, Tennessee, Kentucky and to conquer Mississippi before moving on to other adjacent Southern states.[112]

Charles Parsons was mustered in the Union army in January 1862 in St. Louis and mustered out on July 13, 1864.[113] Lewis was the driving force behind Charles joining the Union cause. Lewis had been friendly with Abraham Lincoln, going back to the days when Lincoln was "riding circuit" in southern Illinois and making visits to the town of Alton to hear cases. Lewis began to take an interest in the growing developments of train travel and transportation of goods, and in the late 1850s, he invested in the construction of the Ohio and Mississippi Railroad between St. Louis and Cincinnati. By 1861, he was serving as the general manager of this railroad company, and he returned to St. Louis.[114] Men with Confederate leanings were largely in control and aided by the governor and legislature

of Missouri.[115] Talk of seceding from the Union was everywhere in St. Louis. With Missouri as a slave state, the governor and the legislature were planning to give control over to the Confederacy. This was prevented through bold action by General Lyon and the capture of Camp Jackson, on the outskirts of St. Louis, on May 10, 1861. Lewis Parsons was standing by Colonel Frank P. Blair in his service as a volunteer aide, who would later become a general in the Civil War.

The Camp Jackson affair made Lewis realize that war was coming. Lewis was beyond the age of military service but was determined to serve. He wrote to General McClellan, vowing "all aid in [his] power

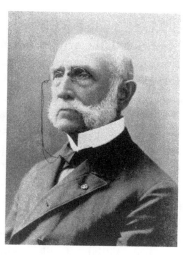

Lewis Baldwin Parsons Jr. *From W.E. Parsons, 1925. Carnegie Fairfield Museum, Fairfield, Iowa.*

for the preservation of the Government as [his] grandfather had given seven years of his life during the Revolutionary War."[116] He offered his services to the general for any position where he thought he could be useful. McClellan invited him to Washington, D.C., and, upon arrival, gave him a position on his staff with the rank of captain. Lewis quickly became anxious, finding that his role did not involve significant duties or responsibilities. He asked for permission to resign and return west to raise a regiment for battle. By then, McClellan had become aware of Lewis's business savvy, so he transferred him west and assigned him to duty under General Robert Allen, then chief quartermaster at St. Louis.[117]

Lewis's first active service was on a commission with Captain Hoyt and General (then Captain) Phil Sheridan to investigate claims of fraud under Major General John C. Frémont's administration.[118] The claims were so significant, often involving large amounts of money and requiring careful and immense investigation, that a civil commission was created, composed of Judge David Davis and Joseph Holt, the judge advocate general of the United States. This commission released Lewis from service, so he sought to go to the front once more. But having clearly demonstrated his superior executive ability, he was denied, and General Allen ordered him to take command of the St. Louis quartermaster's office. One month later, Charles joined his brother in St. Louis, commissioned as a captain and an assistant quartermaster, respectively.[119]

The beginning of the war in St. Louis was extremely dangerous and chaotic, and military and governmental services were rife with fraud. If St. Louis had not aligned itself with business interests in the East and not been occupied by Union forces since 1826, it is believed that the entire state would have seceded with the Confederacy.[120]

Charles had been well warned by his brother that arriving in St. Louis and assuming the quartermaster duties would not be easy. Charles replaced the former assistant quartermaster of St. Louis, Justus McKinstry. In November 1861, McKinstry was arrested by the military command in St. Louis. McKinstry and others inside the office had conspired with dishonorable individuals to divert large sums of public money and supplies to their own financial gain.

After visits with the commanding general at that time, General Frémont, General William T. Sherman, writing from St. Louis early in the war, observed in his memoir, "Where the vultures are, there is a carcass close by; and I suspected that the profitable contracts of the quartermaster, McKinstry, had drawn to St. Louis some of the most enterprising men of California. I suspect they can account for the fact that, in a very short time, Frémont fell from his high estate in Missouri, by reason of frauds, or supposed frauds, in the administration of the affairs of his command."[121]

The success of the federal branches of the Union army were dependent on quickly recruiting men from all walks of life. Mismanagement was rampant in the first months of the war, as largely untrained and unscrupulous men were charged with coordinating the war effort with various railroads and safeguarding and distributing millions of dollars' worth of supplies. The government was careful to ensure that McKinstry's replacement would be of good character and capable of the task at hand.[122]

As General Sherman illustrated, St. Louis was a very dangerous place for anyone opposed to secession. Of the Rebel influence there, he wrote:

But the whole air was full of wars and rumors of wars. The struggle was going on politically for the border States. Even in Missouri, which was a slave State, it was manifest that the Governor of the State, Claiborne Jackson, and all the leading politicians, were for the South in case of a war. From "The Fourth City" the house on the northwest corner of Fifth and Pine was the rebel headquarters, where the rebel flag was hung publicly, and the crowds about the Planters' House were all more or less rebel. There was also a camp in Lindell's Grove, at the end of Olive Street, under command of General D.M. Frost, a Northern man,

a graduate of West Point, in open sympathy with the Southern leaders. This camp was nominally a State camp of instruction, but, beyond doubt, was in the interest of the Southern cause, designed to be used against the national authority in the event of the General Government's attempting to coerce the Southern Confederacy. General William S. Harney was in command of the Department of Missouri, and resided in his own house, on Fourth Street, below Market; and there were five or six companies of United States troops in the arsenal, commanded by Captain Nathaniel Lyon; throughout the city, there had been organized, almost exclusively out of the German part of the population, four or five regiments of "Home Guards," with which movement Frank Blair, B. Gratz Brown, John M. Schofield, Clinton B. Fisk, and others, were most active on the part of the national authorities. Frank Blair's brother Montgomery was in the cabinet of Mr. Lincoln at Washington, D.C. and to him seemed committed the general management of affairs in Missouri.[123]

Where the Civil War has often been described as "brother against brother," for Charles and Lewis it was truly a "brother with brother" effort. Unified in conflict, Lewis and Charles continued a family tradition of military service. They were proud that their grandfather had fought in the Revolutionary War from 1775 until 1783. He held the rank of first lieutenant and was with George Washington at Valley Forge, was wounded at the Battle of Monmouth and was present at the surrender of Cornwallis, which brought the American Revolution to a close.[124] Perhaps now in the War Between the States, Charles and Lewis could contribute as their grandfather had a mere eighty-eight years before in gaining independence from the British. In the Civil War, the luminaries did not hold names like Washington or Cornwallis. The titans of the day were Ulysses S. Grant, William T. Sherman and Robert E. Lee, among others.

History has shown that in times of national crisis, opportunistic men rise to positions of power and importance but ultimately show themselves to be incompetent and dishonest with respect to national interest. With McKinstry revealed as one such person, the government took great pains to ensure that a qualified candidate replaced him. It was not enough that Lewis Parsons vouched for his brother; others were asked to recommend Charles for the quartermaster's office. The men who recommended Charles Parsons were E.M. Breckenridge; J.M. Love; teacher, lawyer and business executive W.D. Griswold; General Robert Allen, the U.S. Army's assistant quartermaster general; Major W.W. Belknap, a lawyer and soldier

who went on to a become a government administrator in Iowa; and the thirtieth secretary of war under President Ulysses S. Grant, James E. Yeatman, a St. Louis banker, first president of the Bellefontaine Cemetery and cofounder of Washington University in St. Louis, the Merchant Bank and Mercantile Library.[125] Vouching for Charles Parsons was also the Honorable David Davis, one of Abraham Lincoln's favorite companions when they rode the circuit together in Illinois in the 1850s. Davis went on to become a U.S. senator from Illinois and associate justice of the U.S. Supreme Court. He also served as Abraham Lincoln's campaign manager at the 1860 Republican National Convention, engineering Lincoln's nomination, alongside Ward Hill Lamon and Leonard Swett.[126]

Captain Parsons's list of recommendations was impressive and swiftly ensured his approval for commission as a captain and assistant quartermaster in St. Louis under the command of his brother, Colonel Lewis B. Parsons. Outside of known Union circles and beyond city limits, St. Louis and the surrounding western regions were a dangerous place for a Union man who did not support slavery. Charles had never known slavery on the rural family farm in New York. Charles's father was not an abolitionist, but he did not agree with slavery and felt it should be eliminated—that no man should be enslaved to another.[127]

Charles Parsons's experience of the Civil War was entirely in St. Louis. The battles in Missouri were not the grand tales of Gettysburg, Manassas and many other well-known battles in the East. Although Parsons moved the large armies of Grant, Sherman, Rosecrans and others and provided supplies, he often had to inform mothers and wives of their sons' and husbands' passing, often at the hands of guerrilla bands of fighters, not in grand battles with thousands of men.[128]

It was imperative that the Confederacy never reach the interior city limits of St. Louis, so ten forts were constructed in a semicircle around the city. Martha's sister Euphrasia Pettus wrote to Martha to discuss the fortifications early in the war: "[W]e drive out every evening to see the fortifications growing. There are two on the Gravois road, one on Charles ave., and another near Morgan. It does not look humane to plant them so near the town, there are pretty houses around them, which will, of course, be destroyed if the guns are used at all...we do not feel uneasy... but many...either wiser or more timid are going away."[129] Today, many are surprised to learn that the state of Missouri experienced the third-largest number of engagements and battles between 1861 and 1865.[130] Although there were large fights like the Battle of Athens and the Battle of Wilson's

Creek, the majority of fighting in Missouri is now considered primarily to have been guerrilla warfare in nature.[131]

The Quartermaster Service was responsible for the transportation and supply of the entire Union army in the field of battle. Although the planning and execution of transporting troops to the battlefield was paramount, just as vital was the feeding of the men and their animals, as well as the supply of guns and ammunition and the movement of wounded and prisoners from the battlefield.[132] Capable men like Charles Parsons were well suited for the Quartermaster Service. Lewis and Charles could have obtained commissions as officers in combat service, but they did not seek this type of glory and instead applied their business acumen and personal integrity to the cause. As mentioned, Lewis made several attempts to serve in combat, but he was continually denied due to his other key abilities.[133]

The American Civil War was an extraordinary conflict because of the size of territory involved, the size of the armies and the infrastructure these required. Paramount to all were steamboats and steam-powered trains that could move men and supplies with stunning speed; these innovations determined the course of the conflict and outcomes of military campaigns. It was imperative that Union troops in the west took and kept control of the Mississippi River and all its tributaries, which included the Ohio, Yazoo, Arkansas, Cumberland and Tennessee Rivers.[134]

In the early months of the war, the federal government's credit was nearly destroyed. Federal forces in the western area that had been under the control of General Frémont and others were transferred to General Halleck after corruption had come to light. More than corruption, Halleck found chaos and inefficiency in the transportation processes of the Quartermaster Service. Management was decentralized, and leadership was incompetent. Orders of transport on the railroads were often in conflict and supplies were looted. Companies working with the federal government, from railroads to steamboat owners and all classes of laborers, could not collect money for their services rendered to the government.[135]

In April 1862, General Halleck began to fix the issues with the Quartermaster Service in the Midwest. He promoted Lewis Parsons to the rank of colonel and placed him in full command of railroad and river transportation in the Mississippi area based in St. Louis.[136] Lewis brought Charles to St. Louis to serve under him, along with three other assistant quartermasters, charging them with the successful movement and distribution of arms, men and supplies by army railroad and by river.[137]

One interesting report from Captain A.S. Baxter, an assistant quartermaster stationed in Cairo, Illinois, illustrates the early desperation experienced by the service. He wrote that his department had "no funds, no nothing" and that it "don't seem as though we would get anything. Everybody, high and low, in this district is discouraged, and I assure you I had rather be in the bottom of the Mississippi than work night and day as I do without being sustained by the government."[138]

Baxter complained to Washington, D.C., and St. Louis directly from his station in Cairo, feeling the stress of the government's debts on everyone in his area. Reports show that the laborers of the Quartermaster Service had not received pay in at least six months. Predicting collapse, Baxter wrote that if immediate assistance were not received, "the whole concern would sink so low that only the day of resurrection would raise it."[139] In a direct request to Lewis Parsons, Baxter wrote that the "liabilities were more plenty than Confederate scrip are as worthless."[140] The situation in Cairo was typical of federal supply and transportation services at the onset of the war, and repairing and modernizing the Quartermaster Service would be the Parsonses' greatest contribution to the war and, ultimately, Union victory.

The Parsons brothers both possessed superior business skills that quickly produced results for the service. Lewis, a railroad manager and executive, along with Charles's banking and operations experience, brought efficiency and economy to the Union rail and transportation service. They did so by conducting their government and military business as they would private enterprise. Lewis and Charles ensured, in no uncertain terms, that the government would only pay for actual goods and services rendered. They demanded that the government would not be overcharged and quickly did away with incompetent and dishonest officers and laborers. The success of their operations soon saw another promotion for Colonel Parsons, which placed him in charge of "territory west of the Alleghenies extending from the Gulf of Mexico to the Indian Wars 2000 miles up the Yellowstone River and on the upper Mississippi River."[141] In 1864, Secretary of War Edwin Stanton and General Grant directly urged Lewis Parsons to accept the position of superintendent of army rail and river transportation for the entire country.[142] Lewis accepted this role, and Charles remained in charge of the St. Louis office of the service. Following the war, Charles was promoted to brevet lieutenant colonel. Informally, he kept the title and enjoyed being called "Colonel" for the rest of his life.[143]

Four assistant quartermasters were responsible for the St. Louis office. Their duties encompassed the transportation of men and supplies from

the Indian territories to New Orleans, including the Cumberland River as well as the Tennessee. When the Union army advanced south, their responsibility included the Arkansas River and Vicksburg Campaigns. Their roles were incredibly complex; it was imperative that a consistent flow of food, ammunition, men and animals be moved by train, steamboat and over land as necessary. Often this was required on extremely short notice, and entire armies of ten thousand or more needed to move from one battle location to another.[144]

A powerful example of the demands placed on Lewis and Charles Parsons during their time in the Quartermaster Service can be seen in the western campaigns of 1862–63. On December 11, 1862, the brothers received orders to move General William T. Sherman's entire army of forty thousand men and associated supplies, artillery, cavalry horses and munitions from Memphis, Tennessee. Seven days later, on December 18, the transport service saw to it that sixty-seven large boats and many smaller craft were docked and ready for Sherman's army in Memphis. In the following twenty-four hours, that entire army, which had been on forced march from deep in Tennessee, was aboard the boats moving swiftly to Vicksburg, Mississippi. The stretch of four hundred river miles was quickly traversed by the fighting force. The massive army arrived in Vicksburg on December 26, 1862. Though arriving successfully, the force fought for two days in the unsuccessful battle at Chickasaw Bluffs before retreating and again embarking. This time, though, the force was moved upriver three hundred miles in about sixteen hours, to the Mississippi and Arkansas Rivers, arriving at the Arkansas post, where, after landing, the force captured seven thousand prisoners and the Confederate fortifications. After embarking again for the South, this force began the historic siege of Vicksburg, Mississippi. During the capture of Vicksburg, in April 1863, orders from General Grant for more and more riverboats continued. During the battle of Vicksburg, all available boats in the St. Louis and Cairo area were already in service, causing Parsons to move outside his normal operating area to fulfill his orders. Charles Parsons found himself ordering from as far north as Chicago for all manner of river-ready boats to do battle.[145]

In yet another example of impressive movement of men and supplies with very short notice, in June 1863, Lewis urgently called up his brother to move General Burnside's ten-thousand-strong army from central Kentucky to Vicksburg, to meet up with Grant's army. Movement of these troops began immediately, without any advance preparation. Within the hour of the order,

Ambrose Burnside's force was being moved by rail from Kentucky through parts of Ohio, across southern Indiana and a large part of Illinois, to Cairo. Within forty-eight hours, the force embarked on waiting steamers, and within three more days, Burnside and his men had joined Grant's forces before Vicksburg, having covered one thousand miles.[146]

Military records of the Civil War show time and time again that Captain Parsons and the Quartermaster Service in St. Louis was constantly inundated with orders to provide transportation and supplies for the Union forces in the west. In 1862, it was reported that this office supplied General Grant with steamboat transportation for the successful attacks on Fort Donelson and Fort Henry, which opened the Tennessee and Cumberland Rivers to the Union army's fleet of gunboats.[147]

Captain Parsons was not only moving Grant's and Sherman's armies between July and August 1862, but he was also tasked with removing all shipping traffic between Cairo and St. Louis to transport and supply the expedition of Major General Samuel A. Curtis to Little Rock, Arkansas.[148] It should be understood that the massive armies under the direct command of Generals Grant, Sherman, Rosecrans, Banks and Steele, when campaigning in the western fighting areas during 1862–63, were nearly exclusively dependent on steamboat transportation for movement, reinforcement and all manner of supplies needed for the war efforts.[149]

Responsibility, planning, execution and the movement of men and supplies in the western fighting area was the sole charge of the St. Louis Quartermaster's Office. As the senior officer, Colonel Lewis Parsons was responsible for the planning and broad details of every mission. Given the dangers they faced, it was imperative that Lewis could trust his brother to execute the minutia, along with three other assistant quartermasters, all of whom reported to Charles. The trust, ability and complete dedication shown by Lewis and Charles enabled great success during these campaigns for the federal government.

As the Civil War continued in the autumn of 1863, General Sherman prepared his March to the Sea. To accomplish this, Sherman was readying 100,000 men at Nashville, Tennessee, to begin his march through Georgia. Lewis and Charles were called on to supply this massive army.[150] To accomplish this, massive quantities of supplies from St. Louis, Cincinnati and Louisville were shipped as quickly as possible to the general. Sherman found himself so impressed following the campaign that he personally thanked Lewis and the other quartermasters for their precision and efficiency.[151] It is this campaign that endeared Sherman to

both Parsons brothers and established his strong friendship with Charles, which lasted until his death.

Acknowledgement of the success of the western rail and river transportation system during the war was not limited to Sherman. Near the end of the conflict, President Lincoln agreed with Grant and Sherman when they remarked on the superior management system that Lewis and Charles refined and directed as not only a vital instrument in winning the war but also one that saved the federal government millions of dollars.[152]

There was nothing glamorous about the arduous task of creating the movement of troops and supplies for 100,000 men. The amount of accounting, tracking, chartering and writing of contracts that had to constantly be checked and updated is hard to imagine. Quartermasters also had to keep a keen eye on corruption with workers and contractors alike.

Given the heavy reliance on steamboats during the war, the government was forced to charter privately owned vessels. Owners of these boats knew the leverage they had and regularly overcharged for the war effort. From the remaining records, we see that boats during the conflict were charging the government two and three times the rate they would have charged during peace time.[153]

Three cases stand out in the historical record that Captain Parsons specifically targeted for overcharging: the steamers *Luminary*, *Bostonia* and *Diligent*. He discovered that the owners of the *Luminary* were charging a rate of $400 per day while in service to the federal government. Parsons compared its costs and capabilities against the steamer *Continental*. The latter was deemed to be of equal value to the former, but the *Continental* could carry six hundred tons more and had been obtained for only $200 per day. Parsons felt that the owners of the *Luminary* were netting at least $250 per day, which in today's money is estimated at $8,000 per day. The blatant profiteering of steamboat owners stopped under Charles's watch.[154]

Given the initial rates that steamboat owners were paid by the government prior to Parsons's arrival, they could easily net twice the original cost of their boats within a year of service to the government. In the case of the *Diligent*, the owner applied for repairs at government expense. Parsons refused the application, angering the boat owner.[155] The impact of profiteering is most powerfully understood in light of the fact that the government assumed all risk and would fully indemnify owners if the vessels were destroyed or damaged.[156]

It was clear to Captain Parsons early in his role in St. Louis that he had to end this charter system that made exorbitant profits for the owners and bled

the government dry. This became a dangerous time for Parsons, as there was powerful and persistent opposition to his efforts. Records show that by November 1863, Parsons had succeeded at creating a system that was fair to both boat owners and the government. The new equitable but economical system paid the shipment of men and animals on a per-head basis, and freight shipments were paid by weight. The rates were fixed in both non-urgent and emergency times. When appropriate to the mission, or as time allowed, the bids were publicly advertised for transparency.[157]

More problematic than the owners of the boats were the licensed river pilots who had made an informal agreement to ensure high wages for their expertise. It was law that every boat had to have a licensed pilot, and the monopoly worked to keep all the pilots unified and accept no apprentices to build their ranks. Before Parsons's reforms, pilots demanded and received salaries of $500 per month, plus board (equivalent to more than $10,000 per month today). The fight with the riverboat pilots was too much for Parsons to win on the local level, so he appealed directly to the secretary of war for adjustment. The secretary's intervention ensured that if pilots refused to work for reasonable compensation, firm measures would be employed, including suspension of pilot's licenses and mandating immediate withdrawal from service.[158]

Parsons instituted accountability at all levels of the Quartermaster Service. Under his watch, the assistant quartermasters were required to check and verify all supplies against the bills of lading. When supplies were found to be lost or stolen during travel, troops were sent to track down the supplies and immediately punish the guilty parties. When boats sank due to snagging (i.e., running aground in the river) or combat, the boats were raised and the cargo salvaged. If a mishap occurred during operation that resulted in damage to government-owned cargo and it was found to be caused by the owner's or pilot's negligence, Parsons efficiently deducted the loss from the compensation owed to the boat owners.[159]

More than these duties, Parsons and his other quartermasters had to deal with groups known as "fire-eaters." These were groups loosely under the control of Southern commanders, like General Johnson and General Price, who set all manner of boats in the service of the Union on fire to see them sink. For example, Captain Parsons recorded that the steamer *E.M. Ryland* was sabotaged by the enemy on October 10, 1861.[160]

Although Parsons was not yet commissioned when the *E.M. Ryland* was destroyed, he was the investigating officer who settled the permanent record of the fate of this vessel.[161] It is estimated that up to one hundred boats were

sabotaged by a nefarious "fire-eater" named Joseph W. Tucker. Tucker had become a lawyer before moving with his family to St. Louis. Before the war, he rose to prominence as a devout Methodist deacon and was a committed educator aligned with the University of Missouri on its board of curators. He made a living as a newspaper editor and was a confidant of both Governor Claiborne F. Jackson and General Sterling Price. Through Parsons's paid spy network, in communication with Grenville Dodge, a pioneer in military intelligence, as well as interpreters for the large population of Germans in St. Louis and a few other nationalities, he was well aware of Tucker, his men and their Confederacy-sanctioned terrorist activities in Missouri and other states to the south throughout the war.[162]

Parsons also noticed an issue in the ranks of the Union army regarding travel and transport; he worked to stop officers, who felt they were above the law, from refusing to pay for railroad tickets when traveling on personal matters. The reforms that Captain Parsons and Colonel Parsons made, with support from military leaders in Washington, D.C., continued through 1864, as did resistance and protests by those who were financially affected. The result of reform efforts saw the western rail and transport system operating efficiently and economically as the war effort shifted from west to east and to the Deep South.[163]

In 1864, it was time for Charles Parsons, who by then held the rank of lieutenant colonel, to resign from the army and reenter the banking business in St. Louis, but he was known going forward as Colonel Parsons. During his time in and contributions to the Quartermaster Service in St. Louis, General Allen wrote that Charles "bore the brunt of hard work and was always ready to duty day and night."[164] One year later, when Lewis, now officially a general, was leaving the service, General Grant took time to write a letter of appreciation. Lewis felt very strongly that without the superior efforts of his brother, and his commendation from General Grant, success in St. Louis would not have been achieved. General Grant wrote:

Dear General,

I have long contemplated writing you and expressing my satisfaction with the manner in which you have discharged the very responsible and difficult duties of Superintendent of river and railroad transportation for the armies both in the West and East. The position is second in importance to no other connected with the military service and to have been appointed to it at the beginning of a war of the magnitude and duration of this one and

holding it to its close providing transportation for whole armies with all that appertains to them for thousands of miles adjusting accounts involving millions of money and doing justice to all never delaying for a moment any military operations dependent upon you meriting and receiving the commendation of your superior officers and the recognition of Government for integrity of character and for the able and efficient manner in which you have filled it evidences an honesty of purpose[,] knowledge of men[,] business intelligence and executive ability of the highest order and of which any man ought to be justly proud. Wishing you a speedy return to health and duty, I remain,

Yours truly,
U.S. Grant[165]

BUSINESS, BANKING
AND POLITICS

T he mental health of both Lewis and Charles Parsons suffered during the Civil War. Both men required travel following their service to recover and return to business life. After his rest and recovery was sufficient, Charles Parsons, now referring to himself exclusively as Colonel Parsons, was made cashier of the State Savings Association.[166]

The State Savings Association had formed in 1855 and steadily grew to become one of the most prominent financial institutions in St. Louis and was recognized as one of the strongest and best-managed banks in the country. The names of the founders and initial leaders are still recognized in St. Louis today: R.M. Henning, John How, Eugene Miltenberger, Isaac Rosenfel Jr., Lewis V. Bogy, William L. Ewing, Neree Vallé, R.J. Lockwood and B.W. Hill.[167]

When Charles joined the bank in 1864, the staff were still telling the tale of an attempted heist in 1859. Would-be robbers attempted to tunnel from an adjacent building's basement into the vault when it was located at the corner of Vine and Main Streets. The vibrations of the digging alerted staff, and the affair was quickly averted.[168]

In 1864, Charles assumed his duties as cashier and set to make this bank his home for more than three decades. Charles and Martha moved into their new home at 2804 Pine Street, and from this home, he conducted his affairs and began amassing a collection of artwork that would eventually be praised as one of the finest in the country.[169] Martha's father and mother, William and Caroline Grymes Pettus, lived at 2825 Locust Street—less than a half

mile away—in an affluent neighborhood west of downtown. Neighbors also included Mrs. Frank P. Blair, Colonel John Knapp, Hugh Campbell (the older brother of Robert Campbell), the Honorable Erastus Wells and Senator Wayman Crow, founder of what would become Washington University in St. Louis, among others.[170]

Diligently applying himself to the operations of the bank, Colonel Parsons was elected president of the State Savings Association in 1870, when it became the State Bank of St. Louis. Officers under Charles's leadership included cashier John H. McCluney and directors William H. Scudder, Daniel Catlin, A.F. Shapleigh, C.C. Moffitt, Joseph Franklin and John T. Davis. The bank moved to its final location in 1876, to the corner of Vine and Third Streets, where it remained until after Parsons's death.[171]

Colonel Parsons held the position of president for thirty-five years. Bankers and other businessmen of the day revered Parsons as a leader in commerce. It is reported that under Parsons's leadership, the State Bank of St. Louis "ha[d] never failed to make a dividend of at least 5 percent semi-annually, and for the last twenty-three years one of 8 per cent semi-annually,

Parsons Residence, 2804 Pine Street, St. Louis. *Missouri Historical Society, St. Louis.*

and in addition ha[d] accumulated during these past thirty-three years a surplus of more than $1,100,000."[172] Today, that surplus would be worth in excess of $34 million.

Colonel Parsons also became the president of the St. Louis Clearing House. In the nineteenth century and even today, clearing houses ensured market efficiency and increased stability in the financial system. During post–Civil War Reconstruction, the St. Louis Clearing House Association was formed in 1868 with thirty-five members—men and organizations that prospered and shaped the development of St. Louis in the nineteenth century.[173] With Parsons holding positions of leadership and power in an established bank and the St. Louis Clearing House, coupled with his Civil War reputation and close relationship with General William T. Sherman, General Grant and many other leaders of the Civil War who had found success in business and government, his influence was immense.

Colonel Parsons took the banking and business knowledge he had acquired as a child working in his father's store, along with the experience of banking in Keokuk, and developed a comprehensive understanding of principles that governed his commercial and financial affairs. More than his longtime position as president of the State Bank of St. Louis, he was also the president and director of many railroad companies, public institutions and charitable organizations, to which he offered his wisdom and contributed to their successes. These included the Keokuk and Des Moines Railroad Companies; the Ohio and Mississippi Railroad Companies; the Hannibal Gas Company, where he served as president; the Bellefontaine Street Railroad Company, as its vice-president; and director of the Missouri Street Railway Company. He also served as director in both of the waterworks companies of Atchison, Kansas, and Hannibal, Missouri.[174] Charles Parsons was so highly regarded in financial circles that he was elected president of the St. Louis Clearing House for twenty-two consecutive years.[175]

Colonel Parsons maintained ties with his New York business associates and the surrounding areas during his lifetime, traveling often to New York. In 1875, he became one of the founders of the American Bankers Association in Saratoga Springs, New York, and he served as president in 1890–91; at the time of his death in 1905, he was still a member of the executive council.[176]

A major highlight for Colonel Charles Parsons came in 1893, when he was selected to oversee the World's Congress of Bankers and Financiers at the Chicago Exposition.[177] Colonel Parsons traveled to Chicago as all eyes were on this impressive Midwest metropolis. In a mere sixty years

from its origin as a swamp on Lake Michigan, Chicago had become host to the world. With the twentieth century under a decade away and all of the most state-of-the-art inventions and leaders on display, Colonel Parsons, the banker and financier from St. Louis, was elevated to a position of international recognition, overseeing the World Congress of Bankers and Financiers. In his opening speech, he said, "When I was solicited to occupy the position of permanent chairman of this Congress it was not the understanding that I was to make a speech. It was the understanding that I was to come here and preside over the intelligent gentlemen who from all parts of the country, we hoped, would be present. It is a profound satisfaction to me that there are so many bankers here who are not in any way pledged to be making up their fences, as the politicians call it, at home now. I am therefore happy because I wish to do honor to this place which has so wonderfully and remarkable prepared for us a treat beyond all expression."[178]

A HOTEL RESURRECTED

As Colonel Parsons diversified his financial portfolio and served in wide-ranging executive positions in numerous industries, he found himself in the hotel business as an investor. A year before Parsons mustered out of the Union army to join the State Savings Association, the Lindell Hotel opened on Washington Avenue, in downtown St. Louis, in 1863. With 270 bedrooms, a barbershop and a Turkish bath for guests to enjoy, it was one of the largest and most well-equipped hotels of the day.[179]

The hotel took its name from brothers Jesse G. and Peter Lindell. The Lindells were already well known to St. Louis high society and the Pettus family. In a letter to Charles during the Civil War, Martha recounted details of seeing Peter Lindell while attending a party. She saw that one Mr. Yeatman was trying to raise money for a "Lunatic Asylum" and that he attempted to receive a donation from "Peter Lindell, the old bachelor who glories in the possession of *seven* millions of dollars."[180] Peter and Jesse contributed the land that the hotel was built on in exchange for $80,000 in stock and devoted $10,000 in cash to secure their interest in the hotel.[181]

Four years later, in the spring of 1867, a fire began on the upper floors of the building and quickly spread. The responding firemen, unable to reach the massive building's roof with their equipment, failed to stop the flames.

Efforts to save the building were abandoned, and focus was shifted to save the surrounding buildings.[182] The Lindell Hotel was considered a total loss, although some furniture was saved and limestone blocks were salvaged and purchased by Henry Shaw, founder of the Missouri Botanical Gardens. Henry Shaw was also a friend of Charles Parsons. The limestone blocks from the hotel eventually made their way to what is now St. Louis's Tower Grove Park and the Missouri Botanical Gardens. Shaw was planning to deed the land that became Tower Grove Park to the City of St. Louis, and when the transaction was complete, he had the blocks transported there. They were used in gate entrances and a centerpiece of the park, an area around a small pond that was meant to resemble ancient ruins. The plans for this architectural curiosity were created by Henry Shaw and his horticulturist, James Gurney; this feature is still on display today.[183] In an 1886 letter from Shaw to Parsons, it is interesting to see an etching on the stones of the old hotel used in the architectural features of Tower Grove Park.

The public considered the destruction of the Lindell Hotel to be a calamity and wanted it to be rebuilt. In 1872, new construction began on the same site as the original, after Mrs. Vincent Marmaduke, a friend of the Parsons family, determined that the new hotel should be built in the same location that made it famous in the first place. Along with William Scudder and Levin H. Baker, businessmen Colonel Parsons was already engaged with in other matters, a new company was formed. The new company hired George I. Barnett, known as the "Dean of St. Louis Architecture," to design the new hotel.[184] Barnett had already designed the Old Courthouse in 1864 and the Grand Avenue Water Tower and the Missouri Governor's Mansion, both in 1871. He went on to design hundreds of buildings not only in St. Louis but also around the country. He designed Henry Shaw's home in Tower Grove Park and Shaw's mausoleum in 1889, after his death.[185]

In September 1874, the new hotel was opened to the public, and Colonel Charles Parsons was now a part owner of the newest and finest hotel in St. Louis. The Lindell Hotel enjoyed 270 guest rooms that offered guests lace curtains and steam heat from radiators. The selection of baths had expanded from the first hotel, with a cold-water bath, a Russian steam bath and a Turkish bath. The barbershop was even larger than before, employing upward of twelve barbers full time and serving thousands of hotel guests and the city's businessmen.[186]

The new hotel thrived for about a decade until April 1885, when fire struck again. This time it was from a basement storage area, ignited with piles of garbage that had been allowed to accumulate. The fire spread up

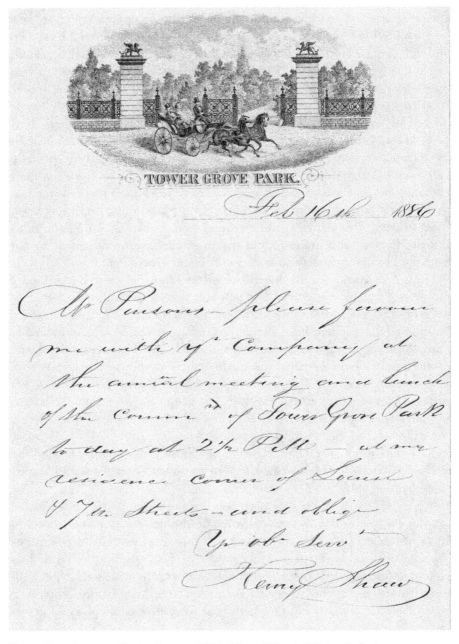

Henry Shaw, letter to Charles Parsons, 1886. *Missouri Historical Society, St. Louis.*

the grand staircase, panicking the guests, and the spectacle attracted an estimated forty-five thousand people. The fire was out within an hour, but not before "the floor had all fallen into the basement....The parlor floor was drenched with water and the rich carpets looked like dirty rags."[187] Colonel Parsons collected his insurance money and never invested in the hotel business again. One year after Parsons's death, the Stix, Baer & Fuller department store occupied the old site of the Lindell Hotel.

GENERAL WILLIAM T. SHERMAN

The connections that Colonel Parsons made and the reputation he secured because of the Civil War were responsible for a large part of his success after the hostilities. He continued to be active and loyal to his fellow veterans, becoming a member of the Grand Army of the Republic, the Missouri Commandery of the Loyal Legion of the United States (to which he dedicated his travel book, *Notes of Travel in 1894 and 1895* [1896]) and the Army of the Tennessee.[188] These societies were filled with powerful and influential men who contributed to the Union cause and saw it to victory. Colonel Parsons was generous with his time and resources to organizations supporting veterans of the Civil War and other charitable causes of the day.

Parsons's participation in these military societies led to the direct support of his friend General William T. Sherman. Following the war, Charles Parsons was among the group of businessmen and friends who raised $30,000 to purchase and furnish General William T. Sherman's St. Louis home at 912 Garrison Avenue in 1865.[189] From this home in 1884, Sherman responded to the famous telegram in which Republicans pressed him to accept the presidential nomination. He responded, "I will not accept if nominated and I will not serve if elected."[190] Parsons remained lifelong friends with Sherman and held the honor of being a pallbearer at his funeral in 1891.[191]

The friendship between General Sherman and Colonel Parsons went beyond the supplying and moving of Sherman's and Grant's armies during the war, even though this was the basis thereof. Sherman knew firsthand the challenges of performing successfully as a quartermaster, a role he undertook and where he received some of his first praise in the army.[192] Then there was the matter of banking. Colonel Parsons rose to be one of the nation's most recognized and respected bankers. General Sherman also had banking experience when he worked for the St. Louis firm of Lucas, Turner

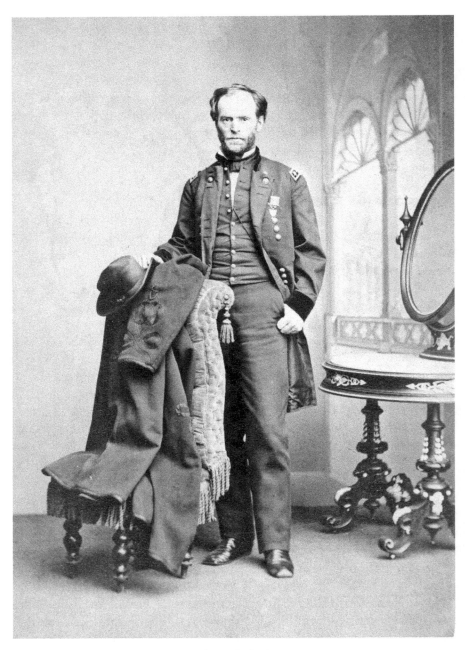

William T. Sherman. *Missouri Historical Society, St. Louis.*

& Company and was sent to San Francisco to manage the branch there.[193] The developing banking industry in America following the Civil War was probably a constant feature of their conversations. The third and perhaps most surprising aspect of their friendship was in the art world. In 1842, while stationed in South Carolina, Sherman began painting landscapes with great passion. In a letter to his wife, Ellen, dated November 28, 1842, he told her that his enjoyment of painting "made it painful to lay down the brush."[194] Sherman did not continue painting, though, as O'Connell noted:

> [It] *did bring him closer to his former West Point instructor and now immediate superior, Robert Anderson. He and his wife were avid collectors and were happy to spend hours with Sherman, showing him their many paintings and engravings. In the process a friendship blossomed, one that would have significant consequences for both of them. Sherman recalled standing on the battlements with Anderson and watching cotton ships from the North dump their rock ballasts on the designated spot within the harbor, where the army engineers were building a new, far more defensible fort. It would be called Sumter, and it would make Robert Anderson famous.*[195]

Perhaps a similar friendship with Charles and Martha following the war echoed the one with the Andersons before it. It was an easy walk for Sherman, who lived only a few blocks away, to visit the Parsons at their home to enjoy their growing art collection.

Two surviving letters give insight into the relationship between the Parsonses and Sherman. The first, from 1868, is a letter on military letterhead from General Sherman to Edward J. Morris, the minister resident in Constantinople, Turkey, requesting that the minister accept Charles Parsons, his wife and her sister, Euphrasia, when they visited Constantinople during the summer:

> *Headquarters Military Division of the Missouri*
> *Edward J. Morris, Esq.*
> *Minister Resident*
> *Constantinople Turkey*
>
> *Dear Sir*
> *A small party, friends of mine from this City propose to visit Europe this summer and to spend some time at Constantinople. They are Mr. Charles T. Parsons & wife and her sister Euphrasia Pettus. I beg to solicit for them*

your usual polite attention, assuring you that it will be highly appreciated, and by none more than me.

Your humble servant & friend
W.T. Sherman
Lt. Genl.[196]

The second letter is from 1884, on letterhead from his home at 912 Garrison Avenue. Here, Sherman admits being "embarrassed" regarding a matter apparently important to both himself and Charles:

912 Garrison Avenue
St. Louis, Mo., Jan 28 1884

Dear Mr. Parsons,
I am embarrassed at this minute by the uncertainty as to Mr. Matthew Arnold, expected here tomorrow Tuesday night—He has sent ahead letters to me which make it necessary for me to assist in his entertainment. I think he will give me Thursday but till he comes & decides I am estopped as to time.

Yrs truly,
W.T. Sherman[197]

The third piece of correspondence from William T. Sherman is not a letter but an envelope addressed to "Little Charlie." This points not only to their relationship but also to the fond connection that Sherman enjoyed with Charles Parsons Pettus, Martha's nephew, who would come to inherit the majority of Parsons's estate after his death in 1905. Assuming Sherman wrote the note the same year as the Matthew Arnold letter, Charles Parsons Pettus would have been eight years old. The envelope reads, "A note of Gen. W.T. Sherman for Little Charlie." Unfortunately, the "note" has not survived.[198]

General William T. Sherman died on February 14, 1891. The final resting place for Sherman and his family had already been determined as Calvary Cemetery, in North St. Louis, and so Sherman's body was returned to St. Louis from New York, where he was living at the time.[199]

With the sound of light artillery filling the area around St. Louis's Union Station, the impressive funeral procession for the general began the

William T. Sherman, letter to Edward J. Morris, 1868. *Missouri Historical Society, St. Louis.*

Envelope addressed to "Little Charlie." *Missouri Historical Society, St. Louis.*

morning of February 21, 1891. Marching behind the horse-drawn hearse draped in American flags were veterans, business and military notables of the time and twelve thousand soldiers, proceeding past onlookers and mourners who lined the route all the way to Calvary Cemetery, seven miles from Union Station.[200]

Two groups of pallbearers were selected for General William T. Sherman: military officers and private citizens. The military list included Major General John Pope, Brevet Major General Amos Beckwith, Brevet Major General A.J. Smith, Brevet Major General John W. Turner, Brevet Major General Willard Warner, Brevet Brigadier General John W. Barriger and Commander Charles S. Cotton, United States Navy.[201]

Colonel Parsons was selected as one of the private citizen pallbearers to carry the general to his final resting place, along with Judge Samuel Treat; Colonel George E. Leighton; Byron Sherman, Esq.; Daniel R. Harrison, Esq.; and R.P. Tansey. It was a somber day for the city of St. Louis and Colonel Charles Parsons.[202]

THE PUBLIC GOOD

As Colonel Parsons's fortunes began to rise over his long and active business life, he was increasingly generous in his support of religious, charitable and educational institutions. This was the time in his life when he could act on and satisfy his father's example, remembering his quote that "the true use of wealth, at least to a reasonable amount, was for the public good."[203] Parsons was motivated and inspired to give of his resources and time. He contributed greatly to his personal church, Christ Church Cathedral, at the corner of Locust and Olive Streets in St. Louis City.[204]

In 1889, Charles experienced the heartbreak of a lifetime when both Martha and her mother, Caroline R. Pettus, succumbed to pneumonia on the same day.[205] What eventually became the St. Louis Children's Hospital was first the Augusta Free Hospital for Children; then in 1890 (a year after Martha had passed), it was named the Martha Parsons Free Hospital for Children. He "donated $15,000 in memory of his late wife, Martha Pettus Parsons. The hospital held 40 patients and was staffed by 21 prominent St. Louis allopaths."[206]

Charles also served as president of the Humane Society of Missouri for the Prevention of Cruelty to Children and Animals.[207] Colonel Parsons

BETWEEN ART AND WAR

was frequently engaged in travel during this period, with frequent trips to New York City and the surrounding areas. He supported the New England Society, one of the oldest charitable societies in the country, as a member and president.[208]

He financially supported Parsons College (1875–1973) in Fairfield, Iowa, the dream of his father, with two endowed professorships: the Martha Parsons Professor of Biblical Literature and Evidences and the Levi Parsons Professor of the Latin Language and Literature, the latter named after his late brother, who died in St. Louis due to cholera.[209]

Colonel Parsons also supported the Methodist Orphans' Home in St. Louis; the Home for Old Persons, located on Grand Avenue in St. Louis; the Protestant Orphans' Asylum, in Webster Groves, Missouri; the Episcopal Orphans' Asylum, St. Louis; the German Protestant Orphans' Asylum on Ashland Hill, St. Louis; and St. Luke's Hospital, also in St. Louis.[210]

In upcoming chapters, we will cover Colonel Parsons's immense support for Washington University in St. Louis. His time, energy and financial contributions brought into being the St. Louis School and Museum of Fine Arts, the first art museum and arts education school west of the Mississippi River. His large, prized painting collection and collection of artifacts jumpstarted the world-class collection that was first enjoyed at the St. Louis School and Museum of Fine Arts. His collections and contributions would then be appreciated as part of the Palace of Fine Arts during the 1904 St. Louis World's Fair (officially known as the Columbian Exposition). Following the world's fair, the Palace of Fine Arts became the City Art Museum and, as it is known today, the St. Louis Art Museum. As Washington University in St. Louis grew, so did its ability to care for Parsons's collection itself. Today, some pieces of Parsons's collection may be found at the St. Louis Art Museum, but the majority now resides at the Mildred Lane Kemper Art Museum on the campus of Washington University in St. Louis.

A SENSATION IN ST. LOUIS

Colonel Charles Parsons held the respect and admiration of nearly everyone who knew him, including individuals in high levels of government. The Colonel was considered more than once to be nominated for the secretary of the treasury; the last call was to join President McKinley's cabinet in 1897.[211] Some historical sources indicate that the Colonel had no interest

in holding national office, although he did take public office in St. Louis. This was not a position he sought through election but rather a calling out of a sense of duty.

In December 1892, Charles Parsons was appointed the temporary treasurer of St. Louis after a scandal. At the time, Michael J. Foerstel was treasurer for the City of St. Louis, and his son, Edward, was the assistant treasurer. Newspapers reported that on the morning of December 19, Edward killed himself in the office after attempting to set fire to the records there.[212] A "hurried investigation" revealed a shortage of $60,000 from the city funds. Acting Mayor C.P. Walbridge relieved Michael J. Foerstel of his duties immediately. The mayor and other prominent citizens urged Charles Parsons, "the best known banker of the city," to assume the role temporarily. The paper reported that "Mr. Parsons immediately gave the required bond of $500,000 and assumed the position."

The motivation behind the fire in city hall and the suicide of Edward J. Foerstel was reported to stem from his reputation as "a wild young man and plunger. On horses he was a heavy better, placing a thousand dollars or more at a time." This alone could have accounted for the missing $60,000, but the attorney for the deceased Foerstel offered this explanation: "He called upon me in the past three or four weeks almost daily to confer with me about an attempt which a certain party was making to obtain money from him. He said that this person had demanded $10,000 as the price of his keeping his mouth shut concerning what he knew about the City Treasurer's Office."

In the weeks that followed, the paper reported that "stories of peculiar doings in the Treasurer's office have been afloat. There have been suits brought against the Treasurer by money lenders, notorious for their usurious charges, and assertions have been made regarding real estate debts of the Treasurer and his son and the use of the city money by some one who recouped the Treasury, previous to the regular examinations, by borrowing from the Shylocks, who at last sued the Treasurer himself on notes which he declares to be forgeries." On the morning of December 19, there came a call that a fire had started in the office of the city treasurer, "where with the doors of the vaults wide open, an attempt has clearly been made to destroy everything in that office. Scarcely two hours after came the news of Foerstel's suicide." Following the full investigation, the ledgers were reconciled, and with the election of a new treasurer, Charles Parsons promptly resigned his position as temporary treasurer.

Free Silver

Near the end of Colonel Parsons's business career, the "free silver" movement arose. This was an economic policy that proposed to offer the unlimited coining of silver, which risked devaluation and was in direct opposition to the carefully fixed money supply practiced with the gold standard.[213] The fight against free silver became an important cause for him.[214] In the Colonel's words, the proposal at hand was to change the current financial system and "make this country the common depository of the silver in the world, to allow dollars to be given for all silver at the rate of $1.29 to the ounce, whereas its recognized bullion value is only about one-half that amount."[215] Parsons not only wrote a paper that he circulated widely, entitled "The Silver Question," hoping to see an end to the debate, but also personally addressed audiences, passionately reading his paper and engaging in public debate; this included at least two banking conferences in 1896, in Saratoga Springs, New York, and Pertle Springs, Missouri.[216] Colonel Parsons reminded his audiences, "Cheap money is not good money."[217]

He began with a story of his early days in banking in St. Louis: "I was a clerk where much money was handled fifty-eight years ago and after, and we saw no American Dollars. It was Spanish and Mexican dollars and five franc pieces that constituted the silver coin of the country almost entirely before 1849."[218] In 1785, the United States created a silver standard for its currency based on the Spanish milled dollar and also established gold at a fixed ratio. The balance between gold and silver to back U.S. currency was a long-running debate over the creation of a bimetallic standard that took nearly 140 years to resolve.[219]

The Panic of 1857, which hit Parsons in Keokuk, was in part to blame for American banks choosing to decline payments in silver. This action caused devastating shockwaves through the entire U.S. financial system. Between 1860 and 1871, numerous attempts to establish bimetallic standards were proposed, but with new deposits of silver being discovered, there was no longer the expectation that silver would become scarce.[220]

To Colonel Parsons and his associates, "free silver" made no fiscal sense, and its advocates received no compassion from him or his associates.[221] Regarding it as a get-rich-quick scheme, Parsons had no patience to endure it. He wrote, "In my life I have seen many alleged opportunities on making money rapidly, but in almost every case there were large risks; in watching the outcome of these it has almost always occurred that the result was

unfortunate and that the best way to acquire a fortune is to avoid these modes of gaining it rapidly."[222]

He believed that the "free silver" movement bordered on evil and worked to convince audiences that those behind it were worthy of contempt. In his role as a banker and a leader of national banking organizations, Parsons was directly involved with and able to debate the issue completely. He saw the debate as much more than a financial argument and used it as an educational opportunity. He asked his audience:

> [C]onsider also that we are invited to be so foolish as to purchase silver at twice its value in the world's markets and then to transport it abroad to pay our debts with it at its real value. It is a curious fact that many people think a nation is not governed by the same correct principles of business individuals, that in some peculiar way a nation can defy all legitimate rules of trade and commerce and yet thrive; that the fiat of the nation can make values. They do not stop to consider there is a limit to all human power; that while a man of acknowledged wealth can pass his notes freely for a certain reasonable sum, yet if he makes too free use of his credit, people will examine, hesitate and finally refuse to take his paper. It is the same with nations....Promises of wealth without work are delusive, and promises of great gain made by free silver men may turn out to be like the promise of the whole world made by one who did not own a foot of it.

The silver question was not merely an issue for the United States; it affected Parsons's international business dealings as well. Parsons traveled to Japan twice during his lifetime: first in 1876 to seek opportunities for his bank during the Meiji Restoration (1868–1912) and then again in 1894 (the subject of a later chapter). In 1876, the biggest banks from the eastern United States were chartering in additional U.S. states and in Japan. Some of Parsons's motivation to visit Japan was following the example of other banks to develop new business. Paper notes were devaluing and silver ceased to circulate, causing a depression, and the government began demanding coin—known as a "hard money" policy or specie—rather than paper.

Colonel Parsons saw firsthand the impact devalued currency could have on an economy during his world travels. Referring to his journey in 1894 and 1895, he wrote, "Within a year past I was in India, where the currency is entirely silver. It is almost needless for me to inform you how the great mercantile people view it there, as I trust that you already know they all feel the burden of cheap money." From this direct experience he demanded,

"All our foreign commerce must be on a gold standard, and our coffee, tea, sugar, woolens, cutlery, etc., etc., bought abroad must be paid for in gold or its equivalent."

Parsons continued, "Gold is the articulation of commerce. It is the most potent agent of civilization. It is gold that has lifted the nations from barbarism. So exact a measure is it of human effort that when it is exclusively used as money, it teaches the vary habit of honesty. It neither deals in nor tolerates false pretenses. It cannot lie. It keeps its promises to rich and poor alike."

Parsons was unwavering in his support for gold, and not merely as a monetary backbone: "It is certain that for all purposes, gold possesses elements that make it of far more greater value than any other metal used or available as money." He was declarative in his statement as a leader in his time to "maintain the money of these United States on a standard with that of the best and most highly civilized nations of the earth."

Resolute words from this world-renowned banker and financier flowed to his readers and audiences: "I am satisfied that we shall have no good times, no settled business conditions, no new enterprises undertaken or active general prosecution of those now in hand, until this Free Silver heresy is buried deep under an avalanche of negative votes, and until we know that our money is the same as that of the civilized world, and on a par with it." Parsons's efforts finally came to fruition in 1896 when the U.S. economy moved to the gold standard.[223]

THE POLITICAL MR. PARSONS

As already stated, Colonel Parsons was interested in politics at a young age. Although he never sought national office, he was a leader within the Republican Party and worked diligently to see that capable men found office. By the late 1880s, Parsons was at the top of Republican leadership in St. Louis and the state of Missouri.

In November 1888, there was a massive Republican rally called the "The Republican Parade" in downtown St. Louis that took place near today's city hall, from Market Street to Washington Avenue.[224] Thousands of Republicans carried torches to see their way, creating a stunning visual impression to illuminate their causes. Many party leaders spoke, but the *St. Louis Post-Dispatch* printed Parsons's entire ten-minute speech and noted that

"Chairman Parsons was in good voice, and with his first sentence secured the closest attention of his immense audience."[225]

He began: "Gentlemen: I thank you for inviting me to preside over this great assembly. It may seem to require an apology for my appearance before an audience to make a speech on political questions. But now however, it seems to me, as a businessman, as a man interested in the prosperity of this country, important that every man should raise his voice and use his influence in defense of the principle that for twenty-eight years has given us such unexampled property—I mean the principle of protection to American industries."

He went on to speak of his travels west in 1841, seeing all the banks "broken or suspended." He discussed how the currency of "Ohio, Indiana, Kentucky and Tennessee was at a great discount." This was all due to "the great stimulus given to importations from the low tariff during the year preceding." Parsons shared how he "spent a week in Washington in 1842, and was in the House of Representatives during some of the debates on the tariff of '42, and on the day when the bill passed the House. The new tariff worked wonders....[It] became a law and the change was wonderful."

To the audience of Republicans, Colonel Parsons described the ineptitude of the Democrats and recounted his financial troubles during his days in Keokuk, Iowa. Colonel Parsons discussed wages and the differences between them in 1846 and 1860. He engaged his listening public with the question, "Will you have an American market with 65,000,000 of customers and comfort for all? or will you try to compete with all the world to get a more extended market. There is no doubt about the matter, the question is a protective tariff or large reduction in labor wages to compete with other low-priced labor." He then rallied his audience: "We are now as rich in the precious metals as England and France combined. Let us favor a legitimate trade in those things we cannot produce here only, and look forward with faith and hope to the day in the future when New York will be the commercial and financial capital of the world." The *Post-Dispatch* wrote, "On the conclusion of Chairman Parsons' speech, the band struck up, 'The Battle Flag of Freedom,' in which the audience joined in a grand chorus."

In the late 1880s and into the late 1890s, Colonel Parsons found himself quoted in the *St. Louis Post-Dispatch* many times regarding his political dealings. When reports about his views or activities were incorrect, he contacted the paper immediately. For example, in 1896, Colonel Parsons was accused of creating a political fund with contributions from local St. Louis bankers that he gave to businessman and Republican politician Mark

A. Hanna (1837–1904).[226] It was believed that Parsons ensured that $37,500 was raised locally to use in the election campaign of President William McKinley, which Mr. Hanna was orchestrating. Parsons denied this and wrote the paper the next day, and the *Post-Dispatch* printed his statement:

> MR. PARSONS DENIES.
> *To the editor of the Post-Dispatch.*
> ST. LOUIS, Mo., Sept. 24, 1896.
>
> *Dear Sir: I notice in your paper of yesterday a statement that Col. Charles R. Parsons had raised a fund from St. Louis banks for political purposes and sent to Mark A. Hanna, to the amount of $37,500. I suppose you must refer to me, as there is no person in town of that name other than myself. I can only say that I have not asked from any bank or received or sent one dollar to Mr. Hanna, nor do I believe anybody has done so. Please put this in as prominent a place as the statement in your paper. Respectfully yours.*
>
> *Charles Parsons*[227]

On November 28, 1896, the *St. Louis Post-Dispatch* ran the headline, "Mr. Charles Parsons, President of the State Bank, Becomes a Member of the Board of the Pulitzer Publishing Co."[228] Explaining that Colonel Parsons filled a vacancy "created by the resignation of Mr. S.S. Carvalho," the article stated, "Mr. Parsons is one of the most prominent bankers of St. Louis. He is one of the leading Republicans of the State and was a member of the special committee designated towards the end of the last campaign to take charge of the Republican campaign in Missouri. In politics he has long been regarded as a friend and co-worker with Chauncey I. Filley. He is an earnest advocate and champion of the single gold standard." It is pure speculation that after November 1896, when Colonel Parsons joined the board of the Pulitzer Publishing Company, that fewer articles appeared accusing Mr. Parsons of anything out of the ordinary.

In a final note about the political Colonel Parsons, his influence was not merely felt in the continental United States. In 1893, Colonel Parsons went to Washington, D.C., to present a paper at the National Boards of Trades in support of the Nicaragua Canal, which was reported in the St. Louis newspaper.[229] He cited the success of James B. Eads, whose bridge across the Mississippi drove new commerce and prosperity to St. Louis, and argued

that the Nicaragua Canal would save American ships "10,000 miles of navigation." The Colonel demonstrated how the British government made a yearly income of about $16 million (a value today of nearly $500 million) from the Suez Canal and stated that the same could be had for the United States if the Nicaragua Canal were approved. He warned that England was ready to take on this endeavor if the government failed to do what was in the best interest of the United States. He ended his speech: "It certainly seems to me, when we consider the value of that great interior lake, [Lake Nicaragua] its utility in freeing our ships of salt water accretions, when we consider that the canal duplicates the power of our navy by making the same ships available in either ocean, with the various other benefits to our whole people, that every man in the United States who has a regard for the sovereignty and the glory of his own country, and who desires that her flag shall float on all seas alike will be in favor of this grand scheme." Following his speech, the United States approved the Suez Canal.

An Exchange of Violent Words

On June 5, 1890, the *St. Louis Post-Dispatch* ran the headline, "Noonan's Menace. He Threatens to Punch Bank President Parson's Head. An Exciting Scene on Third Street in Which Prominent Citizens Were the Actors."[230] Mayor Edward A. Noonan (1852–1927) was the twenty-seventh mayor of St. Louis, serving from 1889 to 1893.[231] Noonan was an attorney and a staunch Democrat, winning his party's support for mayor in 1889 and defeating Republican Colonel James Butler. His primary contributions as mayor were signing the ordinance for the construction of Union Station, the selection and designation of the current city hall to be constructed in the area then known as Washington Square and the consolidation of the system of horse-drawn street railways to a new trolley system run by electric motors.[232]

As the newspaper recounted, on the afternoon of June 4, citizens and officials at city hall were "excited" by an exchange between Mayor Noonan and bank president Charles Parsons. "The Chief Executive [the mayor] was using some very vigorous language, and both he and Mr. Parsons appeared to be very much excited. Mr. Campbell, who was standing close by His Honor's buggy, was employing his time in endeavoring to pacify the irate Executive. The scene only lasted a few minutes, but was of such a character

that several persons were attracted by it and heard enough to learn what was the cause of the tempestuous meeting."[233]

The nature of the exchange between Parsons and the mayor centered on the appointment of James Brennan to the position of street commissioner. The mayor was resolute that Brennan's appointment would be confirmed by the city council. The city council's failure to appoint Brennan "incensed" the mayor completely. The paper wrote, "During the past few days [the mayor] has become impressed with the belief, it is said, that the council's conduct was due entirely to Mr. Metcalfe's determination to vote in the negative, and that Mr. Metcalfe's position in the matter was due entirely to the influence of Mr. Parsons."

Known to be impulsive, Mayor Noonan wanted to ask Colonel Parsons in person why he had seen to it that the appointment of Mr. Brennan was opposed, so he proceeded by buggy to the State Bank of St. Louis. On his way, the mayor traveled to the office of broker James Campbell, and Campbell joined him in his buggy to confront Colonel Parsons.

Arriving at the bank, Noonan sent Campbell in to tell Parsons that the mayor wanted to see him outside. Parsons and Campbell exited the bank together, and on the street, the mayor greeted them and proceeded to ask in "his blunt way why Mr. Parsons was going out of his way to thwart him by influencing Mr. Metcalfe to vote against Mr. Brennan's confirmation."

It is reported that Mr. Parsons's response could not heard, but whatever the Colonel said, "it was of such a character as to make as to make his honor exceedingly angry." The mayor "is said to have exclaimed: 'I will get even with you for this. I will follow you and your friends as long as I live.'" Also, "If you were twenty-five years younger I would get out of this buggy and lick you." Bear in mind that in 1890, Charles Parsons was sixty-six years old. It was reported that an exchange of violent language was shared and that "Mr. Campbell prevailed upon the Mayor to end the scene by driving away."

Following the incident, Noonan, Campbell and Parsons had no comment for the inquiring newspaper reporter who wanted to know more. It was reported, though, that Colonel Parsons had shared the story with his close friends and that he "was naturally very indignant at the abuse heaped on him by the Mayor, but his friends persuaded him not to make any fuss about it."

The paper moved to interview politicians about the incident. The paper reported that it was "the prevailing opinion among politicians to-day that the Mayor's conduct yesterday had lessened the chance of Brennan's

confirmation. In fact many of them, especially those of Republican affiliations who knew what had occurred between the Mayor and Mr. Parsons, asserted that is was not all unlikely that if the Mayor did not change his course an attempt would be made to impeach him. Mr. Parsons is one of the most influential amongst the Republican silks, and if the Mayor has made an enemy of him it is the general opinion that he has made one to be feared." No attempt to impeach Mayor Noonan was ever made, and no further incidents are known to have occurred between the mayor and Colonel Parsons.

Chapter 5

PARSONS AND SCHLIEMANN

Remnants of a Friendship

W hen Charles and Martha Parsons met German businessman and
archaeologist Heinrich Schliemann in 1868 on a two-week train
ride through the Alps, Schliemann was a mere six years away from worldwide
fame.[234] As an archaeologist, Schliemann went on to (re)discover the fabled
city of Troy (Hisarlik), in Turkey, and became a household name by the end
of the nineteenth century. The Parsonses' chance meeting with this soon-to-be
international figure, on their way to Paris for Martha's sister's wedding, set the
stage for a twenty-year friendship.

Heinrich Schliemann was born in the German territory of Mecklenburg-
Schwerin (about 115 kilometers west of Hamburg, Germany) on January
6, 1822. When Heinrich was very young, his father gave him an illustrated
copy of *History of the World*, a book that would begin to fuel his passions
that made him a household name in the years to come.[235] It is well known
that Schliemann claimed that his interest in antiquity began around the
age of ten, when his father introduced him to the Homeric epics of the
Iliad and the *Odyssey*.

Schliemann experienced a difficult childhood. He lost his mother at the
age of seven. His father embezzled funds from their church, causing a major
scandal for his town and the family. His father's offense led to Heinrich's
release from grammar school. Although these early setbacks caused stress
and upset, the young Schliemann was not to be defeated. While attending
a vocational school, he began to teach himself as well. According to one
source, he learned French, English, Spanish, Dutch, Italian and Portuguese

in the short span of two years. Later, he added Russian and Greek to his languages as he began employment as a merchant.[236]

In 1851, Heinrich moved to California to be with his brother Ludwig, who had amassed a fortune during the gold rush.[237] He received his American citizenship in that same year and set up a banking operation to buy and sell gold. Records show that his bank processed at least $1.3 million ($46 million today) in a mere six months.[238] Although it is not reported how much of the profits he retained, when he moved to Russia in 1852, he at least partially retired from business life and assumed the life of a nineteenth-century gentleman. It was also in this year that he married Ekaterina

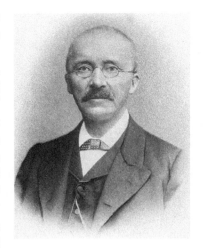

Heinrich Schliemann.
Universitätsbibliothek, Heidelberg.

Lyschin, the niece of one of his Russian high society friends.[239]

Schliemann's partial retirement did not last too long. Between 1854 and 1856, he became a military contractor during the Crimean War, providing saltpeter, sulfur and indigo dye, among other supplies, to the Russian army.[240] This experience was no doubt a point of connection for Parsons and Schliemann on their train ride. Charles would probably have been very interested to hear about the supply chains required for Schliemann's success and would have shared his exploits in the Quartermaster Service of the Union army years before.

Retiring entirely from business in 1863, Schliemann devoted himself completely to his lifelong interest in ancient civilizations, specifically Greece and the site of Troy.[241] He based himself in Paris, but his new wife did not follow and also would not let his three children leave Russia, thus putting strain on their marriage.[242] Six years later, in 1869, Schliemann boarded a boat for America and headed farther west, arriving in Indianapolis, Indiana. Indiana was chosen, at least in part, for the fact that at this time it had the most convenient divorce laws, and since he had American citizenship, he needed an American court to complete the process.[243] Indiana politicians casually created the state to be a "freewheeling divorce mill" in the 1850s.[244] Although divorce was permitted in Russia through the Orthodox Church, it was considered scandalous and was therefore rare; the high society family that Schliemann married into would not permit this separation. Schliemann

submitted his divorce petition through three lawyers in the Marion County Common Pleas Court. Years later, in 1877, the *Terre Haute Weekly Gazette* reported on the controversy of divorce, citing the then-famous archaeologist Heinrich Schliemann as receiving an "Indiana copper bottom divorce."[245]

Indianapolis would have been very comfortable for Schliemann, as the town had a very high German population and "a quarter of the city's newspaper readers still got their news *auf Deutsch*."[246] In a letter to his cousin Adolpho, Schliemann wrote of his new German friends in America: "As everywhere in America, so here, too, Germans are greatly respected for their industry and assiduity as well as their solidity, and I cannot think back without alarm of Russia where the foreigner, and the German in particular, is despised because he is not a Russian."[247]

To establish his residency and convince Judge Solomon Blair of his pure intentions, he bought a house at 22 North Noble Street along with interests in a starch factory, and he was subsequently granted an annulment of the marriage to his Russian wife. Schliemann took advantage of Indiana's divorce laws, but he took offense to other laws there. On June 1, 1869, he wrote in his diary, "The most disagreeable thing here is the Sabbath-law, by which it is prohibited to grocers, barbers and even to bakers to open their shops on Sundays."[248]

Also according his diary, he bathed in the White River daily and was disappointed at the lack of "coffee houses,"[249] but he was most struck by the impact of the Civil War: "One meets here at every step men with only one arm or one leg and sometimes even such whose both legs are amputated. I saw even one whose both legs were amputated close to the abdomen. The disabled soldiers of this State come here to the Capital to receive their pensions and this accounts for the numberless lame men."[250]

After Schliemann's death, an acquaintance of his in Indianapolis recalled that during the former's time in Indiana, prior to his archaeological work, "He was not then recognized as a great person. He was a very entertaining talker and excellent company."[251] Martha and Charles must have been quite entertained by Heinrich during their friendship, especially as his fame grew. Parsons and Schliemann were in regular contact by letter when Schliemann was in Indiana. Schliemann clearly was following the success of Parsons. On May 10, 1869, he wrote to Charles, "I was much gratified to see from your circular that particulars of your banking establishment which under your wise management, cannot fail to grow rapidly in wealth, inspiration."[252]

As a free man ready to focus his attention completely on the discovery of ancient cultures, he sought an assistant who could provide insight into

Greek culture. Perhaps it was the traditions of the time or his personal eccentricities, but it is reported that Schliemann placed an ad for a wife in a newspaper in Athens, Greece. The archbishop of Athens recommended seventeen-year-old Sophia Engastromenos, a relative, to join Schliemann in matrimony.[253] In October 1869, they were married and later had two children, Andromache and Agamemnon.[254] With his new wife in tow to assist him with research and Greek language and history, he began to write and put his theories to the page.

Schliemann returned to Turkey and began excavations in the area that he believed to be the Homeric Troy. As he had predicted in his book *Ithaka, der Peloponnes und Troja* (1869), ancient fortifications were found in 1872 and in 1873, as well as significant copper, gold, silver and other artifacts.[255] Schliemann declared to the world that he discovered treasure from the famed King Priam of Troy and named it "Priam's Treasure."[256] By 1874, Schliemann was a household name in America.

The Turkish government disapproved of Heinrich Schliemann's announcements of his discoveries and revoked permissions to excavate at Troy (Hisarlik) and other locations for years to come. It is believed that Schliemann and his business partner at the time, Frank Calvert, smuggled "Priam's Treasure" out of Turkey,[257] although Schliemann portrayed this action in a much different light in a letter to Parsons from Athens, dated December 3, 1874:

> *Your appreciation of my work is the greatest recompense I could wish for and it encourages me to continue the excavations with the utmost vigour as soon as my dispute with Turkey is amicably arranged, which I trust will be the case in the course of a fortnight. The Turkish minister had taken ill my remarks on page LII-LV of the preface of my book and has brought here in the beginning of April last a suit against me to revindicate one half of my whole Trojan collection. He had engaged the 3 most powerful lawyers and brought it so far that I have been obliged in May last to make the whole collection of 25000 objects suddenly and mysteriously disappear in order to save it. I have been immensily [sic] annoyed by the suit. Seeing now that I am fully a match to him and that he cannot recover anything at all of the collection, he wishes to negotiate and with $4000 cash and the continuation of the excavations for the exclusive benefit of the Turks for 3 or 4 months I shall no doubt settle the matter very shortly. But the suit has already cost $8000. However, large as these expenses are, they are but trifling as compared to the value of the collection, for not only it derives from*

the city, the mere name of which makes all hearts bound with joy, but it belongs to that remote antiquity, which we, vaguely groping in the twilight of an uncertified past, call the heroic or prehistoric age. I joyfully continue the excavations even without taking anything of what may be discovered, for I am afraid some government may step forward and continue the work, in which case all my gigantic trenches would at once be filled up....Ever since my discoveries have become known I have libeled here by the envious scholars and during all the time the suit has lasted the Greek government has brought its crushing influence on the Courts in order to get the decisions against me. This I have had to fight all the time with my 6 lawyers against 2 governments. In consequence of that we shall henceforward again live in Paris, or perhaps Naples; but first we have to finish Troy, where we cannot begin before 1 March. Perhaps you can come see us.

Embarking on other excavations in Greece, in 1876 he discovered skeletal remains and a mask he called the "Mask of Agamemmon" at the eponymous site of Mycenae that he associated with the ancient Myceneans of the Late Bronze Age, approximately 1600–1100 BCE. To promote his findings, in 1877 Schliemann published a daily record of his excavations, entitled *Mycenae*.[258] It is reported that he wrote this book in as little as eight weeks, publishing it in German, then French and finally English, with a preface by W.E. Gladstone, an esteemed Homeric scholar and a statesman of the time. *Mycenae* and Priam's Treasure continued to increase Schliemann's fame. The Treasure remains in the National Museum in Athens today. It is reported that Schliemann also had problems, similar to those he experienced in Turkey, with his discoveries at Mycenae. During his friendship with the Parsonses, it was not only Charles but also Martha who corresponded with Schliemann directly. In a letter, she requested a souvenir from Mycenae, and Schliemann responded from Athens on January 18, 1877:

I am unable to send you any souvenirs at all from Mycenae, because, as you will have seen from the London Times...I have presented to the Greek nation one half of the treasures which I could have claimed by law....I have not even kept the slightest particle of gold for myself...the Greeks are so jealous of me that the Archaeological Society here refuses to even let me have 100 common Mycenae potsherds of the million beautiful fragments and thousands of splendid vases which I have gathered for them at the risk of my life and with large expenditure.

It is interesting to note that Martha and Charles may have received artifacts from Troy and Mycenae through another person close to Schliemann. Soon after the preceding letter, Schliemann wrote to Charles and Martha from Paris on April 26, 1878, saying that he would "have much pleasure in giving to Messrs. Smith, Payne and Smith, some little reminiscences from Troy for you."

As stated earlier, Heinrich Schliemann did smuggle a large quantity of artifacts out of Turkey before he was embroiled in legal battles with at least two governments. Given the laws and archaeological practices of the time, it is completely in the realm of possibility that Schliemann used these artifacts in his business dealings to begin conversation and gain favor with prospective investors. This theory may explain why artifacts associated with ancient Greece and Turkey are often found in collections of the nineteenth century with little to no associated provenance.

Charles Parsons could have added "archaeologist" to his list of accomplishments if he took Schliemann up on an invitation, noted in a letter of June 17, 1882, at Troy near the Dardanelles:

> *You express the wish to be engaged in something that, while giving pleasure to you would confer benefit on the world. I can indeed propose something which would render your name immortal and confer an immense benefit on the world; namely to excavate the artificial mounds in the land of Goshen in Egypt and thus bring light into the dark night of the history of the Jews before their emigration from Egypt. If you will do it I shall probably excavate the mounds of the first Greek settlements in Egypt; but if you will not operate in Goshen I may do it myself; I shall, of course, not do it conjointly with you for if you do the work you must have all the glory of it.*

The logistics of accepting Schliemann's offer would have been immense. Charles would have had to retire completely from his established business ventures in St. Louis and move permanently to a life in Egypt full of hardship at nearly the age of sixty. Yet it appears as though Parsons deeply considered this opportunity. In his book, *Notes of a Trip Around the World in 1894 and 1895* (1896), he wrote:

> *We finally got to Zigazag...I was here in 1876.... [It] is in the land of Goshen of the Bible. There have been some fine discoveries made near here within the last few years. It was to this very place that Dr. Henry Schliemann recommended me to go and make diggings, but I could not do*

*it without giving up all my affairs at home for a long time, and my present
business for life. It turned out to be as good a point as he contemplated and
might have made one's name famous among archeologists, and I think I
would have liked the work.*[259]

Returning to Schliemann, in 1878 he received permission from the Turkish
authorities to resume excavations at Troy, and his second campaign ran
until 1879.[260] During the last eleven years of his life, Schliemann continued
to receive praise and also criticism as his fame grew and the practice of
archaeology and the laws surrounding it continued to be refined.

Remembering their meeting when he was preparing to cross the Alps
again, Schliemann sent Martha and Charles Parsons a letter from Paris on
April 26, 1878: "In recrossing the Alps a fortnight hence I shall remember
the great pleasure I enjoyed 10 years ago in your and your ladies' charming
company, on our trip from Chamber to Susa."

In subsequent excavations of new and previously investigated sites,
Schliemann continued to publish his findings. In 1881, he published *Ilios*,
containing new evidence establishing Hisarlik as the site of ancient Troy.
Also in 1881, he published *Orchmenus*, documenting his travels and finds at
Orchomenus, where he excavated the treasury of Minyas, believed to be
similar in structure to the treasuries of Agamemnon and Clytemnestra at
Mycenae. Working nonstop for the next ten years, he uncovered the royal
palace in Tiryns, Greece; traveled to Egypt to visit excavations underway by
William Petrie, who described Schliemann as "dogmatic but always ready
for facts";[261] and worked on the Greek island of Cythera and at the town of
Pylos, also know historically as Navarino.

In November 1890, Heinrich Schliemann developed complications after
a surgery in Greece—an infection in his ears that became serious. Traveling
from Greece against the orders of his attending physicians, Schliemann went
to Leipzig, Berlin, Paris and then Naples, with the intention to visit Pompeii.
During this time, his infection continued to worsen to the point that he
collapsed on December 25, 1890, in Naples. The next day, he succumbed to
his illness and died of cholesteatoma, an abnormal skin growth that develops
behind the eardrum.[262]

News of Schliemann's death traveled quickly to St. Louis, and it must
have been hard news for Charles to hear. Having lost Martha only a year
before and remembering that it was he and Martha who had enjoyed two
weeks on the train with Heinrich, Parsons felt sadness. Perhaps even more,
Charles's feelings could be expressed as Sir John Myres wrote, upon hearing

of the death of Schliemann, "the Spring had gone out of the year."[263] Schliemann's friends and family erected a large mausoleum in Greece on an Athenian hill for his final resting place. The inscription above the entrance to the mausoleum reads, "For the hero, Schliemann."[264]

We can only imagine how the seminal conversation between Charles Parsons and Heinrich Schliemann began and developed as they traversed the Alps in 1868, setting the stage for a lifelong friendship. Perhaps it was their shared experiences, providing men and supplies during wartime— Charles with the Civil War in the Quartermaster Service and Schliemann supplying the Russians during the Crimean War. These two self-educated, self-made men no doubt talked of their banking and business successes as they traversed the highest and most extensive mountain range of Europe. Being roughly the same age, they would have shared comparisons and contrasts of their upbringing in America and Germany, respectively. Parsons would have delighted to hear of Schliemann's success in the California Gold Rush, although Charles did not get gold fever. Both Schliemann and Parsons— with their varied interests in language, culture, art, architecture and their positions in high society—would have kept them in deep and expansive conversations for hours on end. From what remains of their letters, their sentiments demonstrate affinity and perpetual, mutual respect—timeless examples of true friendship.

FIRST ART MUSEUM
WEST OF THE MISSISSIPPI

By the 1870s, Charles Parsons had become a fully established businessman known nationally for his successes. His love of art fueled his most significant contribution to St. Louis and its citizens: leadership of the first art school and museum west of the Mississippi.

Art appreciation in St. Louis began after this small trading post on the banks of the Mississippi River was settled by the French in 1764.[265] As the settlement grew, so did interest in the fine arts. Early fine art in the area was displayed primarily in churches and the private homes of well-to-do citizens. As Washington University, which was founded in 1853, began its growth, art was no doubt important to its early leaders as a display of refinement and wealth, but it was not yet a part of the curriculum.

By 1859, art instruction in St. Louis was being offered by the Western Academy of Art.[266] The academy and its first president, Henry T. Blow, were empowered by an act of the state legislature to "use its funds in the cultivation and extension of the Arts of Design; in making collections of works of art; in founding and sustaining Schools of Art."[267] Names still recognizable today from St. Louis's nineteenth-century past included Carl Wimar, Ferdinand Boyle, A.J. Conant, James B. Eads, James E. Yeatman and George I. Barnet—the academy's board of directors.[268] The focus of the academy was to establish three art schools, which they designated as the Primary School of Design, the Antique School and the Life School.[269]

By the fall of 1860, the Western Academy of Art had formally opened its art gallery with an inaugural exhibition on Washington Avenue at Fourth Street.[270] The opening attracted the participation of at least two eminent

visitors: the Prince of Wales and the British ambassador Lord Lyons, who reported that he was "highly pleased with the fine collection of paintings and especially admired the Western scenes painted by Wimar."[271] The outbreak of the Civil War ended the promising beginnings of the Western Academy of Art, which could not fund further growth.[272]

When the Civil War ended, a number of art professors attempted to start a school in St. Louis by establishing Art Hall in 1866.[273] Although this effort was complimented at the time and was reputed to be "complete in all its details," its failure in 1868 was attributed to the fact that it was not connected to a private school, which would have provided infrastructure and financial support.[274] It seems that in 1868, an attempt was made to revive this art school as the St. Louis Academy of Art, but again, it was met with failure.[275]

The third attempt to create a permanent art school in St. Louis was known as the St. Louis Academy of Fine Arts.[276] The academy was in the capable hands of Director Halsey C. Ives and conducted its classes in buildings owned by Washington University in St. Louis, although it was not officially affiliated. It merged with Washington University in 1879 when six members of the academy's leadership joined the university to create the St. Louis School of Fine Arts, with Halsey C. Ives as its director.[277]

By the 1870s, Charles Parsons's businesses, reputation and wealth were well established. He and his wife were positioned at the highest levels of society in St. Louis and other cities where Charles conducted business. As a man of distinction, he had been building his art collection for many years. Mulkey wrote:

> *The best of the private collections were begun after the Civil War, for that time some of those pioneers who had come west to seek their fortunes had found their pots of gold in the trade and manufacturing then flourishing in St. Louis. These collections were of three main types. Some consisted chiefly of the works of artists of high repute, such as the galleries belonging to Charles Parsons, Hercules L. Dousman, Daniel Catlin, J.G. Chapman, George Leighton, and John J. O'Fallon. Others expressed the taste of the collector in a special direction: water colors, etchings, etc. Still others were composed exclusively of works of local artists, some of the more important of which were the collections of Halsey C. Ives, E.A. Hitchcock, Thomas E. Tutt, and J.B. Henderson. Although most of the private collections were in the owners' homes, the public was frequently invited to view them. In the case of Hercules L. Dousman, who had perhaps the finest art collection in the city, those interested in art were admitted one day a week by card, which could be obtained on application by "anyone of respectability."*[278]

Washington University and Charles Parsons came together on the subject of art in 1879 and began to collaborate on an endeavor that continued until his death in 1905. On May 22, 1879, the St. Louis School of Fine Arts officially became the art department at Washington University.[279] Charles joined the board of control that year and served continuously for the rest of his life as a general member and as chairman.[280]

Now affiliated with an institution of higher learning, the permanency of the art school was expected. Within weeks of the creation of the St. Louis School of Fine Arts, Wayman Crow—a powerful St. Louis businessman, Missouri politician and a founder of Washington University in St. Louis—contacted Ives and presented him with a plan for an art museum that would house the greatest art treasures of the world and also fulfill one of Crow's personal goals. The museum would serve as a "memorial to his only son, a young man with artistic tastes, who had died about a year before."[281]

Crow and his wife, Isabella, requested a meeting with Ives and the board of directors of the art school to move forward with the plan for an art museum for the school.[282] The meeting took place on June 6, 1879, and the Crows presented the boards of the art school and the university with the deed for land at the corner of modern-day Nineteenth and Locust Streets in downtown St. Louis to be used for this purpose.[283] This land is now home to a large warehouse, but in 1879, it was barren. Crow had solicited a design from the Boston architectural firm Peabody and Stearns, and he estimated that it would cost between $75,000 and $90,000.[284] Today, this would equate to between $1.9 million and $2.3 million.

Charles Parsons officially entered the picture on June 17, 1879, at a meeting of the board of directors for the School of Fine Arts that was held at the home of Chancellor William Greenleaf Eliot. Parsons, along with Daniel Catlin, Edwin Cushman, John B. Henderson, Ethan A. Hitchcock and Thomas E. Tutt, was elected to the board of control of the St. Louis School of Fine Arts, with Wayman Crow as president.[285]

The board of control moved quickly to develop art instruction and public arts education in St. Louis for present and future generations. The raising of capital by the university to fulfill Crow's requirements to receive the land was an early order of business, and the board focused on attracting donors. Mulkey wrote:

> [D]onors to the St. Louis School of Fine Arts were granted certain privileges, determined by the amounts of their gifts; thus, donors who contributed the sum of five thousand dollars [around $127,000 in today's dollars] at

any one time, became Founder and Life members, and were entitled to two
perpetual scholarships in the school; donors who paid one thousand dollars
became Life members and were permitted during their lifetime to give to
one student, annually, all the advantages of art instruction; donors who
contributed two hundred and fifty dollars at any one time, were privileged
to attend all lectures and exhibitions under the direction of the school, and
also to award to one student all the advantages of art instruction given in
the evening classes of the school; donors who gave fifteen dollars annually,
were allowed to attend all lectures and exhibitions under the direction of
the school, and also to send one student to the night classes in drawing.[286]

A brief introduction to Halsey Cooley Ives (1847–1911) is important
to understanding this time in Charles Parsons's life. Beginning in 1879,
the two were interlinked until Parsons's death in 1905. Ives was born in
Montour Falls, New York (only sixty miles from where Parsons was born),
on October 27, 1847, to Hiram Du Boise and Teresa McDowell Ives,
and he attended the Union Academy of Montour Falls. After the death
of his father at the beginning of the Civil War, Ives began working as a
draftsman.[287] Mulkey wrote:

In the autumn of 1864 he was employed by the government in that capacity
and was sent to Nashville, Tennessee, where he began his art education
under the direction of Alexander Patowski, a talented Polish refugee. Five
years later he became a designer and decorator and as such traveled for the
next few years in the South and West, and in Mexico. In 1874 he came to
St. Louis, where he began his life work [sic] as a teacher of art. During his
first year in this city he served as an instructor in the O'Fallon Polytechnic
Institute of Washington University. In 1875 he went abroad for study and
on his return was made a member of the faculty of Washington University.
Through his efforts the St. Louis School of Fine Arts, the art department
of Washington University, was established.[288]

Halsey C. Ives was internationally recognized and applauded by many;
one biographer wrote, "As a teacher he inspired his pupils with lasting
respect and affection. As an organizer, administrator, and protagonist of
the popularization of art, he was a power not only in his own community
but throughout the country."[289] On April 18, 1906, Ives received a letter
from President Theodore Roosevelt that commemorated a "special
commendation" from the commander in chief, acknowledging the museum

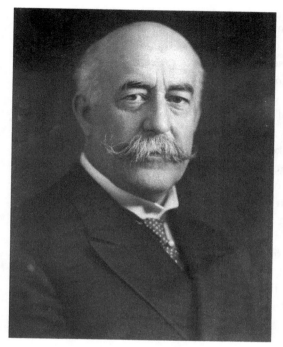

Halsey C. Ives. *Missouri Historical Society, St. Louis.*

that followed the St. Louis School and Museum of Fine Arts, the City Art Museum in Forest Park, now the St. Louis Art Museum:

> *My Dear Mr. Ives, I can hardly imagine that any good American would fail to feel interest in and hearty approval of the enterprise in which you are engaged. The artistic merits are sufficiently proved by the testimony of men like John La Farge, Augustus Saint Gaudens, Frederick Dielman, F.J. Skiff, D.H. Burnham, Charles F. McKim and the other architects, artists and sculptors who have written you. It seems to me that such a museum as is suggested would be one of the strongest factors in the development of art education and of the appreciation of art, not only in your own part of the country, but throughout the Union. I feel such a monument would not only have an excellent influence upon the development of an appreciation for good architecture in the Middle West, but throughout the entire country. I earnestly hope that you may find men wise and generous enough to enable you to undertake the work in question.*[290]

Returning to the first museum west of the Mississippi, as decided at the winter board meeting on February 11, 1880, the museum ought to

"be in the nature of a permanent exhibition with loan collections of paintings and other objects of the fine arts."[291] The finished Museum building was an imposing presence at the corner of Nineteenth and Locust Streets. The two-story building rose seventy-four feet in the air from the street entrance that allowed easy access for the general public. The St. Louis School and Museum of Fine Arts building had been built from the meticulous plans of Peabody and Stearns of Boston, who, according to a contemporary journalist, ranked "among the most distinguished architects in the country."[292] When the building was completed, housing the St. Louis School and Museum of Fine Arts and serving as a memorial to the deceased son of Wayman Crow, it was said to be "in itself a work of art."[293] Though the museum was intended to display beautiful works of art from around the world, from antiquity to the present, it was designed to be beautiful from the outside as well. The facade of the building was enhanced with artistic reliefs. Over the main entrance patrons would see an immense head of Phidias, the Greek architect, painter and sculptor. On the right of the facade was Raphael, the Italian Renaissance architect and

St. Louis School and Museum of Fine Arts. *St. Louis Art Museum.*

painter, and to the left was Michelangelo.[294] Reporters said that "there was no feature, 'even the minutest appointment,' in which the building was at fault. One reporter declared the building "will prove an enduring as well as conspicuous ornament to the city, while, as a temple of art, it will be its crowning honor."[295]

Finally, the opening day of the museum arrived:

> On May 10, 1881, all was in readiness for the dedication and formal opening of the St. Louis Museum of Fine Arts. At 8 P.M. the Memorial Hall was entirely filled by invited guests, an audience "representative of culture, refinement, and wealth." On the platform were the Reverend Dr. W.W. Boyd of the Second Baptist Church, Chancellor Eliot, Wayman Crow, James E. Yeatman, Halsey C. Ives, Daniel Catlin, Henry L. Dousman, Edwin Harrison, John B. Henderson, Ethan A. Hitchcock, Henry Hitchcock, Judge John M. Krum, George E. Leighton, Charles Parsons, Ex-Governor E.O. Standard, Thomas E. Tutt, and several members of the Board of Control of the St. Louis School of Fine Arts. The ceremonies of the evening were opened with a prayer by Dr. Boyd. Then Wayman Crow arose and delivered a short address.[296]

Before the assembled crowd, Wayman Crow outlined the purpose of the museum and the school, and he also discussed "the character of the man who, twenty-eight years before, had conceived the idea of creating Eliot Seminary, now Washington University."[297] Some highlights of his speech include:

> [U]nder favorable auspices and with the cordial cooperation of the public-spirited citizens, an organized effort will be made to render this museum an important centre of art education....It will be the aim of this School of Fine Arts to educate the public taste, instil [sic] sound principles of aesthetic culture and foster a distinctively American type of art. Nor will the delight which the cultivated mind feels at the sight of beauty be the only result of this artistic culture. Industrial art will feel a quickening impulse.[298]

Mulkey continued:

> The erection and dedication of the St. Louis Museum of Fine Arts was considered by at least one writer to be "the most notable event in the history of" Washington University this far. William M. Bryant, in an

Atrium of the St. Louis School and Museum of Fine Arts. *St. Louis Art Museum.*

article written for The Western, a periodical of that day, stated: "The opening of the Crow Museum of Fine Arts has marked an epoch in the history of St. Louis well worthy of all that has been or could be said in its commendation. Such an event could not but be highly gratifying to all friends of art education, the highest and best sense of that term. To add to the works of praise that have already been uttered would be difficult."[299]

The early school of art produced excellent students who worked under equally impressive faculty. One of the original faculty members of the School of Fine Arts was Carl Gutherz, who had worked tirelessly to help the school succeed.[300] In 1884, he resigned his position to work in Paris, receiving great acclaim.[301] When he returned to the United States, he was commissioned to create a large-scale mural on the ceiling of the House Reading Room in the Library of Congress entitled *The Spectrum of Light*.[302] Gutherz went on to create portrait paintings of major figures of the time like Susan B. Anthony, Jefferson Davis and General Robert E. Lee.[303]

Awareness of the St. Louis School and Museum of Fine Arts reached from coast to coast, and by 1891, national talk of a world's fair in Chicago had taken center stage; here, the St. Louis School and Museum of Fine Arts

played an important role. As the 1893 Columbian Exposition approached, the entire world watched an event of epic proportions come to pass. Charles Parsons received the highest honor of his profession when he was selected to oversee the World's Bankers and Financiers of the event.[304] Parsons ensured that his participation went beyond his personal contribution to the fair. It is difficult to convey the importance of this fair at the time, but it was seen as the "greatest event in the history of the U.S. since the Civil War."[305] With Parsons leading the World's Bankers and Financiers, "on June 4, 1891, the Board of Directors of Washington University granted Professor Ives a three-year leave of absence to enable him to serve as chief of the Department of Fine Arts at the Fair."[306] The relationship between Parsons and Ives could not have been closer at this time.

During the Chicago Columbian Exposition, the work of the students of the School and Museum of Fine Arts was lauded internationally when they took first place. "The students receiving honorable mention were: Messrs. Louis F. Berneker, Ralph C. Ott, and Field; Misses Talby, Knemmel, Armstrong, Larimore, and Bryan."[307] Thus the museum and school were set to attract new students accordingly.

By the time of the planning of the Columbian Exhibition in Chicago, the art and artifacts on display at the St. Louis museum were impressive and may reveal Parsons's motivation for collecting two Egyptian mummies in 1896 that he would later donate to the museum. Although these mummies will be discussed in a later chapter, one was from the reign of Amenhotep (Amenophis) III. By 1890, the museum owned nearly four hundred examples of art representing nearly every period of art history from Egyptian art from Amenophis III forward to Italian art from the time of Michelangelo.[308]

These collections only grew more immense with Parsons and Ives contributing to the development of the Chicago fair. While Ives traveled on behalf of the Columbian Exposition, he was also purchasing valuable works of art for the St. Louis Museum of Fine Arts. By the spring of 1894, records show that Ives had purchased an immense collection of paintings and other art objects valued at $25,000 for the museum in St. Louis with funds donated by contributors wishing to see the school and museum grow. Today, that figure would hold a value of $700,000. [309]

With these new acquisitions and many others, the museum was quickly running out of instructional space for the school and exhibition space for the art. It is unclear when Charles Parsons became the chairman of board of control, but in 1897, he received approval from the Washington University

Board of Directors for the board of control to initiate a plan to secure funds in order to complete the building as planned as well as expand it.[310]

As chairman, Parsons worked with Director Ives to address security concerns for the museum and the classrooms. Security had been discussed at great length by the board of control. It was common knowledge among the leadership that would-be art thieves could move unimpeded from the vestibule to galleries on the top floor and then to the library and classrooms located in the basement when Memorial Hall was open to the public.[311] To increase security, the vestibule was secured from other valuable parts of the building holding the art and artifacts with gates, rails and other security features in 1897.[312]

In April 1897, the first mention was made of moving the museum to Forest Park, where the St. Louis Art Museum is located today, and the Washington University Board of Directors authorized an application for land in Forest Park, as well as approved Chancellor Eliot "to interview the Crow heirs as to their views on the matter of the removal of the museum."[313] This proposal was controversial to some and required serious deliberation. William S. Curtis of the Washington University law school was consulted on the matter, and in his report to the board of directors, Curtis said:

> [A]fter carefully reading a copy of the deed by Wayman Crow and his wife, a copy of Crow's letter accompanying the deed, and the agreements made by the Board of Directors in accepting the gift, he found that the land and building were intended to be used for art education and as an art museum. He believed the Board of Directors could move a part of the contents of the museum without violation of the conditions of the grant and without any legal proceedings, provided a substantial collection would be left at the old location to be administered in connection with the art school.[314]

Using a clause in the original contract with Crow that stated "that the land and buildings should be forever held, used, occupied, and employed for the above purposes 'as far as shall be found practicable,'"[315] the board of directors built a case that because of the pollution present in the area around the museum producing smoke, dust, soot and gas, the art in the building was being harmed not only in terms of its artistic value but also in terms of its longevity for the enjoyment of future generations.[316]

In December 1899, "after two years of discussion, Ives reported that action ought to be taken soon to secure through the Council and House of Delegates that passage of an ordinance permitting the erection of a

museum in Forest Park and to have this privilege granted to the St. Louis School of Fine Arts."[317]

On March 13, 1900, a bill was enacted that authorized the construction of a new school and museum in Forest Park that "together with the site upon which it is located, shall be devoted to the use of this institution forever, for the exhibition of pictures and sculpture and such other means as are usual in such institutions for the education of the public in art." It also provided that the location of the building be determined by the board of control.[318] With all assurances, Charles Parsons and his board of control chose the location of the current St. Louis Art Museum. This bill also altered the leadership structure in that the museum and school were to be governed not only by the board of control but also the city's mayor, comptroller and park commissioner, who would serve in an ex officio capacity.[319]

On May 17, 1901, the museum was brought up again in the context of St. Louis's own world's fair. The city was planning a celebration of the 100th anniversary of the Louisiana Purchase, "and the Board had in mind the possibility of obtaining the cooperation in the erection of the building."[320] After the fair was complete, a building, at least partially permanent, would "be given to the Board of Control of the St. Louis School and Museum of Fine Arts as a permanent home for the museum, thus relieving the Board of the necessity of providing means for the erection of a museum building in the park."[321]

It was rumored that Halsey C. Ives would be the art director of the St. Louis exposition, as he had been for the 1893 fair in Chicago.[322] Further, Ellis Wainwright—St. Louis businessman, brewer, art collector and socialite— was rumored to be chairman of its fine arts committee.[323] A telegram was sent to Wainwright to accept the position:

Absolutely essential for Museum of Art in St. Louis that you accept appointment. Great danger to our interests if you decline. We lose situation unless you accept.

[Signed]
Charles Parsons
W.S. Chaplin
Halsey C. Ives
Charles Nagel
Harrison I. Drummond[324]

The Louisiana Exposition Company considered the proposal of the board of control for the St. Louis School and Museum of Fine Arts, and the board of directors agreed to it.[325] Leaving a permanent building following the fair that would be visited by millions per year would serve as an impressive memorial of the Louisiana Purchase Exposition. The building that would be the Palace of Fine Arts, designed by Cass Gilbert of New York City, during the exposition would become the City Art Museum following the fair at the top of what is now known as Art Hill in Forest Park.[326]

Charles Parsons lived to the end of the fair, but not long enough to see the final iteration of the museum building in Forest Park that he and his board of control willed into being. In September 1905, Charles Parsons passed away, leaving his collection of art and the majority of his fortune to his nephew, Charles Parsons Pettus. Perhaps more valuable in the years to come was the $75,000 ($2,200,000 today) that Parsons bequeathed to the university, "in trust for a fund, the income of which was to be used first, to keep the collection in good condition and insured, and second, to purchase paintings to be added to the Parsons' collection" in perpetuity.[327]

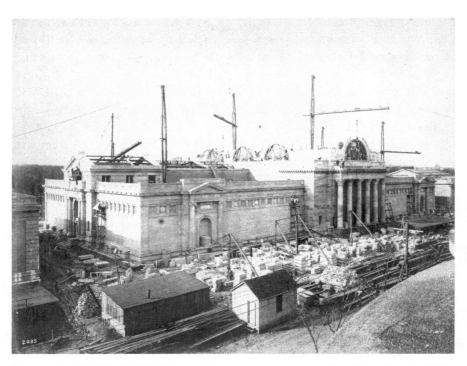

View of the 1904 World's Fair Palace of Fine Arts under construction, November 30, 1903. *Missouri Historical Society, St. Louis.*

As a member of the board of control of the St. Louis School and Museum of Fine Arts, from its inception in 1879 until his death in 1905, Charles Parsons was part of every decision and initiative to grow arts education and public awareness in St. Louis and the region for twenty-six years.[328] Today, the St. Louis Art Museum, a permanent building dedicated to art in one of the largest public parks in the United States, stands as a testament to years of dedicated service and the continuing education and inspiration of the public for generations to come.

Chapter 7

PARSONS'S PAINTING COLLECTION

W hen the United States was in its infancy, personal ownership of art was seen as immoral; it was believed that the arts and artists were "decadent, and, as such, potentially dangerous."[329] In the late eighteenth century, art in America was regarded as having "informational, rather than artistic, value and [people] saw art as a way to promote national values."[330] By the early nineteenth century, attitudes toward personal ownership of art had begun to shift, and the middle and upper classes of America began to be influenced by European attitudes and refinement.[331] Thus the ownership of art, with emphasis on paintings and sculpture, became a mark of such social qualities.[332]

As early as the 1870s, Charles Parsons's painting collection received acclaim in St. Louis and was gaining attention as one of the best in the country.[333] According to Graham W.J. Beal, it was "a perfect example of the informed St. Louis gentleman's of that time."[334] In 1879, Charles Parsons's painting collection was included in Edward Strahan's *Art Treasures of America: The Choicest Works of Art in the Public and Private Collections of North America* and was listed along with his friends D. Catlin, J.A. Scudder, S.A. Coles, H.L. Dowsman and J.J. O'Fallon. As Beal wrote, "Though these collections vary in size, a number of artists are represented in most: Corot, Daubigny, Verbochhoven, deNeuville, Coomans, and others are at least duplicated. Further duplications occurred after the publication of Strahan's catalogue. Parsons added a Jules Breton and a George Inness to complement those in the collection of his friend Catlin.[335]

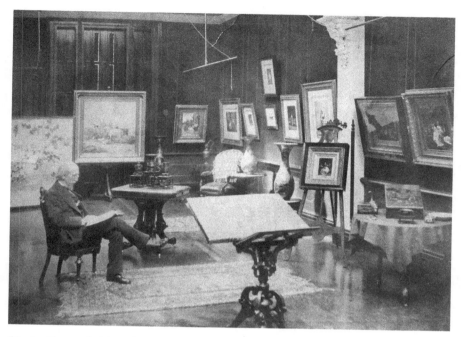

Charles Parsons in his study. *Photo courtesy of Mildred Lane Kemper Art Museum, Washington University in St. Louis.*

The majority of the paintings that Parsons collected were landscapes, genre scenes and French academic art from the Salon.[336] Parsons's landscapes have received the most scholarly attention since he bequeathed them to Washington University in St. Louis and, ultimately, the Mildred Lane Kemper Art Museum, where many are on display today. In Charles Parsons's will from 1905, the collection was gifted to the university with the provision that his nephew, Charles Parsons Pettus, was allowed to keep the paintings and art objects until his death. Although the collection was not fully accessioned by the university until after Pettus's death (in 1923), Parsons's collection began to receive public audiences in 1907. At this time, Charles Parsons Pettus announced to the board of control that he intended to loan parts of the collection into the custody of the university and to the new art museum in Forest Park, with the caveat that he would be able to exchange any object of equal value for his own use at any time.[337]

It is unclear why Pettus decided to loan the collection at this time. His inheritance also included his uncle's new, massive home at 33 Westmoreland Place, where Pettus and his wife, Georgia A. Wright Pettus

(1880–1934), had moved prior to Charles Parsons's death. This home was well suited for the collection of art and artifacts, as Charles had designed it with a rear wing to accommodate his personal museum. By 1907, the care and organization of hundreds of objects and paintings may have been too much for Pettus to handle, motivating him to offer custody of the collection to the university. The home currently at 33 Westmoreland is not the original structure, which was abandoned in the late 1930s and then torn down in 1941. A new house was constructed on the site in 1941, and this is the structure that stands today.[338]

After Pettus's death in 1923, the meeting minutes of the administrative board of control of the City Art Museum record that on October 19, 1923, the museum accepted for "indefinite loan…eighty-four paintings and three hundred and sixty-nine miscellaneous objects of gold lacquer, Japanese and Chinese pottery and porcelain; also carved ivories and metal work."[339] Though far from a complete list of talented and important nineteenth-century artists, the following overview provides an introduction to the artists of Charles Parsons's collection of paintings. The reader is strongly encouraged to visit the Mildred Lane Kemper Art Museum to experience the world-class art exhibitions and academic scholarship it offers there, although one may visit its website to view all works from Parsons's collection.[340]

French artist Jean-Baptiste-Camille Corot (1796–1875), primarily a portrait and landscape painter, was a pivotal figure in the nineteenth century.[341] Corot belonged to the Barbizon School of painters, who strove for realism in their paintings through soft form, loose brushwork, color and tonal qualities.[342] Around 1872, Parsons purchased Corot's *Le chemin des vieux, Luzancy, Seine-et-Marne*.[343] As Noelle Paulson wrote, "Despite the painting's lack of detail, its title is highly specific. It explicitly identifies the location as a particular path—Le chemin des vieux, or the Path of the Old People—in Luzancy, a village in central France. Luzancy is situated on a bend in the rather narrow Marne River but is otherwise distant from any large body of water. Yet the strip of blue on the left side of the horizon suggests an ocean or lake in the distance. Indeed, Alfred Robaut—the painting's first owner, Corot's biographer, and coauthor of the catalogue raisonné of the artist's paintings—described this blue patch as 'a horizon of sea.'"[344] Charles and Martha Parsons may have first encountered Corot on their honeymoon in Europe in 1857, though it is unknown if Parsons began collecting paintings at this time.

American landscape painter Frederic Edwin Church (1826–1900) was a principal member of the Hudson River School and was lauded for his

immense landscapes featuring "precise topographical detail that emphasized the majestic power of the natural world."[345] At the height of his career, he was one of the most famous painters in the United States.[346] The first painting by Church that Parsons acquired for his collection was *Twilight: Mount Desert Island, Maine* (1865).[347] In 1880, Parsons was motivated to commission another work by Church, "sight unseen," entitled *Sierra Nevada de Santa Marta* (1883).[348] Church did not seem confident that Parsons would be impressed with this "majestic piece" and wrote him a letter to share his artistic process: "As I developed the picture I introduced a more verdant country that exists in that part of New Granada where I first saw the snowy mountains. But it is reassurable to believe—indeed it is more than probably [*sic*] that the country in the interior is well watered and that all the conditions I have presented may be found there. So we may regard it as a title consistent with the subject. I hope that the picture will not only please you and Mrs. Parsons at first sight, but what is of more importance that it will grow in favor the more it is studied."[349]

The letter that Parsons wrote back to Church has not survived, but it appears as though Parsons was not initially impressed with his new painting. Church responded, "Although I confess to being much disappointed that it did not impress you with the decided favor I hoped... yet I feel confident that as you study and contemplate it more and more you will be impressed with certain features and effects which cost me much study and effort to attain—imperfect though they be. I certainly should be sorry if all there is in the picture could be comprehended in a glance or two. It was so warmly commended by my artist friends that I was encouraged to expect too much probably."[350]

Church's humble implications of his failure to please Parsons may have prompted Parsons to see the work with new eyes. In a later letter, Church expressed his thanks for the "bountiful praise" that Parsons bestowed on Church for his work on *Sierra Nevada de Santa Marta*.[351] Beal pointed out the uniqueness of the painting as "a type of landscape radically different from the generally cow ridden composition of a Troyon or (A.F.) Bellows."[352] Both of the paintings of Frederick Edwin Church purchased by Parsons are stunning nineteenth-century landscapes. At the same time, Church recommended that Parsons not waste his time or money collecting any of the new French Impressionists, considering them to be "radical and of questionable merit."[353]

Sanford Robinson Gifford (1823–1880) came into prominence as a second-generation member of the Hudson River School,[354] and his

reputation as a master of "light and atmosphere" was well deserved.[355] He was first trained to be a portrait and figure painter, but at the urging of the president of the National Academy of Design, Asher B. Durand, Gifford began to paint landscapes.[356] He was a founder of the Metropolitan Museum of Art, New York, in 1870, and his work was granted the honor of the museum's first monographic retrospective in 1881, the year after his death.[357]

Parsons acquired three works by Gifford: *Early October in the White Mountains* (1860), *Rheinstein* (1872–74) and *Venetian Sails: A Study* (1873).[358] *Early October in the White Mountains* is a stunning landscape that invites the viewer to enjoy the profound sense of calm of the distant White Mountains, a visual experience similar to that of the faraway boats on the tranquil canal in *Venetian Sails* or the gorgeous, sunlit castle in *Rheinstein*, high above the Rhine River, which Gifford visited in 1856 and 1869. In all, the works that Parsons collected are superb examples of Gifford's oeuvre.

George Inness (1825–1894) has often been called the father of American landscape painting.[359] His influences were varied, including the Barbizon School, the Hudson River School, the European Old Masters and the religious and spiritual writings of Emanuel Swedenborg (1688–1772), the Swedish polymath and religious leader who lived at the height of the Enlightenment.[360] Another master manipulator of shadow, light and color, Inness compounded order and chaos to invoke the divine in his paintings.[361] In his own words, he sought to communicate the "reality of the unseen" and "visible upon the invisible."[362] Although there are three works by Inness in the collection of the Mildred Lane Kemper Art Museum today, only one was from Parsons: *New England Village (Catskill Cove)* (1866), a wonderful scene of a small town below the Catskill Mountains.[363]

In Strahan's account of Parsons's collection, Parsons's recent acquisition of Spanish artist Don Luis Alvarez's *The Introduction of the Betrothed* (1877) received high praise from Strahan.[364] Strahan incorrectly identified Alvarez as an Italian artist, most likely because he was working in Rome as student of Italian artist Madrazo the Elder.[365] Alvarez's list of clients in the nineteenth century was impressive, and there were at least six Alvarez paintings in St. Louis by the early twentieth century in the collections of H.L. Dousman, J.A. Scudder, D. Catlin and, of course, Charles Parsons. Other notable clients of Alvarez were Samuel Hawk, H. Hilton and J.P. Morgan.[366]

Parsons purchased Narcisse Virgile Diaz de la Peña's work *Wood Interior* (1867), most likely in the 1870s, to go alongside other landscapes and idyllic

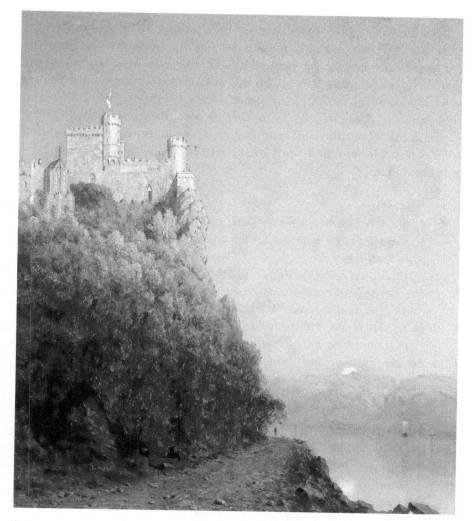

Sanford Robinson Gifford (American, 1823–1880), *Rheinstein*, 1872–74. Oil on canvas, 31⅜ x 27¼ in. *Mildred Lane Kemper Art Museum, Washington University in St. Louis. Bequest of Charles Parsons, 1905. WU 2182.*

scenes of the countryside in his collection. Diaz de la Peña was "known in his day as a first-rate colorist and a master of light."[367] As a central figure of the Barbizon School, Diaz de la Peña worked diligently to communicate the school's "utopian aspirations to experience nature and rural life directly and to depict such scenes poetically through painterly techniques that highlighted the subjective expressions of the artist."[368]

Jules Breton (1827–1906) was another painter with whom Parsons corresponded and perhaps met in person on his numerous trips to Europe, beginning in the late 1850s. Breton was a naturalist whose mastery was recognized in his ability to convey the power and beauty of idyllic, pastoral scenes of his native northern France.[369] Following the publication of Strahan's *Art Treasures of America*, Parsons sought to add a Breton to his collection and sent a letter to the artist. Breton responded in French in a letter dated April 1881, from his hometown of Courrières, translated here:

> *Sir,*
>
> *I am so very flattered that you are manifesting this desire to own one of my paintings and at the same time I really wish to please you and it will be a joy to create it for you.*
>
> *When could I possibly do it! There is the ultimate question. I am already late with my other customers who do not appreciate my work as you do.*
>
> *All I can do at this time is to take some good notes of what you wish for me to create for you. I will create it when I have time.*
>
> *In the meantime, I am praying that you please accept my sentiment here for your good words that describe your acknowledgment.*
>
> *I wish you the highest of praise.*
> *Jules Breton*[370]

Breton was a prolific artist and was probably telling the truth to Parsons regarding his schedule, but this letter may have been an attempt by Breton to raise the price of the commission if Parsons wanted it sooner. It seems as though Parsons was unsuccessful in purchasing a new painting and settled for a work from 1858, entitled *Le Lundi (Mondays)*.[371] In another letter to Breton, Parsons pressed the artist to provide "details of the characters" displayed in the painting, although Breton's response has not survived.[372]

Charles Parsons's collection of paintings was among the best private collections of its time in the United States, recognized as including works of "high technical quality carefully composed and finely executed."[373] Parsons truly loved art in all its expressions, and his collecting tastes demonstrated that he was educated in the arts and aware of the most modern and popular collecting trends.[374] He was not merely collecting to demonstrate the mid-nineteenth-century sentiment that art ownership demonstrated "power and superiority."[375] Charles Parsons was genuinely

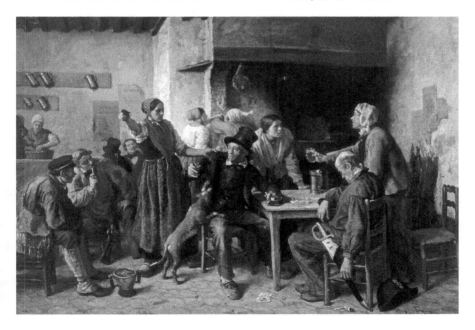

Left: Jules Breton, letter to Charles Parsons in French, 1881. *Missouri Historical Society, St. Louis.*

Below: Jules Breton (French, 1827–1906), *Le Lundi* (*Mondays*), 1858. Oil on canvas, 24⅝ x 36⁹/₁₆ in. *Mildred Lane Kemper Art Museum, Washington University in St. Louis. Bequest of Charles Parsons, 1905. WU 2101.*

moved and inspired by having the means to surround himself with objects of art and dedicated nearly thirty years of his life to contributing to the education of students who would go on, in many cases, to inspire a nation with their creations. To the general public, he dedicated his time and resources to create a central repository, the first museum west of the Mississippi, for all to enjoy.

Chapter 8

SCULPTOR HARRIET HOSMER

W hen twenty-year-old Harriet Hosmer arrived in St. Louis in the fall of 1850, she was not yet internationally famous for her sculptures depicting classical figures.[376] Charles Parsons was in St. Louis, considering joining his brother Lewis and trying to determine whether the city would be a good place to settle. With Lewis's successful law practice and Charles's plans to open a bank, the possibilities looked good. Sadly, though, they lost their brother Levi (also in St. Louis) in April of that year to the devastating cholera outbreak that claimed the lives of four thousand residents.[377] Martha Pettus, not yet Mrs. Charles Parsons, was a twenty-year-old debutante moving in the social circles of the city's upper class. Harriet, Charles and Martha were destined for a friendship through the arts, but this was still many years off.

Hosmer traveled from Boston to St. Louis for the sole purpose of studying anatomy at the McDowell Medical College, with the support of one of the most successful and powerful businessmen and politicians in St. Louis, Senator Wayman Crow (1808–1885).[378] Crow is best remembered as a twice-elected Missouri senator who chartered the St. Louis Mercantile Library (the oldest library west of the Mississippi), established an asylum for the blind, deeded the St. Louis School and Museum of Fine Arts in 1881 and chartered what eventually became Washington University, where he continued as a member of the board of trustees until his death in 1885.[379]

Hosmer had befriended Wayman Crow's daughter, Cornelia—a midwestern girl who was not from an established eastern family—

Harriet Hosmer, 1850. *Watertown Free Public Library, Massachusetts.*

while attending the Sedgwick School in Massachusetts; she was often called "Corney."[380] This lifelong friendship provided Harriet with a powerful sponsor in Corney's father for her work as a sculptor and her rise to international fame. In the following years, this friendship inspired Cornelia to publish a collection of Hosmer's letters and travels. When Harriet learned of Cornelia's engagement, she wrote to Wayman Crow explaining that she had "suffered a spasm" upon hearing the announcement:[381] "I told her not to mention the subject again as I couldn't bear to think of it—not that Mr. Carr is a very nice young man but I shall feel that I have lost her entirely when she is married."[382] At the beginning of their friendship, Wayman Crow could not have been happier with his daughter's connections to Harriet and other daughters of influential families. Crow's motivations for sending Cornelia to an elite school in the Northeast were to make a statement about his wealth, to insert the Crow family name into the circles of prominent New England families and ultimately to promote St. Louis as the "gateway city," where all goods going west passed through his growing Mississippi town. This, in turn, increased his local power and wealth, as well as that of his friends and business associates. Wayman Crow's relationship with Hosmer in the years to come would elevate St. Louis as a hub of art as she continued to gain international awareness.[383]

Harriet Hosmer's father was Hiram Hosmer, a physician, who wanted nothing but the best for Harriet. Dr. Hosmer's motivation for sending Harriet to Sedgwick differed from Crow's. The school was run by Elizabeth Buckminster Dwight Sedgwick (1801–1864), the great-granddaughter of Jonathan Edwards (1703–1864), who was a president of Princeton University.[384] Hosmer's training under Sedgwick was designed to be self-guided. Regarding her instructional philosophy specifically for women, Sedgwick wrote, "If you succeed in training properly their powers of mind, in forming in them habits of patient careful study, of a concentration of their powers, bearing upon a single point, as the sun's rays are collected in a focus, and in inspiring them with a love of knowledge of for its own sake, you have done inexpressibly more for them than if you had made them

passive repositories of the knowledge to be got out of all the school-books that were ever printed."[385] Upon accepting Harriet Hosmer into the school, Mrs. Sedgwick said to her father, "I have a reputation for training wild colts, and I will try this one."[386] Harriet studied with Sedgwick for three years. Years later, Mrs. Sedgwick remarked that "[Harriet] was the most difficult pupil to manage I ever had, but I think I never had one in whom I took so deep an interest, and whom I learned to love so well."[387]

The Sedgwick School became known as "the Hive," and within its circles, Harriet was known for "her humor and loquacity...often called to entertain the distinguished guests frequenting the Hive."[388] These guests included statesman Daniel Webster, author and diplomat Washington Irving, British author and art critic Anna Jameson and the successful, famed author Catharine Sedgwick (1789–1867), Elizabeth's sister.[389]

In seeking to understand Harriet's worldview and how the Sedgwick School shaped her young mind, it has been suggested that she and her classmates were privy to discussions of women's rights: "Most famously, in July 1848, in the midst of Harriet's time at the Sedgwick School, Elizabeth Cady Stanton and Lucretia Mott helped organize a women's rights convention in Seneca Falls, New York."[390] Returning to Catharine Sedgwick and her contribution to the pupils, she spent months out of the year providing instruction at the school. This was a windfall for the Hive, as Catharine was a major American writer in 1835. *The Ladies Companion* declared, "She is no copyist of another's skills: She has now a name for herself—she is one of our national glories—our Sedgwick."[391] Hosmer, who never married, was perhaps influenced by the example that Catharine Sedgwick provided. Catharine possessed an international reputation and was unmarried, and she took a personal interest in the young Hosmer. In 1849, Catharine wrote to Harriet from New York, saying, "I have met with nothing in this city so brilliant or half so pleasant as some of our evenings at 'The Hive.'"[392]

In all, the education that Hosmer received at the Sedgwick School was designed to refine her. Her early childhood was not ordinary for a girl of the nineteenth century. Harriet's father—motivated by the loss of his wife, Sarah, to tuberculosis—took extraordinary steps to keep his daughters Harriet and Helen in good health. Dr. Hosmer ensured that his daughters engaged in a "physical fitness regime that included hiking and hunting on the land around the home and swimming in and rowing on the Charles River."[393] Harriet grew strong in body and mind under this program, but her sister died of tuberculosis in 1842. Following the death of her sister, Harriet was all the more in the wilderness, and it is in this time we see the

earliest report of her interest in sculpting: "[S]he not only swam and hunted, but also created models of animals with the clay lining the banks of the Charles."[394] The neighbors often perceived the young, enterprising Harriet as undomesticated, forthright and perhaps somewhat reckless. Toward the end of her life, when her international acclaim focused on her hometown, she reminded the Watertown Woman's Club at a reception in her honor, "In my younger days I was not considered an ornament in society."[395]

At the end of her studies, Hosmer chose to pursue sculpture as her profession over acting or writing, both of which were strong interests.[396] With no northeastern medical school that would allow her to study anatomy, training she desperately needed as a sculptor, she called on Wayman Crow for assistance. Crow was able to use his influence on Dr. Joseph Nash McDowell, a fellow Kentuckian who had moved to St. Louis, first to teach at Kemper College; by 1847, he had planned and was in the process of constructing a medical college at Eighth and Gratiot Streets, on the outskirts of St. Louis. Upon completion, Dr. McDowell led the medical college in both praise and rumors.[397]

On November 6, 1850, Harriet Hosmer began her nine months of instruction under the direct supervision of McDowell.[398] She walked alone daily to the college from the Crows' home, a distance of nearly two miles. On these commutes, she took to carrying a pistol in the folds of her dress. St. Louis was not safe for a woman walking alone to the outskirts of town in the mid-nineteenth century. Although she possessed a powerful ally in Crow, McDowell served as a protector. Hosmer reported that, in accepting her as a student, "he tossed back his iron gray hair as he said, 'I told Miss Hosmer she *might* study here, and that if anybody attempted to interfere with her, he would have to walk over my dead body first.'"[399] More than what she learned about the human anatomy needed to create realistic human features in stone, Hosmer benefited from the fact that McDowell already had experience training artists. When he was at the Cincinnati Medical College years earlier, he trained Hiram Powers, the famous Neoclassical sculptor from whom Harriet took inspiration as her skills developed.[400]

In 1850, Hosmer was already controversial for her views, her upbringing, her choice of profession and, later, the question of her sexuality. When it came to controversy, Harriet and Dr. McDowell were well matched. Though revered by many, there were dark rumors about the headmaster of the medical college. The college possessed a reputation for evil, where grave robbery and unorthodox medical experiments were conducted not only by Dr. McDowell's students but often in collaboration with him as

well. It is reported that at least twice, mobs approached the hospital seeking explanation for the disappearance of loved ones from local cemeteries.[401]

McDowell supported slavery and later joined the Confederacy during the Civil War. He also despised Catholicism and its institutions. From his office window, Dr. McDowell could clearly see the Christian Brothers' Academy, a Catholic institution north of the medical college. A student of the academy, Dr. Warren R. Outten, wrote about the mysterious Dr. McDowell: "I can well remember how the brothers viewed him. To them he was a vice regent of His Satanic Majores. Brother Valgen, who was master of dormitory for fifty years, a man of mild, timid, character, if he could see Dr. McDowell a square off, would cross himself and hunt for cover."[402]

The full extent of Harriet's direct experiences with Dr. McDowell remain unclear, whether she participated in the exhumation of bodies for study, but it is well documented that in her childhood, she was acquainted with some medical practices because of her father. As a trained and successful hunter, "her room was a perfect museum. Here were birds, bats, beetles, snakes, and toads; some dissected, some preserved in spirits, and others stuffed, all gathered and prepared by her own hands."[403] There is also evidence that before she trained with McDowell, she studied the human body at the Sedgwick School and was well desensitized by her amateur experiments in taxidermy.[404]

Even though he was both a man of science and a Protestant, Dr. McDowell wholeheartedly believed in the existence of spirits and ghosts. He believed that his mother's spirit had saved his life, and he became an early promoter of Spiritualism, a belief system that Harriet Hosmer appears to have learned of during her training in St. Louis.[405] In one story, Dr. McDowell is reported to have participated in séances with other luminaries of the time. At one séance, the daughter of Senator Thomas Hart Benton was in attendance. Though complete coincidence, it is interesting to note that Senator Benton later played a part in Hosmer's artistic life.[406] Hosmer became a Spiritualist as well following her time in St. Louis, and perhaps more than Dr. McDowell's influence, Spiritualism "held particular appeal for early women's rights advocates, as it allowed them direct communication with God and was free of the sexism and hierarchy they found in the Christian churches. Its staunch commitment to individualism was also a good fit with the civil rights agenda of the early women's rights movement."[407]

Dr. McDowell was possessed of other oddities as well. He was known to wear body armor under his suit and stocked the medical college with at least 1,400 rifles. He designed the college much like a fortress and posted at

least six cannons in the tower, often setting them off, causing loud booms across the town, and yelling "make Rome howl!"[408] These fortifications made it easy to convert the college into a barracks for the Union army at the outbreak of the Civil War and, later, into one of the more-feared Northern prisons as the war raged on.[409] On the subject of the tower, it is reported that McDowell designed "architectural niches...for the purpose of suspending his beloved family members' corpses for preservation."[410] Dr. McDowell also feared thunderstorms so much so that when they struck, "he would crawl under the nearest examination table to hide."[411]

Oddities aside, the medical college was state-of-the-art for the time, with a laboratory, a lecture hall and a dissecting room. Dr. McDowell had a reputation for his immense knowledge, and his effective teaching techniques were among the finest in the world, leading students through "hands-on dissection, lecture and storytelling."[412] Harriet probably felt very much at home in the college museum, which housed mummies, myriad animals and other natural specimens.[413] Although his presence was often a force of nature that struck fear into many, his students "found him to be warm and kind to the people he cared about, and he cared about his students very much. His lectures were legendary, and his appearance was striking and singular."[414]

In August 1851, Harriet Hosmer completed her anatomy training and headed back east to Watertown and Boston to begin her career as a sculptor. To thank Dr. McDowell, some months later, Harriet carved a medallion featuring his portrait and shipped it to him.[415] Wayman Crow was so impressed by this piece that he installed it in the medical school's museum. Culkin wrote:

> *Though Harriet claimed she did not expect the work to receive any publicity, the medallion generated a buzz in the city and beyond. One article, reprinted in the* Boston Evening Transcript *from a Cincinnati paper, offered a description: "The medallion is as large as the natural head, and the features are admirably preserved, whilst the outline is perfect." The same article boasted, "It will compare favorably with the best specimens of the art to be found in the country." The work received so much attention that she eventually teased Corney, "Aren't you heartily tired of hearing about the medallion? I hear you say 'yes.'" Harriet had used her social connections to help her achieve publicity, and her art to publicize her relationship with an influential member of society, setting patterns that she would follow throughout her career.[416]*

In response to the medallion that Harriet carved for Dr. McDowell, he wrote a sentimental response from St. Louis in October 1852:

Dear Hatty:

I have called this evening on our mutual friend J. [the other female student at the college when Harriet was attending] to refresh myself with a sight of a living human body, having run off from the dead ones hoping to recount with her, many of the pleasant hours I spent with you in the college and where there is a great vacuity since you left. The bench you sat upon has never been filled since you were there. I often turn to the spot and think I can see the little Quaker girl in the brown sacque and close-fitting bonnet, and an eye that beamed with pleasure at the exhibition of Nature and Nature's work. J. is sitting beside me, holding one end of the portfolio while I write, and laughing at me for being so old and so sentimental. Dear Hat, I like, not love you, for my poor old heart, that has so often been chilled by the winters of adversity, cannot now love, but could I love any one, it would be the child who has so remembered me as to send me an undeserved monument of esteem, as you have done.

And now let me say to you, that the time may come when you may feel that others should be grateful; if so, let your eyes turn on that lean and hungry looking friend who, as days increase, will have his regard for you increase. We do not know the value of friends until we have lost them. It were best sometimes never to have known them, but, Hattie, I shall never consider you lost to me, unless you shall prove that you have forgotten me. You no doubt have thought me unfeeling, that I have not written, but I shall see you and tell you all; until then, believe my feelings for you are, as ever, pure as Nature and as enduring. Hattie, I have covered the marble you sent me, in white crepe, not to mourn for the loss of a friend, but for the absence of the one who wrought it and to preserve it as pure as the one who gave it to me. Long may you live, my child, long may you be comforted in this cold world by friends; and believe me ever yours,

J.N. McDowell[417]

McDowell was a proud southerner, and once Harriet had achieved worldwide fame after the Civil War, he was "proud forever after that he, a southerner, had given the sculptor Harriet Hosmer the start denied

her by northern medical schools."[418] As previously mentioned, when McDowell joined the Confederacy, the college was seized and converted into Union barracks and then became one of the most notorious prisons in the North. After the war, Dr. McDowell reclaimed the college. He passed away in 1868, but the college continued until 1899, when it joined with the St. Louis Medical College and formed the Washington University School of Medicine.[419]

In the midst of Hosmer's training at the medical college, it is possible that Charles Parsons and Martha Pettus met Harriet upon her arrival in 1850. Although there was one other woman attending the college at this time, Hosmer would have been a bit of a sensation in St. Louis for a number of reasons. She was from an established family in the East, the daughter of a Harvard-trained doctor. She was under the protection and advocacy of one of the most powerful men in the city at the time. She was also embarking on training in anatomy that was, though not completely unheard of, extremely rare in the mid-1850s, especially in the Midwest.

William Grymes Pettus, Martha's father, and Wayman Crow were both members of the business and political elite in St. Louis. It is not clear how their specific businesses intersected in the mid-nineteenth century, but they worked together in organizing commerce in St. Louis and sat on the executive council for the St. Louis Chamber of Commerce; Pettus was the secretary and Wayman Crow was president. Their business interactions were just as numerous as their efforts in local and state politics.[420]

Wayman Crow and William Grymes Pettus lived only a few city blocks from each other in 1850. They both had daughters the same age as Harriet and most likely encouraged socializing among them. Charles's brother Lewis was growing his law practice in Alton, Illinois, and St. Louis at this time. He was Harvard- and Yale-trained and would have been in demand for counsel by men like Crow and Pettus. Even though Charles Parsons stayed in St. Louis less than a year before going to Keokuk in 1851, he would have had ample time to socialize with his brother and the Pettus and Crow families, among other elite households.

Although the Parsonses and Hosmer may have met in 1850–51, their friendship most likely began after 1857, when Charles and Martha were married. They would have known of her due to the publicity and praise she had received for her medallion bearing the likeness of Dr. McDowell and *Hesper, the Evening Star* in 1852—an original bust that propelled Hosmer to new heights in the art world when it was displayed in Boston, a major art center of the time.

In 1857, Hosmer's celebrity continued to rise when she caused a new sensation in St. Louis upon receiving a commission from Alfred Vinton, businessman and chairman of the board of directors of the Mercantile Library, which Wayman Crow helped bring in to existence.[421] The library was in the process of expanding to include an art gallery, and Crow was working in the background to secure a work of art from Hosmer to serve as the gallery's focal point. Hosmer was commissioned to create a statue of sixteenth-century Italian Beatrice Cenci, who had her father murdered after he sexually assaulted her in 1599.[422] Before it came to the Mercantile Library, Hosmer exhibited the piece in London, Boston, New York and Philadelphia. Though not without criticism, she was hailed by some as a master sculptor at only twenty-seven years of age and only having studied for five years.[423] When the sculpture was finally installed in the Mercantile Library, Hosmer was called "a master of her art, a credit to her country, and a role model for her sex."[424]

St. Louis continued to play a role in Hosmer's success as a sculptor. In 1860, she won a commission to create a memorial for Missouri politician Thomas Hart Benton. Although Benton had been a slave owner, he spoke out against the expansion of slavery prior to the Civil War, declaring, "I deem it an evil" and warning that "the harmony and stability of our federal Union" was at stake.[425]

During the same month that Charles and Martha Parsons were on a train over the Alps meeting Heinrich Schliemann for the first time, the statue of Thomas Hart Benton was unveiled in Lafayette Park to a crowd of more than forty thousand on May 27, 1868.[426] It is in this year that direct evidence for the friendship between Harriet Hosmer and Mr. and Mrs. Charles Parsons exists, and it creates more questions than answers.

In 1868, when Charles and Martha traveled to Europe again for the wedding of Martha's sister, Harriet Hosmer had already been established in Rome since 1852. In 1852, she shared a house with the most celebrated actress of the time, Charlotte Cushman, who was known to prefer the company of women over men.[427] Hosmer trained under the famed sculptor John Gibson from 1853 to 1860, and she was living at Via Quattro Fontane no. 26 since 1865.[428] To understand the relationship between Charles and Martha Parsons, an examination of Hosmer's reputation with men and her alleged sexual preferences are important for additional insights. In one account, Harriet Hosmer was respected by men, admired by all women and loved by a select group of special friends.[429]

Famed American British author Henry James (1843–1916) wrote that Hosmer was "above all a character, strong, fresh and interesting, destined, whatever statues she made, to make friends that were better still even than these at their best."[430] Hosmer was dependent on publicity to sell her work, and as scholar Martha Vicinus asserted, "[She] became a kind of living artwork, to be viewed, even shown off, as a national trophy. It was a role that she embraced heartily."[431] Hosmer's commitment to her art and the powerful, masculine manner that set her apart with respect to many social conventions of the time made her a sensation in Rome and further fueled an international awareness of her work.[432] The gossip about Harriet often regarded her "boyish appearance and numerous flirtations with other women," which scarcely caused disdain within her own circles.[433] When they were in Rome together, Harriet's friend and poet Elizabeth Barrett Browning (1806–1861) "was captivated by Hosmer's impetuosity and marked individuality."[434] It was engrossing to Browning that Harriet "could walk the streets at night alone, like a man, but to be a man was too threatening," referring to a prank where Harriet invited some other ladies in her circle to dress as men and parade the streets of Rome.[435]

In Hosmer's time, deep, meaningful relationships between women were not uncommon. Women could choose female partners and live as spouses, and they could maintain partnerships with romantic and sexual dynamics.[436] It is now well documented that Hosmer had many deep and complicated relationships with women during her lifetime, not all sexual. In Rome and in the arts, erotic female same-sex desire was emerging as an accepted aspect of nineteenth-century artistic life. Although the word *lesbian* was not used during this period, the Victorians "recognized and talked about same-sex love between women."[437]

For many years, Harriet used her art as a reason for not marrying, but she was also known to brag about her flirtations with women. She maintained a "reputation as a free flirt until 1867, when she met the widowed Louisa, Lady Ashburton," while she visited Hosmer's studio in Rome.[438] Louisa Caroline Baring (1827–1903) was a Scottish-born patron of the arts. She had been widowed three years prior when she first met Harriet in Rome.[439] As their relationship deepened, Harriet "assumed the role of 'hubby' in her letter to 'my *sposa*,' advising Lady Ashburton on everything ranging from the purchase of furniture and paintings for new homes in Britain to various cures for minor ailments."[440] Furthermore, Harriet worked to seduce Lady Ashburton, promising that "when you are here I shall be a model wife (or husband whichever you like)."[441]

Returning to Hosmer's relationship with Charles and Martha Parsons, she was ever confident in accumulating powerful and famous men and women as friends. These friendships were authentic, but they were also vital to her growth and success as an artist.[442] In the nineteenth century, the societal norms required particular formalities of meeting that are no longer practiced today, especially when meeting someone outside the family, not to mention someone famous as Hosmer. In the case of Mr. and Mrs. Charles Parsons, social practices dictated that both should be present when meeting with Hosmer and that Charles would conduct the majority of the conversation, as was appropriate. Although Charles would have been familiar with Hosmer and her work by 1868, as many of his powerful friends either owned or had assisted in commissioning works by Hosmer, Parsons never purchased one of her works for his collection. If there was a direct friendship between Charles Parsons and Harriet Hosmer individually, there is no extant evidence, but given the following note to Martha Parsons from Hosmer, there is no doubt that some type of relationship existed between Martha and Harriet directly. Although the note is not dated, the address listed and the schedule of the Parsonses' European travels strongly suggests that the year is 1868:

Dear Mrs. Parsons

Thank you for two notes from two particular friends of mine. Now as I want to see you and not make a merely ceremonious visit—which means leaving a card—I propose coming tomorrow (Sunday) evening—Say about 8 1/2 or 9 hoping to find you at home—

Yours very Sincerely
Harriet Hosmer
Saturday evening
26 quattro fontane

This note is far more interesting given what we know today about Hosmer as a person. She could have had a friendly relationship with Martha going back to 1850, when Hosmer was training at the medical college, but there is no surviving correspondence. As discussed earlier, they would have traveled in the same social circles, but there is no hard evidence. All things considered, the relationship between Martha and Hosmer probably never went beyond their connection to the arts. The letter includes a request to

see Martha on short notice late on Sunday evening with no mention of Charles. Martha was a married woman, and Hosmer would likely avoid interfering with a marriage in good standing, especially to someone as prominent as Charles Parsons. Next, Lady Ashburton was involved with Hosmer at this time, and their relationship had been developing for a year. What is delightful about this note from Hosmer to Martha is the tiny glimpse into the relationships of Martha Parsons.

Very little is known about Martha Pettus, partially due to the status of women in the nineteenth century but also because historical documents have, unfortunately, not survived. There is also no known photo of Martha Parsons in any of the historical archives, although it is clear one did exist—Heinrich Schliemann mentioned it in a letter to Charles on November 25, 1883.[443] However, it is clear that Martha was active in high society. She was on the Sanitation Commission Board with all the other wives of powerful men in St. Louis. She hosted lunches and participated in dances and other appropriate gatherings of the time.[444] She was obliged to serve as a chaperone for high-society debutantes traveling to Colorado on holiday.[445] In 1875, Martha was named to the National Women's Centennial Executive Committee for the purpose of furthering the interests of the centennial celebration in St. Louis, along with Mrs. Wayman Crow, Mrs. William T. Sherman, Mrs. Robert Campbell and other notable wives of St. Louis.[446] In 1879, she was the head of the porcelain committee, gathering and installing an exhibition of local collections called *The Secret Treasure of the Private Homes of St. Louis* at the Old Mary Institute building, near Fourteenth Street.[447]

Returning to the letter, to know that Martha was acquainted with "two particular friends" of Hosmer's well enough to pass on two letters from them to her is incredibly interesting. It is also compelling that Hosmer did not mention the other two friends by name in the note to Martha. Whether it was standard nineteenth-century protocol or whether Hosmer was intentionally leaving their names out for other reasons, we will never know. To reiterate, this is not to suggest that Martha Parsons had any kind of relationship with Harriet Hosmer beyond a friendship, but as Vicinus pointed out, "The Victorians were masters of the unspoken and the unsaid, happy to let odd relations, whether hetero- or homosexual flourish as long as no one spoke openly about them."[448]

In the same year of the note from Harriet to Martha, Hosmer came full circle with Wayman Crow when she orchestrated the surprise presentation of a bust of him that she created.

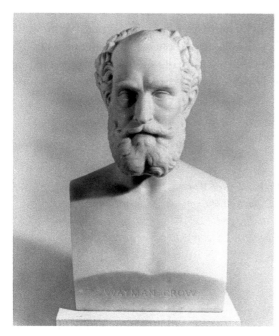

Left: Harriet Hosmer (American, 1830–1908), *Portrait of Wayman Crow Sr.*, 1866. Carrara marble, 25 x 24³⁄₄ x 10³⁄₄ in. *Mildred Lane Kemper Art Museum, Washington University in St. Louis. Gift of the heirs of Wayman Crow Sr., 1868. WU 2061.*

Below: Harriet Hosmer (American, 1830–1908), *Oenone*, 1854–55. Marble, 33⅜ x 34³⁄₄ x 26³⁄₄ in. *Mildred Lane Kemper Art Museum, Washington University in St. Louis. Gift of Wayman Crow Sr., 1855. WU 3783.*

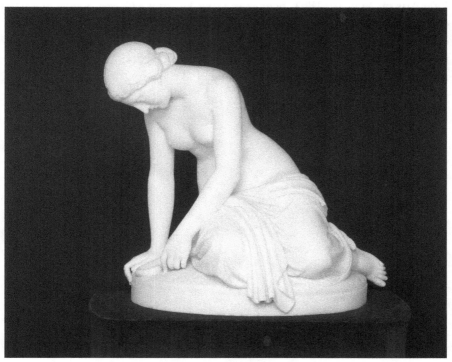

Mr. James E. Yeatman wrote to Harriet, "You may now write, 'Veni, Vidi, Vici.' The day has passed, the bust has been presented, all has gone well."[449] Harriet's fame owed much to the early support of Wayman Crow. Looking back to their early relationship, Harriet wrote to her supporter, friend and father in the arts:

Dear Mr. Crow:

I don't know how I shall ever express to you what I feel for all your fatherly care of me, but this is most certain, that if I ever make anything of an artist, it will be owing to you, for without your most liberal assistance I should be unable to pursue my studies in Rome. Almost all artists have, and have had, a kind patron, and I am sure I may dub you mine....

Affectionately yours,
H.G. Hosmer.[450]

When Crow turned over the deed to the St. Louis School and Museum of Fine Arts on May 10, 1881, he ensured that Hosmer's *Oenone*, a work she had created at his request, was prominently displayed on the first-floor landing just outside the lecture hall, along with his bust, for all to see.[451] Harriet Hosmer was known to say, "I can be happy anywhere with good health and a bit of marble."[452] She passed away on February 21, 1908.

Chapter 9

FRAGRANT CURIOS

A s discussed briefly in the preface of this book, the discovery of the Tokugawa/Edo period (1603–1868) incense burner that was incorrectly labeled as a "bowl" brought me face to face with Charles Parsons and his collection of art and artifacts. This chapter focuses specifically on three objects that Parsons collected related to the incense culture of Japan. Although there are many more objects in the collection tied directly to Japanese incense traditions, these three are the most powerful in their significance and importance to Parsons and his admiration of the culture.

As a student of incense and its history for the past thirty-seven years, it is difficult if not impossible to separate these objects (and my experience of them) from my knowledge of the incense traditions in Japan, as well as how these traditions impacted the warrior, merchant, religious, noble and secular classes of Japan for the past 1,500 years. This chapter unites the past and the present, addressing the historical significance and traditions that impressed Charles Parsons so much that he made these objects a part of his collection, accessible to future generations. In the incense culture of Japan, through the appreciation of incense and the power of fragrance, the past and future merge into the eternal now.

Fragrance—or, more specifically, Japanese artworks dedicated to fragrance as a path of personal and spiritual refinement—is what first drew me to the collection of Charles Parsons in 2007. When Charles died in 1905, there were provisions in his will that his collection would become the property

of Washington University, but only after the death of his nephew, Charles Parsons Pettus.[453] When Parsons Pettus died after a horseback riding incident in 1923, the university took possession of more than 360 art objects, not counting the estimated 80 American and European paintings, and housed them at the City Art Museum, now the St. Louis Art Museum, on permanent loan.[454] It was at this time that the City Art Museum labeled the Tokugawa incense burner as a "bowl."[455]

Other Japanese incense-related objects caught my eye in Charles Parsons's assembled curios. There was a Japanese *kogo* (香合), a round wooden box used to hold chipped incense (*shokoh*), and a curious *okimono* (置物), a carved ivory ornament for display, depicting an incense master with his pupil. In the months that followed this viewing, I found a reference in the museum's deaccession records to a Japanese porcelain cup, known as a *monkoro* (聞香炉), or incense listening vessel, that belonged to Charles and was auctioned off in 1969.[456]

Charles Parsons was keenly aware of his sense of smell, mentioning his perception of this sense numerous times in his world travel chronicle, *Notes of a Trip Around the World in 1894 and 1895*, which was published for private circulation. The white cup and all the other objects mentioned here are related directly to fragrance, incense and self-refinement through the olfactory system when used on a path of self-realization.

THE WHITE PORCELAIN CUP

While in Japan, in either 1870 or on his last trip in 1894, Charles Parsons acquired a white porcelain incense burner to add to his collection. This piece of Satsuma ware, a variety of Japanese pottery that originated in southern Kyushu, in the Satsuma Province, was sold at auction in 1969. This small, unassuming porcelain cup was most likely chosen for deaccessioning for exactly that reason—it was small, contained no overt artistic value beyond providing a fine example of Satsuma ware from the Edo or early Meiji period (1868–1912) and could bring upward of $1,000 to the art fund that Charles Parsons established upon his death for the purchase of art in perpetuity.

Like Marco Polo (1254–1324), who had collected a white porcelain incense burner during his travels in Asia (now owned by the Musée du Louvre, in Paris), Charles Parsons added a central piece of Japanese

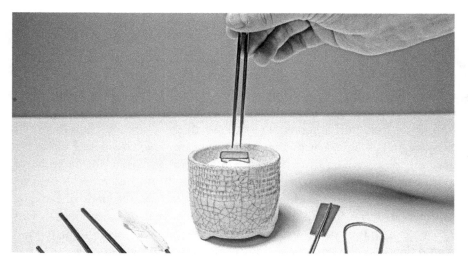

Incense listening vessel (*monkoro*) with metal chopsticks (*kyouji*). *Levi Kirby.*

incense culture to his collection in the late nineteenth century.[457] Parsons's white porcelain cup is known as a *monkoro* (聞香炉), or incense listening vessel, which is used in the Japanese art of "incense appreciation," taught originally to the Japanese by the Chinese about 1,400 years ago.[458] In Japan, participants in an incense ceremony (*kōdō*) do not "smell" the incense. Instead, they are invited to "listen" to the fragrance for what it is communicating to them personally. Paraphrasing from an ancient Buddhist text, Kiyoko Morita, author of *The Book of Incense*, wrote, "Fragrance and incense are synonymous, and Buddha's words of teaching are incense. Therefore, bodhisattvas (Enlightened Ones) listen to Buddha's words, in the form of incense, instead of smelling them."[459] The *monkoro* is a handheld incense burner that allows the participant to bring the incense close to the nose to perform the ancient ritual. The *monkoro* does not "burn" the incense but gently warms a piece of aloeswood (*jinkoh*, *jin* or *aquilaria*) specific to whatever incense ceremony or incense-comparing game is being played.[460] As will be discussed, the *okimono*, which depicts an incense master and his pupil, reveals more about the Japanese incense ceremony and how it relates to the white porcelain cup culturally and philosophically. Both objects were most likely purchased at the same time.

INCENSE MASTER OKIMONO

Parsons's *okimono* depicts an incense master (*koumoto*) and his student (*cohei*) preparing the *monkoro* and reading from an ancient text. The term *okimono* means an "ornament for display," and though similar to a *netsuke*, it is larger. *Netsuke* emerged in the seventeenth century when kimonos were the traditional fashion. Kimonos did not have pockets, and individuals would carry their belongings with them in pouches or carved boxes called *inro*, which held everything from medicine to tobacco or even a powdered hand incense called *zuko*. In order to suspend an *inro* from the kimono's belt, or *obi*, *netsuke* were used as anchors. *Netsuke* are tiny sculptures made of bone or ivory that are pierced with small holes, called *himotoshi*; the user could thread a cord through the holes, connect the *netsuke* to a pouch or *inro* and then hook it onto the *obi*. Bone or ivory sculptures without such functional features are known as *okimono*, and they are usually larger than *netsuke*.[461] Therefore, an *okimono* is purely decorative and treated as an objet d'art.

A number of distinctions are needed to understand the significance of Parsons's *okimono* as an homage to the incense culture of Japan. Beginning with the student, he is shown reading from the work of Mencius (372–289 BCE),[462] a fourth-century Confucian philosopher born a century after Confucius. This "Second Sage" of Confucianism is best known for his teaching that "human nature is good."[463] The influence of Chinese thought on the Japanese extends back to the Tang Dynasty, when philosophical and cultural exchange between the two countries was at its zenith.[464]

In line with Japanese incense tradition, Mencius was concerned with refinement of the self and spirit through benevolence, righteousness, wisdom and civility. Bryan Van Norden stated, "As Mencius puts it: 'People all have things that they will not bear. To extend this reaction to that which they will bear is benevolence. People all have things that they will not do. To extend this reaction to that which they will do is righteousness. If people can fill out the heart that does not desire to harm others, their benevolence will be inexhaustible. If people can fill out the heart that will not trespass, their righteousness will be inexhaustible.'"[465]

The incense master of the *okimono* is dressed in traditional Japanese garb and appears to be of the Shino School of incense study, given his samurai appearance and use of codified manuals. The Shino School was followed by the warrior class during the Edo period. Although around ten schools of incense emerged in Japan, by the Edo period there were only two schools remaining: the Shino School and the Oie School. These two schools were

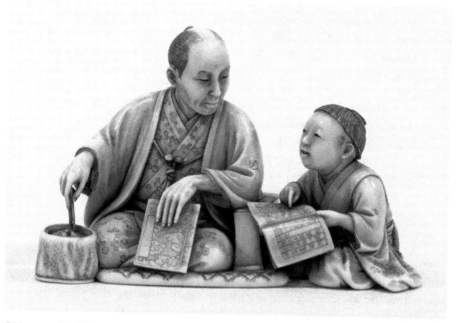

Okimono of a Shino incense master and his pupil, Japanese, Edo period (1603–1868). Carved ivory, 2⁷/₁₆ x 3⅜ x ¹¹/₁₆ in. *Mildred Lane Kemper Art Museum, Washington University in St. Louis. Bequest of Charles Parsons, 1905. WU 1133.*

attributed to founders Shino Soshin, who emphasized a warrior's mindset focusing on strict rules and spiritual attainment, and the Oie School master Sanjonishi Sanetaka, who emphasized courtly games and the development of the individual's pneuma.[466]

In his left hand, the *koumoto* holds an incense manual with a smoke pattern adorning its cover, likely symbolizing the *Kun shu rui sho (Incense Collector's Classifying Manual).*[467] In his right hand, he holds a pair of metal chopsticks called *kyouji*, which were used by the Shino School of incense to move the hot charcoal into place, submerged in a bed of rice ash.

In this sculpture, the *koumoto* is nearly finished preparing a *monkoro*, not unlike Parsons's white porcelain cup. The ash inside the vessel has been pushed together to form a tiny mound, and the master holds a pair of chopsticks, indicating that the hot charcoal has been placed inside the mound of rice ash and the vessel is ready to receive a mica plate to hold a small piece of aloeswood incense that, when warmed, will begin the incense "listening" process. As my incense teacher taught me before her death:

[I]magine you are the incense providing value to others. When you are warmed up, and fully being your fragrant self, there is no smoke to obscure your benefit to others; there is only pure fragrance, your full essence invigorating others. The smoke is your delusion, your unenlightened self, getting in the way of your True nature. This is the Way of incense—to be fully your fragrant self with no obstructions or falsities. The Way of Incense is a path to mastery, as are all the "-do" arts of Japan, like Chado *(The Way of Tea),* Kyudo *(The Way of Archery),* Aikido *(The Way of Harmonizing Energy), and* Kado *(The Way of Flowers), among many other paths up the mountain.*[468]

PARSONS'S TOKUGAWA INCENSE BURNER

Although the *monkoro* and *okimono* provide insight into the incense culture of Japan and the awakening that is possible when studying this path, they do not compare to the value of Charles Parsons's incense burner for revealing the possibilities. This exceptional work of religious art tells the tale of enlightenment through incense, with the blessing of the Tokugawa regime, that is related to a specific festival of casting out evil while deeply honoring the tradition of the Buddha and his disciples.

Parsons worked through his antiquities agent, Peyton Sanders, to acquire an impressive collection of Japanese swords, Buddhist statues, *netsuke* and *okimono*, as well as numerous examples of Satsuma, Makuzu, Kutani and Old Kyoto wares.[469] The Tokugawa incense burner was most likely acquired by Parsons himself during his second journey to Japan in 1894, when he visited the shops of master craftsmen such as porcelain painter Yabu Meizan and celebrated cloisonné artist Namikawa.[470] In his chronicle published in 1896, *Notes of a Trip Around the World in 1894 and 1895*, Parsons instructed his reader in the purchase of Japanese curios: "It is very important to take good advice in the purchase of Japanese curios, the great majorities of goods offered are not of the sort that one wants, and the lot of such goods generally brought to our interior cities are made to sell cheap and most of them are of no artistic value. Really good things are rare and cannot be had without exercise of good judgment and paying well for them."[471]

Marked with keen observations during his world travels, Parsons's writings point to a particular interest in Japan, specifically the samurai culture of the Tokugawa shogunate. When Parsons made his first journey

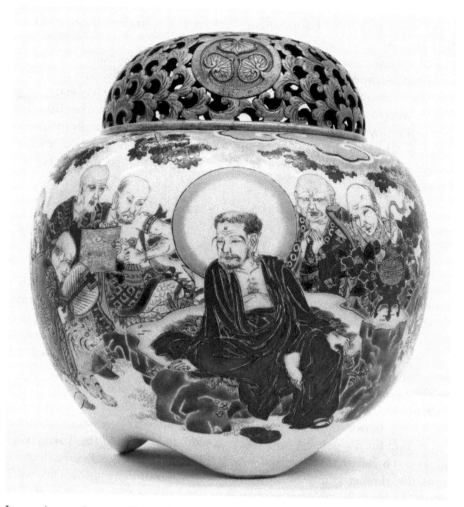

Incense burner, Japanese, Edo period (1603–1868). Satsuma ware; porcelain and bronze, 6½ x 5⅛ in. (diameter). *Mildred Lane Kemper Art Museum, Washington University in St. Louis. Bequest of Charles Parsons, 1905. WU 99.*

to Japan in 1876, only nine years had passed since the fall of the Tokugawa government. Returning to Japan in 1894, Parsons and his nephew, Charles Parsons Pettus, visited the graves of shogunate founder Tokugawa Ieyasu and Tokugawa Iemitsu, the third shogun of the dynasty and grandson of Tokugawa Ieyasu, during their visit to Nikko. Parsons commented, "This is the celebrated place where are buried two of the greatest Shoguns or Tycoons as we call them—Ieyasu and Iemitsu."[472] As a colonel in the Union

army and a successful businessman, Parsons felt a kindred connection to these masters of war and state.

The incense burner measures 6½ inches in height and 5⅞ inches at its widest. Although it may have originally been created with a pedestal, only the Satsuma-form body and lid remain. The body is beautifully glazed with a Tang Dynasty (618–906 CE) depiction of the Buddha surrounded by his most devoted followers, known as the *Arhats* in India, *Lohans* in China and *Rankan* in Japan; they extend around the body of the burner, creating a landscape of Buddhist imagery that relates directly to the importance of incense.[473]

THE LID

The intriguing, functional design of the incense burner begins with the exquisite craftsmanship of the bronze lid; the crown pattern of dotted clouds blend into what may at first seem to be a perforated filigree pattern. Spaced evenly around the side of the bronze lid are three Tokugawa *mons* (crests), emblems used to identify an individual or family. These three *mons* appear to float on the surface of the perforated pattern of the lid.

The open-metalwork lid of the burner allowed smoke to rise up from the smoldering incense on a rice ash base in the belly of the Satsuma body. While the perforations of the lid accommodated the vessel's function, inspiration for the pattern is revealed in the family crest of the Tokugawa. This crest is called *Maruni Mitsuba Aoi* and features a design of three flowers from the *Asarum* genus of flowering plants, commonly known as wild ginger. In English, the crest is often described as the "triple hollyhock."[474] When the individual, recurring designs on the lid of the incense burner are combined, they form a pattern that resembles leaves. The individual pattern element on the lid of Parsons's burner is a folded wild ginger leaf that, when repeated, connects the Tokugawa *mons*.

The iconography on the lid links the burner not only to the Tokugawa but also a yearly festival intended to cast out evil: *Setsubun*. Meaning "seasonal division," *Setsubun* is held on the third or fourth of February, one day before the start of spring, according to the Japanese lunar calendar.[475] Although not a national holiday, *Setsubun* honors a centuries-old tradition of performing rituals to cast out evil spirits at the start of spring.[476] Although these ceremonies may employ incense, they are most commonly

performed with the throwing of roasted soybeans around the home and at temples and shrines across the country.[477] When throwing the beans, known as *mame maki*, the person performing the cleansing ritual shouts, "*Oni wa soto! Fuku wa uchi!*" ("Demons away, happiness in!").[478] At the end of the cleansing ceremony, the person who performed the ritual eats the number of beans corresponding to his or her age.[479]

The work of *ukiyo-e* painter and printmaker Katsushika Hokusai (1760–1849), perhaps best known for his woodblock print series *Thirty-Six Views of Mount Fuji*, unlocks the iconography of the cloud pattern at the crown of the lid and artistically links the Tokugawa shogunate and the *Setsubun* festival to the incense burner.[480] Hokusai gained widespread fame with the 1814 release of his fifteen-volume sketchbook, *Hokusai Manga*.[481] This manga (whimsical images) would have been very familiar to the artisans of the late Edo and Meiji periods, as illustrators often copied Hokusai's work.[482] The print *Setsubun Oni* (Changing of the Seasons and the Exorcism of Evil Festival) provides a guide to link the incense burner with both the Tokugawa shogunate and the *Setsubun* festival.

Hokusai's *Setsubun Oni* prominently displays a samurai warrior, identified by his partially hidden long katana sword and muscular forearm, casting out a demon (*oni*). His kimono is distinguished by the turtle pattern of his raised right arm under his top layered *kashimono*.[483] The two-piece top layer is identified with formal samurai dress and provides the pattern that connects the incense burner to the ruling Tokugawa warrior class and the *Setsubun* festival. An identical cloud pattern present on the crown of the incense burner repeats on the *kashimono* of the samurai.

Hokusai's samurai has been depicted to resemble and conjure the power of *Shōki* the demon queller, who is persistently portrayed as a bearded figure of large stature, dressed as a Tang Dynasty Chinese scholar with black boots, either defeating or controlling a host of demons.[484] In Hokusai's rendering, all the elements of *Shōki* the demon queller are present, with the exception of Chinese robes that have been replaced with traditional Tokugawa samurai garb and black boots that are not visible due to the design of the *hakama*. A comparison between Hokusai's *Setsubun Oni* and the image of Hokusai's *Shōki and a Demon* make the connection apparent. The removal of demonic forces was very real and important to the Japanese psyche.

MAIN BODY: FORM AND FUNCTION

In all cultures that burn incense, numerous variations of burners emerged, whose forms and designs depended on their functional use. Near Eastern burners could be stationary or portable; there were hanging and swinging censers and even spherical burners employed for scenting the body and clothing.[485]

Both China and Japan have a tradition of three-legged, stationary incense burners. Traditionally, in China, the burner would be oriented so that two legs are at the front when in use, but in Japan it is one leg. Therefore, the leg orientation of a burner can be a first step in determining the country of origin. In the case of the three-legged, stationary form of Parsons's burner, it was most likely placed on the altar of a private residence or in the private chambers of a palace or household. When this burner is positioned with one leg forward, the image of the Buddha is at the forefront. To the Buddha's left and right, around the body of the burner, are his sixteen most enlightened disciples, situated in a natural terrain, dressed in traditional Buddhist attire and engaged in rituals employing incense, sutras and other Buddhist implements.

The *Rankan* tradition in Japan is attributed to the founder of Esoteric Tendai Buddhism, Saichō (767–822 CE). Saichō brought the traditions of Esoteric Buddhism back with him from China but was not the only monk to do so. Kūkai, also known as Kobo Daishi, founder of Esoteric Shingon Buddhism, did that same around 806.[486] A connection between the Tokugawa shogunate, Parsons's burner and Esoteric Buddhism is found in the iconography on the main body.

INCENSE

The use of fragrant, burned material may have emerged moments after the advent of fire, with archaeological evidence suggesting its human use beginning thirty-five thousand years ago, but in Egypt, incense use was first recorded in the Eighth Dynasty (1580–1350 BCE).[487] Incense is any natural material that produces a fragrant odor when burned and can include seeds, fruits, woods, barks and resins.[488] Turning to Japan, in 551 CE, during the reign of Emperor Kinmei (r. 540–71 CE), Buddhism and incense burning were introduced from Korea.[489] Literary works of the Heian

period (794–1185) in Japan consistently refer to the use of incense, like the classic Japanese novel *The Tale of Genji* (*Genji monogatari*).[490] Moreover, Silvio Bedini, an authority on Chinese and Japanese incense-burning traditions, stated that the Japanese Imperial court worked diligently to emulate the Chinese aristocracy and adopted their incense traditions as well.[491]

Classification of incense in Japan is recorded in numerous centuries; one example is the *Kun shu rui sho* (Incense Collector's Classifying Manual), which was important between the tenth and fifteenth centuries.[492] More than the classifications of differing incenses, with emphasis on varieties of aloeswood, was the emergence of distinct burning practices. Two traditions of incense burning emerged in the Heian period that satisfied the duality of Japanese religious and secular life and gave rise to myriad incense-burning techniques: *sorodaki* (empty burning) and *sonae-koh* (incense offering to Buddha); these traditions continue to the present day.[493] Any incense that was burned for enjoyment—to compare various qualities of aloeswood, as in the *Kōdō* ceremonies, or simply for the scenting of a room, clothes or hair—that did not involve an offering to Buddha was considered *sorodaki*.

Parsons's burner can be classified as a *sonae-koh* burner. Given the iconography, the superb craftsmanship and the connection to the ruling class of Japan, only the finest varieties of historically significant Buddhist incense that were natural and considered useful for healing mind and body would have been utilized. Although a chemical analysis of the resin markings on the incense burner has not been performed, the color strongly suggests that only two primary types of wood incense were burned: the finest heartwood, sandalwood, and one of the nine *aquilaria* species, known as aloeswood.[494]

There are most likely two ways incense was burned by the original owners of Parsons's burner. The first may have been to place glowing bits of charcoal on an ash bed and then apply pieces of chipped incense (*shoko*) directly to the coals or on top of a light dusting of ash to slow the burn time. The resin markings on the interior indicate that the burner was filled nearly to the top with ash. Incense ash is not merely a medium to safely burn fragrant material; it also holds great philosophical significance because it represents impermanence and merit and is therefore never discarded. The height of the ash bed lends credibility to the charcoal theory, but other evidence, such as the resin markings, seems to indicate the use of a powdered trail of incense, similar to patterns used in Chinese and Japanese "incense seals." These seals were used as a rudimentary means of timekeeping in ancient China that was employed in Japan for specific practices of certain Buddhist sects.[495]

One possible pattern used in this burner may have been the incense seal of Avalokitésvara, which is also linked to the Tokugawa shogunate and Esoteric Buddhism.[496] According to Mahayana Buddhism, Avalokitésvara was a bodhisattva (enlightened one) who vowed to listen to the prayers of all sentient beings and postpone his own transition into Buddhahood until all beings have achieved a state of nirvana.[497] The resin markings on the rim of Parsons's burner and the underside of the bronze lid are light golden-brown in color, indicating that only wood incense was burned. Although wood incense does contain resin, heavy or pure resin incense such as frankincense, myrrh, benzoin or musk would have turned the underside of the lid and exposed walls of the Satsuma body a blackened, reddish color.

Before moving on to a discussion of the Buddhist iconography on the burner itself, it is important to discuss the purification beliefs of incense that not only support Buddhist use of incense but also link the burner to use in rituals, such as *Setsubun*, intended to cast out evil. In numerous cultures, incense has been used to purify or expel evil. All early civilizations attributed illness and misfortune to nefarious ghosts, devils or evil forces that could be "smoked out."[498]

By the seventh century CE, secular incense burning in the homes of the wealthy was commonplace in Japan. As many as twenty-four varieties of incense such as sandalwood, aloeswood, kara-mokkoh, cassia and cinnamon, conch shells, musk, myrrh, star anise, benzoin, patchouli, rei-ryokoh, cloves, frankincense, kansho, Borneo camphor and haisokoh were utilized.[499] When these ingredients are viewed medicinally, they all possess healing and antiseptic qualities. If the household were Buddhist, incense would have already been present in the home for numerous privately practiced religious rites and occasions. These occasions could attract large numbers of people, and separate from its religious significance, the incense would have offset disagreeable smells resulting from primitive sanitary practices.[500] Sanitary and religious practices combine when we consider the Buddhist tradition of burning incense "in the presence of a corpse so that the fragrance will shield the body and the liberated soul from evil demons."[501]

It is well established that incense burning is constant in Buddhist traditions and that types of incense exist to perform numerous purification rites. There exists even for Japanese Buddhist priests a form of incense that is intended to purify but not be burned, known as *zukō*.[502] The incense powder is rubbed between the hands to scent and purify them before ritual. The application of *zukō* by the Buddhist priest, also practiced extensively by the layman, begins an understanding of personal responsibility on the part of the practitioner to purify oneself. To illustrate, Casal wrote,

"Buddhism does not know the swinging censor, such as employed by the Catholic Church (and the ancient Aztecs), and is not always the priest who censes, by mostly the worshipper himself."[503] The responsibility of the worshipper of Buddhism to cense or purify himself by numerous means, coupled with the belief that incense is the teaching of the Buddha leading to Enlightenment, not only explains why incense burners are so prevalent in Buddhist worship but also provides insight into how the original owners thought of and employed Parsons's burner.

MAIN BODY: ICONOGRAPHY

The primary iconography on the body of the incense burner represent the personal disciples of the Buddha whom he commanded to remain alive in this world until the arrival of the future Buddha, Maitreya.[504] About the year 880, an artist named Kuan Hsiu created images of the Sixteen *Rankan*, given to a Buddhist monastery (on Mount T'ien-t'ai) near Ch'ien-t'ang in the province of Chekiang. These became celebrated and were preserved with great care and treated with ceremonious respect.[505] The Buddhist monastery on Mount T'ien-t'ai, where the paintings of the Sixteen *Lohan* were believed to be given, is the monastery where Saichō and Kūkai were initiated into Esoteric Buddhism and would bring back with them the traditions of the Sixteen *Rankan*, named so in their native Japanese.[506]

Having established that the monks Saichō and Kūkai introduced the Sixteen *Rankan* to Japan around 806 CE, we can connect the burner's iconography to esoteric traditions of Buddhism and the Tokugawa. There existed a great competition between the two monks when they returned to Japan from China and began spreading their respective ministries. When the Tokugawa came to power in 1603, nearly eight hundred years had passed between Saichō and Kūkai's introduction of Esoteric Buddhism, and both their doctrines were well practiced by the population of Japan. The Tokugawa would have been wise to keep relationships and understanding of certain rituals present that were practiced by both Saichō's Tendai sect of Buddhism and Kūkai's more popular and powerful Shingon sect of Buddhism during their reign. The Tokugawa appear to have done just that.

The Tokugawa shogunate favored a Shingon Monk named Jōgon (1639–1702), who was a noted scholar and gifted calligrapher.[507] Jōgon studied the Siddham (*bonji*) script, a "branch of esoteric science" introduced by his

sect's founder, Kūkai.[508] Jōgon was highly respected among his peers and lectured on the subject in the temples of Koyasan, the center of Shingon Buddhism.[509] His unique skill set would have brought him face to face with the pattern of the incense seal of Avalokitésvara and other types of seals and patterns. Bedini said, "The incense seal can be traced to a feature of the Tantric ritual described in one of the Tantric scriptures, rendered by Amoghavajra into Siddham script from the Sanskrit, entitled 'The [Incense] Seal of Avalokitésvara Bodhisattva.'"[510] The story of Jōgon illustrates the connection of the Tokugawa to Esoteric Buddhism. Moreover, the story demonstrates how Parsons's burner, intended to burn incense on a bed of ash, was most likely utilized during the Edo period.

We have established that incense is Buddha and Buddha is incense; the Sixteen *Rankan* by virtue of their enlightened nature are considered incense, as is the Buddha. Although their fragrant nature is accepted philosophically in Buddhist belief and practice, the influence of incense extends beyond the iconography of the Buddha and his *Rankan*, linking incense to historical achievements of the Tokugawa shogunate and the deep traditions they practiced within *sonae-koh* and *sorodaki*. Further study of each of the *Rankan* will continue to reveal the message of enlightenment, but the current findings connect the lid and body of the incense burner, demonstrating not only the skillfulness of the maker but also the true cultural and historical value of Parsons's burner.

CONCLUSION

There is no doubt that Parsons's incense burner was created during the Edo period. Its iconography tells the tale of Enlightenment through incense with the blessing of the Tokugawa regime, as well as the casting out of evil linked to the festival of *Setsubun*, and honors the tradition of the Buddha and his disciples.

Parsons's fragrant curios, now in the collection of the Mildred Lane Kemper Art Museum, provide insights into an esoteric world of personal revelation and spiritual understanding through fragrance. Where the Japanese incense ceremony and the tea ceremony were once performed together as a single experience, but now are performed separately, the fragrant objets d'art that Parsons collected have been separated from their source culture. It is up to us to reconnect these objects with their original intentions, to be inspired today and to inspire future generations.

Chapter 10

PARSONS'S MUMMIES

In 1894, during his trip around the world, Charles Parsons visited the Egyptian Museum in Cairo and met with Émile Brugsch (1842–1930), an assistant curator there.[511] His intention was to purchase two mummies that he could donate to Washington University in St. Louis for study and display to the public. Parsons had an interest in Egyptian culture and mummies going back as far as 1879, when C.A. Wellington of Boston wrote a letter to Parsons, dated September 15, about purchasing artifacts:

> We guarantee the genuineness of the pcs. [pieces] and will send the little mummy on also if desired with the pcs. of mummy cloth still on it, which you may remember. We received the pottery from a gentleman now in Paris; we have sold a few pcs. to the Art Museum of this city & the (Agassiz) [word crossed out here] "Museum of Comparative Zoology" at Cambridge, you can present them to the illustrious Dr. Schliemann with nothing but a sure feeling of their authenticity. The price of the pcs. is $15.00 each.
>
> Very truly yours, C.A. Wellington[512]

It appears as though Parsons, along with C.A. Wellington, had seen the pottery and the small mummy in person in Boston; this suggests that Parsons found it necessary to negotiate the deal directly instead of through his antiquities dealer, Peyton Sanders. Likewise, Wellington is aware of Parsons's

relationship with Heinrich Schliemann. There is no evidence, however, that this "little mummy" was ever sent to Charles Parsons, but the letter does give us insight into his early interest in ancient Egypt.

Although Parsons was not able to purchase mummies in Cairo in 1894, he did so in 1896, buying two mummies from Émile Brugsch and shipping them to St. Louis: the coffin and mummy of Henut-Wedjedu (1391–1350 BCE) and the coffin and mummy of Pet-Menekh (400–300 BCE).[513] Brugsch was a man who, along with his elder brother, Heinrich Ferdinand Karl Brugsch (1827–1894), had enjoyed an expansive career in the discovery and stewardship of Egypt's history.[514] Although the brothers contributed to the field of Egyptology for more than sixty years, their legacy is controversial. Both were given the Turkish honorary title of "Bey" (lord or master) and then later "Pasha," a title similar to that of a British knight. Since the two brothers held the same titles, their specific contributions are often conflated. Thus it is difficult to determine who is the "the good Brugsch" and "the bad Brugsch," as they became known colloquially.[515]

Émile Brugsch was considered a major authority on Egyptology at the time Parsons met him, but there is no confusing which Brugsch Parsons met because Émile's elder brother, Heinrich, had already left Egypt. Heinrich was born in Berlin in 1827. As a child, his love of Egyptian artifacts first developed from his visits to the Berlin Museum. Heinrich's interest in Egyptian culture attracted the attention of Guiseppe Passalacque (1797–1865), the curator of the Egyptian collection at the Berlin Museum, as the boy displayed a stunning ability for translating the Egyptian demotic writing system.[516] At age sixteen, he began work on what would become his *Scriptura Aegyptiorum demotica ex papyris et inscriptionibus explanate*, published in 1848. This was the same year that he entered the University in Berlin. After studying in Paris and other locations in Europe with Egyptian collections, he was awarded a PhD from the University of Berlin, gained employment in the Prussian government and was sent to Egypt in 1853. There he formed a lifelong friendship with Auguste Mariette (1821–1881).[517] Mariette was a French archaeologist who, among other contributions, discovered the Serapeum at Saqqara, a necropolis near Memphis that was also a burial place for Apis bulls, the sacred bulls believed to become immortal after the death of the god Osiris.[518] This site connects to Henut-Wedjebu as the oldest burial dated to the reign of the pharaoh Amenhotep III, who reigned in the 1350s BCE.[519] Heinrich worked with Auguste to translate many of the hieroglyphs in the Serapeum.[520]

In addition to his contributions to Egyptology, Heinrich Brugsch served as the Prussian ambassador in Cairo, was a professor of Egyptology at the University of Göttingen and then returned to Egypt in 1870 to become the director of the School of Egyptology in Cairo; he achieved the title of Pasha in 1881.[521] As Dennis C. Forbes wrote:

> *Heinrich Brugsch's contributions to Egyptology were so wide-reaching that many of his contemporaries classed him with Champollion, Lepsius, etc., as one of the founding figures of the discipline. His greatest strength, however, was the ancient Egyptian language, and he was certainly a pioneer in the study of Demotic. Brugsch recognized the Semitic side of Egyptian grammar, thus enabling a far more comprehensive and systematic understanding of hieroglyphs. His body of published work amounts to many volumes and thousands of pages, covering a broad range of topics: hieroglyphic and demotic scripts and texts, the Egyptian calendar, mythology, historical biography and geography, and architecture. He died in Charlottenburg on September 9, 1894.*[522]

Heinrich's brother, Émile Charles Albert Brugsch, was born in Berlin in 1842 and did not join his brother in Egypt until 1870.[523] Apparently due to failures in other lines of work, Émile traveled to Egypt at age twenty-eight to assist Heinrich at the School of Egyptology.[524] Like his brother, Émile made Mariette a mentor and worked under his direction as assistant conservator at the Boulak Museum and the Egyptian Museum in Cairo, where he was employed for more than forty years until he retired in 1914 at age seventy-two.[525] Émile, like his brother, was promoted to Bey and then Pasha for his service. Forbes wrote:

> *As a photographer, Émile took the first pictures of the royal mummies, published by Maspero as the plates to his 1881 La Trouvaille de Deir-el-Bahari. Brugsch later photographed these same mummies again for G. Elliot Smith's Catalogue Général 1912 volume, The Royal Mummies. Émile Brugsch's chief claim to fame came about in mid-1881, quite by the accident of his superior Gaston Maspero's absence in France when word came from Luxor that a cache of royal mummies had been found there. With two other Boulak Museum assistants, Brugsch went straightaway to the site, claimed it for the Antiquities Service and proceeded to have the cache-tomb hurriedly cleared of its some forty royal and anonymous mummies. The rescued royalty were loaded on board the Museum steamer*

and taken to Cairo and Boulak. Impatiently awaiting Maspero's return to Egypt, Brugsch unwrapped the mummy of Thutmose III, for which he received the Frenchman's upbraiding. Émile Brugsch retired to Nice (in France), dying there on January 14, 1930.[526]

It is generally accepted that Émile Brugsch was the "bad" Brugsch because of the preceding incident and for his involvement in the sale and transport of ancient Egyptian artifacts to buyers all over the world versus his brother, whose academic contributions dwarfed those of Émile.

THE COFFIN AND MUMMY OF PET-MENEKH

The mummy of Pet-Menekh has been identified as a male priest who lived during the Ptolemaic period (fourth–third century BCE) and was discovered in 1885 at the necropolis of Akhmim, near the ancient town of Ipu on the Nile River. The man who was Pet-Menekh possessed an imposing stature of about five feet, six inches in height. When he died, Pet-Menekh was middle aged and most likely died of a "soft tissue disease."[527] Pet-Menekh was a priest of the god of fertility and sexuality known as Chem/Khem, or Min. The god is often depicted with black skin (the word *Chem* means "black"), a color associated with the fertile, black soil of the Nile.

Pet-Menekh's coffin is well preserved and typical of the period in which he lived. The hieroglyphs on the coffin identify his name and family lineage and show his journey into the afterlife. Also shown is Pet-Menekh making offerings to the god Osiris and having his heart weighed before the god, determining if he is worthy of entering the afterlife.[528]

Pet-Menekh's coffin does offer some unique features on the underside of the lid. There are inscriptions that surround the image of Nut, the sky goddess, that appear to have been copied from royal inscriptions more than one thousand years prior. Although Pet-Menekh's scribe was a superb scrivener, he did not fully understand what he was copying onto the coffin. A full translation is impossible, as many of hieroglyphs were copied in complete error. It is clear, though, that Pet-Menekh had been an important priest for a significant temple, evident in the utilization of ancient texts to create an expensive coffin.[529] Different from Henut-Wedjebu, Pet-Menekh's brain had been removed during the mummification process—a practice that was adopted after Henut-Wedjebu's time.[530]

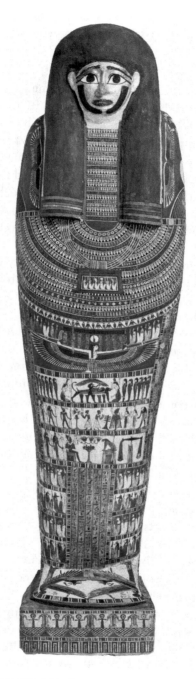

Coffin and mummy of Pet-Menekh, Egyptian, Ptolemaic period, fourth–third century
BCE. Polychrome painted wood, 71¼ in. (length). *Mildred Lane Kemper Art Museum,
Washington University in St. Louis. Bequest of Charles Parsons, 1905. WU 3600.*

The Coffin and Mummy of Henut-Wedjebu

Henut-Wedjebu was known as the "Mistress of the House, Songstress of Amun." She was a singer at the Temple of Amun, in Karnak, during the reign of the pharaoh Amenhotep III (1390–1353 BCE). As such a songstress (*shemayit*), she would have been a member of the highest levels of society.[531] In 1896, French Egyptologist George Daressy discovered her unassuming tomb that belonged to a scribe named Hatiay, which contained four coffins in total. The two largest and most sumptuous coffins belonged to Hatiay and Henut-Wedjebu, who was perhaps his wife. The other two belonged to women named Siamen and Huy.[532] Although it is not known if Parsons purchased other items from the tomb, it is reported that the coffins contained jewelry and other accoutrements.[533]

The coffin and mummy of Henut-Wedjebu are very rare for a number of reasons. There are only eight known gilded mummies from the New Kingdom period, which spanned from 1550 to 1080 BCE.[534] Of those eight, Henut-Wedjebu is the only example in the United States and also the only nonroyal individual; the others reside in Egypt.[535] To gild a coffin in the New Kingdom period required special permission from the pharaoh, and even though she was not royalty, Henut-Wedjebu received such treatment.[536] The other seven coffins were made for queens or kings. To be remembered in gold speaks to the importance of her contributions as a singer, not to mention the physical beauty she must have possessed for the makers of her coffin to provide such detail and lifelike qualities.[537] The care and meticulousness of the modeling of the coffin is evident in the inlaid eyes and raised breasts. As mentioned, Henut-Wedjebu's brain is still in her skull, which is in accordance with the mummification processes of the time.[538]

Henut-Wedjebu's relief work showcasing her hieroglyphics is of the finest surviving examples outside Egypt. In total, twenty-three hieroglyphic texts display excerpts of the Book of the Dead. Gods that are represented are Nut, Nephthys, Isis, the four sons of Horus and Anubis.[539] Her coffin is on par with other examples of nonroyalty that used the Valley of the Kings as their final resting place.[540]

The mummies that Charles Parsons acquired in 1896—then donated to Washington University in St. Louis for display in the St. Louis School and Museum of Fine Arts—are in many ways a fulfillment of the spiritual aspirations of ancient Egyptians.[541] Sharing a translation of one of the breastplate inscriptions on Henut-Wedjebu's coffin sheds light on this fulfillment: "O my mother Nut (goddess of the sky), stretch yourself over

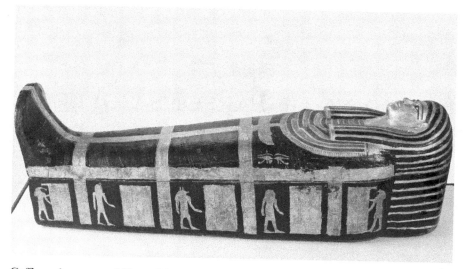

Coffin and mummy of Henut-Wedjebu, Egyptian, Eighteenth Dynasty, 1391–1350 BCE. Wood, bitumen and gold, 72¼ in. (length). *Mildred Lane Kemper Art Museum, Washington University in St. Louis. Bequest of Charles Parsons, 1905. WU 2292.*

me, that I may be placed among the imperishable stars which are you, and that I may not die."[542] Perhaps the millions of people who have viewed these mummies and the scholarship to understand them is the fulfillment of the incantations carved on these treasures of the ancient Egyptian world. More than the fulfillment of spiritual intention, the mummies are a part of Charles Parsons's legacy and his own immortality.

Chapter 11

FOUNDING OF PARSONS COLLEGE

W hen Charles Parsons's father passed away in Detroit, Michigan, at
the home of his son Philo in 1853, Charles was living in Keokuk,
Iowa.[543] Charles's father had spent months visiting his son in Keokuk before
leaving to explore the Iowa countryside.[544] During his travels, he made large
purchases of land that, after his death, contributed to his dream of starting
a Christian college in the Midwest.[545] He believed that the state would grow
in the years to come, so Parsons Sr. invested in it by buying thousands of
acres in Jasper, Worth, Polk, Hancock and Cerro Gordo Counties at $1.50
per acre.[546]

In 1925, fifty years after the founding of Parsons College, Willis Edward
Parsons, the eldest son of George Parsons (Charles's younger brother), wrote
about Parsons Sr.'s motivations for creating the institution:

> *Parsons College grew out of a strong conviction that such an institution
> was needed in the development of Iowa and the Middle West. As
> one remembers that William College was founded at Williamstown,
> Massachusetts, the place of his birth, in 1793, the year the Founder of
> Parsons College was born, a fascinating suggestion emerges: Did Mr.
> Parsons receive an inspiration from that event? There was the same high
> idealism and self-sacrifice, the same forward look, in the one case as
> in the other. Whatever be the exact facts as to the germ of the idea, we
> find that the will setting aside the major portion of his estate to found a
> Christian College was written in 1855.[547]*

The image of Lewis Baldwin Parsons Sr. from the first chapter of this book is one of a man resolute in his faith and of a strong conviction to share it. In the 1830s, he had already founded the Gouverneur Academy in Gouverneur, St. Lawrence County, New York, a college preparatory school.[548] As an illustration of his faith and high idealism, one anecdote records that "on a page of the old family Bible, in the middle of the book where the 'Family Record' occurs, is this interesting item, written by Mr. Parsons himself: 'Believing that the time has arrived when the cause of temperance and especially the safety of reformed drunkards requires from the friends of temperance the relinquishment of all drinks containing alcohol; we do therefore pledge ourselves totally to abstain from the use of all that can intoxicate except as medicine. Gouverneur, January 31, 1836.'"[549] All members of the family signed the page of the Bible. Charles Parsons was only twelve years old at that time.

When the will of the elder Lewis was executed on December 5, 1855, nearly two years after his death, and then finally probated in the Lee County Court on July 21, 1856, steps were taken to bring about the establishment of Parsons College. The will stated:

Having long been convinced that the future welfare of our country, the permanency of its institutions, the progress of the divine religion and an enlightened Christianity greatly depended upon the diffusion of education and correct moral and religious influence, and having, during my lifetime, used, to some small extent, the means given me by my Creator, in accordance with these convictions, and being desirous of still advancing objects so worthy as far as in my power lies, I do, therefore, after the foregoing bequests and the reasonable expenses of administration, give and bequeath the residue of my estate, together with my Natural History of New York and my small cabinet of minerals to my said executors and the survivors or survivor of them in trust, to be, by them, used and expended in forwarding and endowing an institution of learning in the State of Iowa, or to be expended—if it shall be deemed best by my said executors—in aiding and endowing an institution which may have been already established. And while I would not desire said institution to be strictly sectarian in its character, yet, believing its best interests require it should be under the control of some religious denomination, I therefore direct that it shall be under the Trustees, Presbytery or Synod, connected with that branch of the Presbyterian Church distinguished as the New School, or Constitutional General Assembly of said Church,

until such time (which, I trust, may speedily come) when a union of the two branches of said Church shall be honorably accomplished; then to be made the care of said United Church.

The adoption or location of the institution, with the general regulations and proper restrictions to be connected therewith, I confide to the sound discretion of my executors, with the full assurance that, as they know my general views and statements, they will take pleasure, when my spirit shall have departed hence and my memory alone remains with them, in using their best endeavors to carry out my wishes and make most effectual and useful this bequest.

I desire the Institution be selected or located and the expenditure commenced as early as consistent, and unless for very special reasons not to be delayed beyond the period of five years after my decease, and the entire fund to be expended and invested as soon thereafter as the same can be made most available.[550]

Because of the Civil War and the recovery that followed, twenty-two years passed before the official founding of Parsons College in 1875, in Fairfield, Iowa, accomplished by the executors named in the will: Lewis B. Parsons Jr., Charles Parsons and George Parsons.[551]

When Charles and his brothers were ready to honor their father's wishes after the Civil War, they set their sights on Iowa to establish the school their father had wanted. The two Presbyterian Synods of Iowa, one in the north and the other in the south, had been divided over the "Old" and the "New" schools of thought, and although both groups engaged in dialogue about the future of education in the state, their rift left little room for agreement.[552] By the late 1860s, the North Synod had established a school of their own when they assumed leadership over Lenox College, in Hopkinton, Iowa, which was founded as a private school in 1859.[553] Willis Edward Parsons wrote:

The Synod south had no school for higher education of its own. When, therefore, it was learned that the executors of the Parsons legacy were ready to carry out the wish of their father, interest ran high. In 1869 the executors visited Iowa and selected an advisory committee of three ministers, Rev. S.G. Spees of Dubuque, Rev. John Armstrong of Muscatine and Rev. Willis G. Craig of Keokuk. The claims of three towns, Cedar Rapids, Marshalltown and Des Moines, were considered as possible locations for the College under conditions which would insure success. None of the competing towns, however, met the

conditions laid down by the executors. So the matter rested, much to their disappointment. [554]

Another two years passed before the "Synod of Iowa (South)" pushed for the college again by appointing a committee to consult with the executors. [555] It appears as though mutual interest in creating Parsons College united the synods. Two committees discussed the matter for a year, and at a meeting in Keokuk, in 1872, they agreed to establish the college in Cedar Rapids. [556] Although the synods were working together, the proposal failed. Another attempt was made to establish the school in Des Moines in 1874, and this also failed. [557]

In late 1874, a new committee was formed to consider Fairfield as the location of the school. Willis Edward Parsons wrote:

Under the leadership of Rev. Carson Reed, at that time Pastor of the Presbyterian Church of Fairfield, Judge Negus and the Hon. James F. Wilson, public meetings were held and the interest of Fairfield became intense. The Location Committee was invited to come to Fairfield and consider its claims. They met a number of citizens at the Leggett House. William Elliot presided and opened the meeting with a prayer. This fact was noted by General Parsons and made an impression on him, as it was the only place of all which the Committee had visited where prayer was offered. [558]

Impressed with the offer of prayer, Lewis, George and Charles worked quickly with the other men of their advisory board, and on December 11, 1874, Fairfield officially became the proposed location for the college. [559] Willis Edward Parsons wrote:

[T]he sum of $27,000.00 [was] secured in good subscriptions within two weeks. The refusal of three specified sites at prices named was also to be secured. In the proposition thus made the school to be founded is spoken of as "the Synodical College," revealing very clearly that in the mind of the committee it was to be a Church College. After a strenuous campaign all these conditions were met. [560]

[T]o adopt articles of incorporation for the college, on February 24, 1875, twenty-five men of the thirty he [Lewis Parsons Jr.] invited to Fairfield signed the articles and accepted the oath of office. They were as follows: James F. Wilson, Willis G. Craig, Benjamin F. Allen, Charles Negus, Lewis B. Parsons, Charles Parsons, John Armstrong, William

Elliott, G.A. Wells, Carson Reed, James F. Robertson, George B. Smythe, William W. Jamison, Thomas H. Cleland, Jr., Samuel M. Osmond, C.C. Cole, Matthew L.P. Hill, Hiram H. Kellogg, Alexander Scott, Samuel Noble, John H. Whiting, William Bradley, Henry B. Knight, Thomas D. Wallace, Warren S. Dungan, Charles D. Nott, James D. Mason, John Calvin McClintock, Thomas Officer and James H. Potter.[561]

Following the acceptance of the oath, the elected officers were General Lewis B. Parsons Jr., president; Reverend Carson Reed, secretary; and William Elliot, treasurer. General Parsons quickly felt inclined to resign his position as president to Reverend Willis G. Craig, who went on to hold the position continuously for thirty-three years.[562]

As an executor of his father's will, Charles Parsons worked diligently to bring the college into existence and committed to ensuring its success, more than any other family member. In addition to donating throughout his life, from 1875 until his death, he left a bequest of $80,000 to create an endowment, the largest single donation the college ever received; he also endowed two professorships.[563] The first was the Martha Pettus Parsons Professor of Biblical Literature and Evidences, in honor of his late wife, and the second was the Levi Parsons Professor of the Latin Language and Literature, in honor of his late brother.[564]

Charles Parsons's financial gifts to the school totaled more than $150,000.[565] This is the equivalent of $4.5 million today. More than the son of the founder, Charles's significant donations to the college were directly correlated to his success as a businessman. The Latin motto that Parsons College adopted was *Est modus in rebus*, meaning "Proper measure in things." Colonel Parsons contributed his proper measure to the college and the memory of his father.

Willis Edward Parsons left us with a fitting image of Parsons College, as well as Lucina and Lewis Baldwin Parsons Sr.:

Thus Parsons College entered upon its career, not as a creature of impulse, but after mature deliberation and careful investigation. Its modest endowment was not the surplus of great wealth, but the life-long savings of a consecrated Christian man and woman who desired to honor their Maker and benefit their race. There seems to have been no thought of posthumous fame coming to the Founder in the way of exalting his name, but a sincere desire to serve. In this lies the choicest heritage of this institution.[566]

Parsons College operated successfully, though with some struggles, until the late 1960s. By 1973, the college was millions of dollars in debt and declared bankruptcy that year.[567] In 1974, the college was purchased by the Maharishi International University. Maharishi Mahesh Yogi, the same teacher who instructed the Beatles, lived and taught on the grounds of the former Parsons College until 1992, when he moved to the Netherlands.[568]

Chapter 12

NOTES OF TRAVEL
IN 1894 AND 1895

O ne of the most interesting artifacts that remains from the life and times of Charles Parsons is his book, *Notes of a Trip Around the World in 1894 and 1895,* which he published for private circulation. In this volume, Parsons left a vivid cultural and historical account of life in numerous countries of the near and far east just before the turn of the twentieth century. Written in a relaxed tone, Parsons's work provided us with insights of "people, the landscape, the art and architecture, on manners and fashion, on economics and religion."[569]

According to his chronicle, Parsons departed San Francisco on the steamer *Belgic* at three o'clock in the afternoon of November 15, 1894, with his nephew, heir and friend, Charles Parsons Pettus.[570] This departure from the California coast began a journey that included stops in Japan, China, Singapore, India, Bhutan, Egypt, Yemen, Granada and other places in between. Parsons collected art and artifacts from each country he visited. When viewed individually, these acquisitions seem to be simple souvenirs, collected without an overarching goal. But when the artifacts are considered as a group—those currently in the collection of the Mildred Lane Kemper Art Museum and those that have been deaccessioned—along with his known writings and correspondence, a new picture emerges that seems to indicate that Parsons collected his objets d'art with as much attention to detail as he did with his paintings. Although Parsons may have used considerable discernment, Nelson Wu (1919–2002), an internationally recognized scholar of Asian art, described many of the objects as "high quality tourist" art.[571]

This assessment of the collection as "high quality tourist art" is most pronounced with Parsons's appreciation of Japan and the related objects he collected. Although it is difficult to discern Parsons's emotional connection to the countries that he visited from his writings, Parsons was clearly deeply connected to Japan and, in particular, the samurai culture of the Tokugawa shogunate as already discussed in greater detail in chapter 9.

Just after noon on December 3, 1894, Parsons arrived in Yokohama Harbor and saw, "looking up high in the air in the distance, more than a hundred miles away, the silvery cone of the sacred mountain, Fujiyama" (Mount Fuji).[572] Parsons remarked, "[I]t is something to love if not worship."[573] Seeing Mount Fuji must have been a sort of homecoming moment, having seen it eighteen years earlier on his first trip to Japan.

When Parsons first arrived in Japan in 1876, only nine years had passed since the fall of the Tokugawa shogunate, which had ruled the country since 1603. This revolutionary period in Japan's history brought about the rapid modernization of economic, political and social institutions that enabled Japan to become a leading country in Asia and, within the next fifty years, a world economic and political power. Charles and his nephew visited many places that could be considered tourist destinations in Japan, including festivals, castles, the Buddha of Kamakura and both Buddhist and Shinto temples.[574] If Parsons was merely a tourist, he demonstrated an impressive understanding of the culture through his writing and collecting. He wrote, "There are Buddhist and Shinto temples both here. The present Mikado (Emperor) is a Shintoist as I suppose were all his ancestors, for they came from the sun goddess thousands of years ago, but both worships are equally protected."[575]

Parsons's experience in Japan presented interesting differences between Shintoism and Buddhism and personal revelations. He wrote:

I see little devotion in the Shinto faith, there is much more in Buddhism. Almost all the forms peculiar to the latter worship, such as ringing of bells, bowing at the Altar, gorgeous priestly vestments, use of prayer beads, incense, masses, monasteries, nunneries, shaven heads, vigils, wayside shrines, saintly and priestly intercession, etc. are similar to those used by Catholics, who may have inherited them from the Buddhists of India as Buddha was the predecessor of Christ 638 years. St. Francis Xavier, it is reported, when he first visited Japan to introduce Christianity was so struck by this similarity that he imagined the devil had taught the Buddhist these forms to prevent them from becoming Christians.[576]

In some cases, perhaps drawing from his experience as a Union officer during the Civil War, the writings are almost like an intelligence briefing, especially when he refers to the Japanese army and observing their military drills.[577] There is also a passage that seems to border on prophecy in his observations of Japanese industry:

> *I cannot see why there is not in the future a menace to our home manufacture in Japanese competition, they work so cheaply, are so painstaking and imitative, that they may yet buy our cotton and wool, and make up clothing and other things for American use, and instead of fearing European competition we may find our machinery duplicated there to produce all sorts of articles much cheaper than they can be made in Europe.[578]*

In *Notes of Travel*, Parsons described a visit to the Satsuma porcelain painter Yabu Meizan (1853–1934) in 1894, which directly connects a Satsuma ware bowl in the collection of the Mildred Lane Kemper Art Museum to his travels and writings. After visiting the workshop of celebrated cloisonné maker Namikawa and then the silk shop of Nishimura, it was on to Meizan's workshop, a visit that Parsons described in detail:

> *On the 25th we went up to Osaka and visited the shop of the porcelain painter, Yabu Meizan. He is very celebrated. He had 17 men and boys at work, all decorating. He makes the designs and watches them carefully in executing the work. Some are very wonderful workers. All is order, neatness and silence, no words spoken. I saw a bowl which on the outside represents the seasons and inside clouds of butterflies flying spirally, thousands of them minutely drawn, going towards the center.[579]*

Interestingly, the "bowl" to which Parsons refers in his chronicle is most certainly the bowl listed as "Satsuma Ware (Japanese), Bowl, n.d. Porcelain" in the collection of the Mildred Lane Kemper Art Museum. The bowl in question is the work of Yabu Meizan and verified by matching the description Parsons offered and Meizan's signature chop, or *hanko* (判子), on the bottom of the object. Although Yabu Meizan hired artists to assist him later in his career, as he spent a lot of time traveling, it is said that he "would only put his signature to their best work."[580]

Parsons's relationship with the Meizan workshop no doubt led to the artist's participation in the Louisiana Purchase Exposition in St. Louis in 1904, after successes at major exhibitions, first in Kyoto in 1885 at the Fourth Kyoto

Above: Yabu Meizan (Japanese, 1853–1934), Bowl, late nineteenth century. Satsuma ware; porcelain, 2⅞ x 4⅞ in. (diameter). *Mildred Lane Kemper Art Museum, Washington University in St. Louis. Bequest of Charles Parsons, 1905. WU 1058.*

Right: Artist's seal (*hanko*) of Yabu Meizan. *Private collection, Japan.*

Exhibition, followed by the Exposition Universelle in Paris in 1889 and 1900.[581] Parsons's ownership of a bowl made by a world-famous Satsuma porcelain painter, whose work has broken records at auction in recent years, illustrates Parsons's astute eye in collecting objects of artistic value.[582]

Parsons made numerous comments related to art and architecture in *Notes of Travel*, with a strong emphasis on Japan. On the temples of Nikko to Tokyo, he wrote:

I cannot attempt a description of these temples, their wonderful wood, bronze, gold and lacquer work, the beautiful paneled ceilings, the splendid columns, the gateway buildings rich with ornament, the great stone fountains made from a single block of granite, the great images, like the Gog and Magog in the London Guildhall, at the entrance gates, the bronze lanterns, the curious robes and other things shown among their treasures in the museum, the great stone stairway leading up high to the tombs, up which I could not have gone without aid, so long and steep were they. Nothing like this exists or ever will exist. The temples of Shiba in Tokyo are the next finest and of somewhat similar style but nothing like so extensive or fine.[583]

More than temples, Parsons visited the Emperor's Kyoto Palace. He remarked, "The Mikado's palace was full of interest. There are immense halls of audience, of reception, of waiting, great sleeping rooms, great in size and multitudinous in number, and screens and shojis (moveable partitions), painted most artistically."[584] Furthermore, "[Japan] is something worth seeing; I hope these people will never become Europeanized. I want them to adhere to their own artistic original ideas and tastes, their old work and much of their modern, when they remain faithful to their own ways, is marvelous in style and execution."[585]

As Charles Parsons forwarded his world travels beyond Japan, there continued to be insightful commentary in each place he visited. When in China, Parsons again seemed to intuit the future when writing of the possibility of Russia invading China:

It seems that here is the possible and almost probable danger for China and India. Russia has already conquered the Khanates of Khiva, Bokhara, etc., reaching to the borders of Afghanistan and also is on the frontiers of China, and stands patiently waiting the suitable opportunity for further advances when time and circumstances offer. She is completing a great railroad line through Siberia to the Pacific ocean, her people are more prolific in the

increase of population than most others. She will soon have many millions of people along and near the line, with large towns, and the Russians are a race very capable for labor, and submissive to drill and discipline. Should the Czar conclude to over-run China and set up a new Northern sovereignty of his own, it would not be strange nor is it improbable.[586]

Charles Parsons's *Notes of a Trip* is a spirited account for a man who was seventy years old. In Canton, he imagined that he would have to fight pirates when he spent the night on the riverboat *Powan*: "The first thing that struck me as strange was to see weapons in the cabin, and then, in our rooms even, were swords, it seems these are to fight pirates with, luckily we were not put to the test, but I think we would just have had to fight if attacked, as the river pirates are regular devils."[587] And Parsons's description of eating on the streets of Canton is remarkably relatable, even today: "They keep the rice running into their mouths in a continual stream with their little chop sticks [*sic*]. I never became expert with them, although I can use them."[588]

In all, Parsons's *Notes of a Trip Around the World in 1894 and 1895* is a fascinating account, whether one is interested in art, history, politics, economics, fashion, the customs of late nineteenth-century Asia or simply as a tale told by a man of the world in his final years. The images themselves—engravings copied from photographs, taken by Charles Parsons Pettus with his new "portable" Kodak camera—are enough to warrant at least a casual look through the chronicle.[589]

Parsons's deep appreciation for the cultures he visited, the philosophies that challenged him and the expressions of art that so deeply moved him is a wonderful experience to read again and again. Parsons ended his chronicle with what feels like sigh of relief: "And then the whole ends with the broad ocean and America, and my dream is over. Once more I am at home, but the pleasant memory still remains and will do so forever."[590]

Chapter 13

LEGACY OF CHARLES PARSONS

F ollowing his journey around the world in 1894 and 1895, Charles Parsons continued to live an active personal and professional life. After a two-week illness, he passed away peacefully on September 15, 1905, at his summer lake home in Wequetonsing, Michigan, surrounded by his family, including his brother George and his nephew, Charles Parsons Pettus, who had been living with Charles since Martha's death in 1889.[591]

His body was returned to St. Louis by train, and his funeral service took place on September 19, 1905, at Christ Church Cathedral in downtown St. Louis, where he had been a parishioner; he also served on many of the Christ Church Cathedral's governing bodies between 1873 and 1895.[592] The service was presided over by the Very Reverend Carroll M. Davis.[593] The funeral was attended by every banker in St. Louis, and the city's most powerful men and women paid their last respects.[594] The Military Order of the Loyal Legion of the United States (MOLLUS), of which he was elected commander and then had been elevated to a member of the council in 1905, draped the American flag over his casket and erected a beautiful wreath, honoring their fallen companion in the order.[595] In life, MOLLUS had meant much to him. His *Notes of a Trip Around the World in 1894 and 1895* contained this dedication:

> *This little book is respectfully dedicated to the Missouri Commandery of the Military Order of the Loyal Legion of the United States, without whose services, supported by their fellow officers and the grand army of*

*Union soldiers, through four years of bloody strife, we would not now have
a National existence, or see the banner of the Union floating on land and
sea to protect us in our travels,*

By Companion,
Charles Parsons,
Bvt. Lt. Col. U.S.V.

Following the service, Parsons's funeral procession followed the same path
that General Sherman's had to Calvary Cemetery in 1891, located seven
miles away from downtown, but Parsons's procession instead ended at the
adjoining Bellefontaine Cemetery, in North St. Louis. Parsons's cenotaph, a
replica of the ancient Roman sarcophagus of Consul and General Lucius
Cornelius Scipio Barbatus (died circa 280 BCE), awaited, where he would
again join Martha.[596] By dusk on September 19, 1905, Mr. and Mrs. Charles
Parsons were united in eternal rest.

Charles Parsons began his journey in rural upstate New York, learning
to clerk in his father's business. He traveled the country—with stops in
Buffalo, New York; Washington, D.C.; Charleston; Richmond; Philadelphia;
Cincinnati; St. Louis; and other towns—before settling in his beloved
Keokuk, Iowa, to open a successful banking business that prospered for
many years before the crash of 1857.[597] That same year, he married Martha
Parsons Pettus, and he joined the Union effort in the Civil War a few years
later, finding himself associated with General Grant and, more intimately,
with General William T. Sherman, friends until the general's death.

Under the command of his brother Lewis, Charles moved the armies
of Generals Sherman and Grant with great success, achieving the rank of
brevet colonel. Both he and Lewis were known by name all the way to the
White House and even inside the Oval Office. More than their wartime
success, Lewis enjoyed a personal relationship with President Abraham
Lincoln, and both brothers were acknowledged by him as well as General
Grant for their service to the Union. Following the war, Charles continued
to support his brothers in arms as a member of the Loyal Legion, the Grand
Army of the Republic and the Army of the Tennessee.

Charles was already associated with one president on the face of Mount
Rushmore when, in 1902, he along with businessman and philanthropist
Robert S. Brookings, his friend and fellow supporter of Washington
University in St. Louis and founder of the Brookings Institution, found
himself associated with another, President Theodore Roosevelt. Both

Brookings and Parsons were appointed by presidential decree to collect funds for the relief of volcano sufferers on the islands of Martinique and St. Vincent. Parsons had been in correspondence with Roosevelt as early as 1897, when Roosevelt was the assistant secretary of the navy.[598]

Though an outspoken Republican, Charles Parsons avoided public office for the most part, turning down invitations to serve in presidential cabinets as the secretary of the treasury. He did serve the City of St. Louis for a time, when scandal broke out in the Treasurer's Office due to missing money and a suicide. Although he was once in the crossfire of St. Louis's Mayor Noonan, Parsons succeeded as a banker, financier and leader of many enterprises, which provided him with the means necessary to live well and travel extensively. More than the travels previously mentioned, Parsons was able to see the majesty of the West and Yellowstone later in life; he traveled to Hawaii the year before he embarked on his journey around the world, a place that inspired him to write this poem as he departed:

> *Fair home of flowers and fabled song,*
> *Where constant is the sun's bright ray,*
> *In other lands I'll think of thee,*
> *Aloha oe' Hawii ne'*
> *From Kaui's cliffs to Loa's fires,*
> *Bright land of never-ending May,*
> *Farewell to all those lovely isles,*
> *Aloha oe' Hawii ne'*[599]

In the emerging visual fine arts of the nineteenth century, Charles and Martha Parsons supported rising artists like Harriet Hosmer with friendship and connections and collected the masterful paintings of other living artists. He worked for nearly thirty years to establish arts education and a place to exhibit fine arts—the St. Louis School and Museum of Fine Arts, the first art museum west of the Mississippi. He also worked as president of the board of control to establish the Palace of Fine Arts at the 1904 St. Louis World's Fair, which became the City Art Museum following the fair and is today the St. Louis Art Museum. Prior to that exhibition, he was selected to oversee the World's Congress of Bankers and Financiers at the Columbian Exposition in Chicago, the model for the world's fair in St. Louis eleven years later.

He enjoyed a twenty-two-year friendship with Heinrich Schliemann, the archaeologist who rediscovered Troy and was a household name. This friendship expanded Parsons's understanding of the world and led

Charles Parsons (*second from right*) and other early administrators of Washington University in St. Louis. *Washington University Photographic Services Collection, Washington University Libraries, Department of Special Collections.*

to new connections that helped his collection of art and artifacts to grow. This friendship also brought St. Louis architectural features to Athens, Greece, through the immense home that Schliemann built for himself called the Palace of Troy, which now houses the Numismatic Museum of Athens.

After the death of his father, Charles supported the development of Parsons College as a trustee and its biggest donor in history; he dictated in his will that $80,000 ($2.3 million today) should be used to endow a Martha Parsons professorship.[600] He also left $3,000 (nearly $90,000 today) each to the Methodist Orphans' Home in St. Louis, the Memorial Home for Old Persons on Grand Avenue in St. Louis, the Protestant Orphans' Asylum in Webster Groves and the Episcopal Orphans' Asylum in St. Louis. He left the German Protestant Orphans' Asylum on Ashland Hill in St. Louis $2,000 (nearly $60,000 today).[601] Christ Church Cathedral was left $7,000 (nearly $200,000 today), and St. Luke's Hospital was given $14,000 ($400,000 today).[602] The memory of

Martha was already living on in the Martha Parsons Free Hospital for Children, which became St. Louis Children's Hospital after the naming rights expired.

Although Parsons's generosity and influence was felt far and wide, it is difficult to see the full impact with the gap of more than a century since his death. By far, the legacy of Charles Parsons will live on in the art collection and art fund he bequeathed to Washington University in St. Louis. When he died, the collection was valued at $250,000 ($7.2 million today) and was to be "installed in a fine art building to be erected on the grounds or in Forest Park."[603]

He also left the university a fund of $75,000 ($2.2 million today), "the income of which is to be for the care of the collection and purchase of admission to it."[604] As previously mentioned, the collection includes masterful works by Church, Corot, Inness and Gifford, in addition to purchases the university has made posthumously on Parsons's behalf. These purchases include important works by artists such as El Greco, Honoré Daumier, William Hogarth and Joshua Reynolds. Perhaps Reynolds's *Portrait of Mrs. Charles Ogilvie* was to complement another portrait by him that Parsons purchased during his lifetime, *Portrait of Sir James Esdaile, Lord Mayor of London*; the same could be said of *Portrait of Mrs. Craigie Halkett* by Henry Raeburn, to complement another Raeburn that Parsons bequeathed to the University, *Portrait of General Sir David Dundas*.[605]

The Parsons Fund has enabled the university to acquire works continually since Parsons's death, including numerous modern works such as *Your Imploded View* by Olafur Eliasson. *Your Imploded View*, intended to swing "like a pendulum," looks like a highly polished aluminum wrecking ball, measuring "fifty-one inches in diameter and 661 pounds."[606] *Your Imploded View* was the impressive centerpiece in the Saligman Family Atrium when the Mildred Lane Kemper Art Museum opened for the first time in October 2006. It became a centerpiece again when the museum reopened in 2019 after a period of remodeling and expansion.[607]

Charles Parsons's legacy is preserved in his collection of art and artifacts visible to the public today. While naming rights expire, art perseveres. As the museum acquires new works through the Parsons Fund and continues to display works he collected, the name Charles Parsons will continue to be remembered. The same will be true for guests of the St. Louis Art Museum, as they tour the impressive Egyptian exhibition containing Parsons's two Egyptian mummies. Parsons was immensely wise to bequeath his collection to a university that has grown into an internationally respected institution

Charles Parsons. *Washington University Photographic Services Collection, Washington University Libraries, Department of Special Collections.*

of higher learning and research. So long as the university survives, so will Parsons's contributions.

Charles Parsons lived an impressive nineteenth-century life that lasted eighty-one years. Referring back to the Tokugawa incense burner from the chapter "Fragrant Curios," perhaps we can compare Parsons and his lifelong contributions to the arts, education, business and the common good to a character from classical Japanese culture: Kaoru from the *The Tale of Genji*. The description of Kaoru reveals much of what we know about ancient Japan's incense culture: "And there was the fragrance he gave off, quite unlike anything else in this world. Let him make the slightest motion and it had a mysterious power to trail behind him like a 'hundred-pace incense.'"[608] Although Charles Parsons's fire has gone out and his 100 paces are 115 years, his contributions continue to be fragrant and will be for generations to come.

As Brevet Major Horatio D. Wood, T.D. Kimball and George T. Cram wrote in their memoriam on behalf of the Military Order of the Loyal Legion of the United States, "His kindly face and genial presence remain only in our memories. He leaves behind a life record with every page untarnished and every duty fulfilled. Good night, but not goodbye, Companion."

SCHLIEMANN'S LETTERS
TO PARSONS

The surviving letters between Charles Parsons and Heinrich Schliemann are provided here in full to give an expanded experience of their connection. Perhaps there are more letters in archives yet to be found and made available, but for now, this is what is available.[609]

Indianapolis, May 10, 1869

My dear Mr. Parsons!
I had very great pleasure in receiving your very kind letter of 6th inst, for which please accept the expression of my sincerest gratitude.

I see now that I have no chance of finishing the affair, for which I am here, before the middle of June next, but, if nothing prevents me, I shall then avail myself with joy of your kind invitation to go and see you at St Louis. But as I have a great deal of baggage with me I would trouble you too much and thus I beg you will grant me the permission to stay at the Southern Hotel; I promise to remain nevertheless a whole day with you at your house.

I am delighted to hear that both your good Lady and her sister are quite well and happy. I write today to my editor W.C. Reinwald in Paris to send you a second copy of my book; the first copy has miscarried, but since I have now given your exact address I have no doubt that you will receive the book promptly. It has been printed at Paris in french and at Leipsick in german. I suppose you are more familiar with the french and therefore send you a french copy. I should like to send also a copy to your sister in

law. Is not her name Mrs Euphrosia Macquay? I am only afraid it will be a very dry lecture to you all, for it only treats of archaeology and was principally intended to procure me the degree of a doctor of philology. For this purpose I sent it, together with two thesises—one in ancient greek and one in latin—to a german university and I am already informed that I shall have the doctorate this month.

I trust you and your good Lady will soon follow the wise example of General Donaldson and retire to the "ville par excellence" to the wonderful Paris.

Please accept my hearty thanks for your kind endeavors to find out what has become of the missing Edw. Thibaut-Brignolles. Already your mere statement that there were 3 generals Stuart from Tennessee in the Southern army proves to me your superior tact and knowledge. I had also addressed myself to General Beauregard, whose acquaintance I had made in Decbr 1867 in New Orleans, but, strange to say, he wrote me back that neither he himself nor any of his numerous friends whom he had questioned knew or heard of any other General Stuart than the two who served under him (General Beauregard) in Virginia and Tennessee and who were both without families.

At the suggestion of a party here I had also written to Colonel John T.L. Preston of Lexington, Virginia, who answered me two days ago, that there has been in the western army a Lieut genl Alexander I. Stewart, who has commanded a corps and that he is now a professor of mathematics in the Cumberland University, Lebanon, Tenn and that he has a grown daughter, whose name is perhaps Maggie and two grown sons; further that he has a brother, a school-teacher in Memphis, whose name is John D. Stewart. There certainly appears to be some amount of coincidence between these statements and those of the missing Edw Thibault Brignolles and I therefore wrote at once to the Professor of mathematics in the Cumberland University and to his brother the school-teacher in Memphis, but I am afraid that if they are not the parties in question they will not answer me at all. Besides the Colonel did not give me the address of Mr. John D. Stewart, the schoolmaster and further there is a great difference in the names Stewart and Stuart! But I have no doubt that with your valuable assistance I shall succeed in ascertaining the fate of the missing young friend.

I was much gratified to see from your circular the particulars of your Banking Establishment, which, under your wise management, cannot fail to grow rapidly in wealth and importance.

In thanking you once more most cordially for your amiable cooperation to find out the fate of the missing man and in heartily reciprocating your kind wishes, I remain in expectation of your further interesting communications, your faithful friend

HY SCHLIEMANN

~~~

Indianapolis, May 16, 1869

Chas Parsons Esq
St Louis

My dear Sir!

I duly received your esteemed favor of 7th inst, as also Mr Silas Bent's address upon the Theometric Gateways to the Pole, which I have read with immense interest. If you have a taste for scientific pursuits, as for instance the Northpole question, then I guaranty to you that you can never feel tedious if you make Paris your home. The opinions emitted by said Mr Bent perfectly agree with those of Mr Lambert of the Polytechnical institution of Paris, who had raised some funds by public subscription, had bought a vessel and was going to start for the North-pole by way of the Behring's Straits. But the amount he collected falls short of 200000 francs, whereas, in my opinion, at least three times as much is required to do the thing well. Unfortunately, in spite of his profound knowledge, he has not had tact of enough to insinuate himself with the french minister of the Marine, who considers him a visionary man and refuses therefore all and every assistance on the part of the French government. The emperor gave him fr 50/m from his private purse and nearly the whole rest of the money he has got was subscribed by us, members of the parisian geographical society. Though the route this expedition takes is in my opinion the only one by which men can ever succeed to get to the Northpole, and though Mr Lambert is no doubt the most clever man that ever tried to clear up the mysteries of the arctic world, yet his attempts will be frustrated in the very beginning for want of the most necessary, and his expedition is therefore of no account.

But if such a scheme fails in France, where 999 out of a 1000 have more taste to see "Hamlet" than they have to know the exact statistics of the Pole, it could not possibly fail in the U.S., where useful knowledge goes beyond every other consideration and where every one seems to be born with a passion for geography. The only thing would be to start the thing in a serious manner and to get some great american geographer at the head. I would joyfully contribute myself. Please speak with Mr Silas Bent how such an expedition might best be got up in this our great country, which is more entitled than any other to the glory to have reached the Pole. Pray, ask Mr S. Bent also by what arctic exploration our fellow-citizen Dr Isaac J. Hayes has gained this year's great golden medal of the Parisian geographical society? I saw a notice of it the other day in the paper; but I do not know of any recent expedition of Dr. Hayes!?

Pray, accept my warmest thanks for having sent me Mr Silas Bent's address.

General Alex P. Stewart, now professor of mathematics at the Cambridge University, Lebanon Tenn, answered me very kindly, that he knows nothing of Edw Thibaut-Brignolles, that he has no daughter nor niece, nor any female relative of the name of Maggie or Marguerite and that he does not know of any confederate general officers of the name of Stuart or Stewart, except General J.E.B. Stuart of Va, who was killed and who had no family.

In consequence of the advertisements I inserted in the Oswego (N.Y.) Advertiser, I received a long letter from a certain Mr. Charles Rhodes of that city, who enquired about Edw Thibaut-Brignolles, saying that he had employed the young man in 1864 for a considerable time in his railway office, that he left him in spring 1864 and returned in summer of 1865 with a discharge of the Union army, but without money or change of clothes. He (Mr Rhodes) took him again into his office and employed him until November, when the young man suddenly decamped, without saying a word to any body. On seeing him take away his things from the office Mr Rhodes thought that he was merely removing them to some other place. But soon after he had left he found out that he had disappeared altogether. At first he thought that he had been done away with; but on learning that he had also taken away all his things from the boarding house he became satisfied that he had left by the Railway. He adds that nothing occurred there that would permit any reason for his leaving in that sudden manner, but that he looked so depressed ever since his return from the South; he further writes that he made or proposed to make at Oswego arrangements to manufacture toilet-soap.

But all this is perfectly different of the accounts the young man gave to his father in 1865 from Oswego, viz that he had been married end of 1864 in N.Y., that he had left this bounty of $900 with his wife, passed his examination in the engeneer corps, became a lieutenant and left as Captain with a ball in his leg; that after the war, in summer 1865, he was engeneer in the Pic. Ho mines in Pennsylvania, where he lived with his wife and economized in 4 months some thousand dollars; that he came with this money, in company of his wife, who had never touched his bounty of $900, to Oswego, where the [he] started a fabric of soap and candles, which went on in such a successful way that he invited his father to live with them and even offered to pay his passage out.

I think, there can be no doubt but the young man has been mentally deranged and has communicated to his father mere visions but no things that really existed. No doubt he has got, end of 1864, ensnared in N.Y. by some damsel of equivocal character, who styled herself daughter to General Stuart and, who, under promise of marriage, pushed him to enlist in the Northern army and to leave her his bounty. I venture to declare it a falsehood that that young man, whom I considered in St. Petersburg unfit for any serious mental occupation, should, with his superficial knowledge have been able to pass his examination in an U.S. engineer corps and leave some 5 months later as Captain; of this and of the ball-wound Mr Rhodes would have made mention if it had been true.

I declare it likewise a fable that he should have worked as engeneer [sic] in the mines of Pic. Ho, for he had no more knowledge of engeneering [sic] than a cow has of a Sunday; it is a fable also that he should have come from said mines with thousands of dollars, in company of his wife, to Oswego, for he came there immediately after the close of the war penniless and without change of clothes. Had he come there with his wife Mr Rhodes would have mentioned it. No doubt if the damsel has really married him, of which I doubt, then she has certainly left him to his fate as soon as she got possession of his soldier's reward. Mr Rhodes mentions nothing of the fabric of soap and candles and merely says that he arranged or proposed to arrange for manufacturing toilet-soap.

After the young man's sudden departure from Oswego, as mentioned by Mr Rhodes, he has written 2 letters to his father from N.Y. informing him in his last letter, of March 1866, that he was going to Memphis, armed with pistols the roads being unsafe. I suppose that, instead of going to Memphis with pistols, he went with only one pistol to some place in the neighborhood of N.Y. to commit suicide.

I have communicated at once to Mr Rhodes of Oswego my opinion of Edw Thibaut-Brignolles' doings and fate and I will send you a copy of his answer. Meanwhile I beg you a thousand pardons for having given you so much trouble; with great gratitude I shall refund you in St Louis whatever expenses you may have had in the matter. But ere we drop the matter, pray, consult your memory and inform me what battles General Sherman has fought in 1865?

Mr Edw Thibaut-Brignolles who can impossibly have entered the army before January 1865 and still he wrote to his father that he had made nearly the whole campaign of Gen Sherman and that he had taken an active part in the battles of from Macon to Savannah and thence to Charleston; that he had been engaged in the battle of Petersburg and in the encounters at Richmond. Should all this have been possible in the 6 mths which the war lasted in 1865?

Once more I beg you will accept my warmest thanks for your readiness to serve me and my excuses for having troubled you so much. Always most happy to serve you in return I remain yours very faithfully

HY SCHLIEMANN

~~~

From the Indianapolis Historical Society, a letter dated May 31, 1869, followed a few weeks later from Schliemann. The letter here, as indicated previously, reflects that Mr. Th. Thibaut-Brignolles, counselor of the state, St. Petersburg, Russia, enlisted the assistance of Heinrich Schliemann to determine the whereabouts or fate of his son, Edward Thibaut-Brignolles, who immigrated to the United States in 1863. As the son was immediately drawn into the Civil War and then married the daughter of Confederate general Stewart in 1864, it was an effort of the father to know his fate, as he had not been in contact since 1866. The following letter makes an official announcement of reward regarding Edward Thibaut-Brignolles.

Indianapolis, May 31, 1869

To Mr. Parsons, St. Louis

— — —

$50 REWARD
For any reliable intelligence of the present
residence of Edward Thibaut-Brignolles, a native
of St. Petersburg, Russia, or, if dead, of the
time and place of his death. He was last heard
from at Williamsburg, N.Y.

address—Charles Parsons
St. Louis, Missouri

— — —

~~~

Indianapolis, June 18, 1869

My dear Mr Parsons!
I am very much obliged to you for your kind lines of 15th inst and would
with great joy accept your friendly invitation for next week if I could. But I
cannot get on with my business here so promptly as I expected. I should like
to see it terminated before I leave this city even for one day.

I have no doubt that I shall succeed in the first half of July and my first
excursion will be to St Louis. In my present state of mind I would be a
tedious companion and annoy you all.

Any of your friends whom you want me to see, will, with a line from your
hand, find a good reception at my house in Paris.

When at St Louis I shall try to prevail on you to accompany me to N.Y. and
to assist with me at the great Convention of American Philologists to be held
on the 27th July and the 4 days following. Eight highly important questions
regarding the system of our american colleges and the method of teaching the
ancient and modern languages are being discussed there. I have already sent
there a long dissertation on those questions, for I believed that I should not be
able to attend the assembly; but now my desire to be present is paramount.

I have given on 10th May order to my editor at Paris to send you a copy of my last work and so I trust you will have got it by this time.

I am happy to see that you and your good Lady are doing well and return your friendly greetings with cordiality.

Here one third of the population is now suffering from chills and fever, but I hope not to get sick, for I take early in the morning some quinine as a preservative.

I also have but little hope that they will apply to you for the reward regarding Brignolles; but in case it might happen, I refund you the money from here with gratitude. I remain faithfully your friend

HY SCHLIEMANN

~~~

In a letter from the archive of the Indiana Historical Archive,[610] *Schliemann wrote to Parsons in 1870 with a most interesting request.*

Athens, Greece, February 1, 1870

My dear sir!
It is twenty months since I had not the pleasure of hearing from you, but I hope you that you and your good Lady are enjoying good health.

I was in hopes you would come to Paris in the winter of 1869 to 1870, but no doubt you superior genius foresaw the present unlucky war and you quietly remained at St. Louis.

I remember with delight the happy hours I passed with you in 1869, when on my way to Italy, and later in Paris and nothing can give me greater pleasure than to hear of your and your good Lady's welfare.

I shall also be happy to hear that your sister in Law in Calcutta is doing well.

Ever since last spring I have been occupied with archaeological researches in the Orient and particularly in the Plain of Troy, where I have discovered the Palace of Priamus and the Temple of Plinius Minerva. It is more than probable that I shall henceforward spend the most part of my time in excavations in Greece and Asia Minor and remain only three months yearly at Paris.

I wish therefore to have here a dwellinghouse and garden and have already bought here on the principal street a piece of ground of abt 2400 greek...X...which I think corresponds to abt 2000 square yards, with an old building, which I intend to take down in order to rebuild it in the American style, for of all the elegant and comfortable houses I ever saw I must give the palm to those of the U.S. I should therefore feel immensily obliged to you if you would kindly send me at your earliest convenience the plan of a fine specimen of a St. Louis two story private dwelling house of abt 12 or better say 14 rooms, with water conduits and bathrooms, such as I saw in that part of town called St. Lucas I think. When at St. Louis three years since I have quite fallen in love with the American innershutters, which are used instead of curtains and which so convenient that I am sure they would be at once universally adopted in this country if I introduced them here. But since they are a thing unknown in this part of the world I should thank you to give me an exact drawing and measurement of them and to state of what the wood they must be made. I suppose your windows have besides those outside shutters called in French—persiennes.

Your plans will of course indicate how the roof is being made and how much it must project, further how the balconies are to be arranged? Marble being very cheap here I could make the colonnades of the material. Would it not be wiser to build the house immediately on the street—for then the garden becomes larger. Please inform me also how much such a house would cost at St. Louis?

For the trouble to make the plan please pay your architect one hundred francs, which I shall gratefully refund to you.

I intend of leaving on the 4th for inst for Paris in order to bring some order into what God may have saved of my houses and I therefore beg you will kindly send me your esteemed answer, with the plans and all particulars, care of my old friends Messrs. J. Henry Schroder & Co. of London.

I beg to thank you in anticipation most cordially for any trouble you may take in this matter and I assure you at the same time that it would give immense pleasure to be able to serve you in return.

I remain with sincere regards
My dear Sir
yours very truly

HY SCHLIEMANN

My humble respects to Mrs. Parsons and Mrs. Mackay.

APPENDIX

~~~

Parsons Esq.
St. Louis

Athens, Greece, December 3, 1874

My dear friends
It is highly gratifying to me to see from your kind letter of 21st Oct that you
have not only not forgotten your fellow-traveller, but that you have always
received with interest the accounts of his explorations and rejoiced at his
success. Your appreciation of my work is the greatest recompense I could
wish for and it encourages me to continue the excavations with the utmost
vigour as soon as my dispute with Turkey is amicably arranged, which I trust
will be the case in the course of a fortnight. The Turkish minister had taken
ill my remarks on page LII–LV of the preface of my book and has brought
here in the beginning of April last a suit against me to revendicate one half
of my whole Trojan collection. He had engaged the 3 most powerful lawyers
and brought it so far that I have been obliged in May last to make the whole
collection of 25000 objects suddenly and mysteriously disappear in order to
save it. I have been immensily annoyed by the suit. Seeing now that I am fully
a match to him and that he cannot recover anything at all of the collection,
he wishes to negotiate and with $4000 cash and the continuation of the
excavations for the exclusive benefit of the Turks for 3 or 4 months I shall
no doubt settle the matter very shortly. But the suit has already cost $8000.
However, large as these expenses are, they are but trifling as compared to
the value of the collection, for not only it derives from the city, the mere
name of which makes all hearts bound with joy, but it belongs to that remote
antiquity, which we, vaguely groping in the twilight of an uncertified past,
call the heroic or prehistoric age. I joyfully continue the excavations even
without taking anything of what may be discovered, for I am afraid some
government may step forward and continue the work, in which case all my
gigantic trenches would at once be filled up.

I am now married to a young Athenian who fully shares my enthusiasm for
Homer and assists me in my works. We have a daughter Andromache; had a
boy but he died. Mrs Schliemann shall be most delighted to see you at Athens.
But, pray, in passing through Paris enquire with my agent Mr Beaurain 25
Chausée d'Antin where we are, for we are both disgusted here. Ever since
my discoveries have become known I have been libelled here by the envious

scholars and during all the time the suit has lasted the Greek government has brought its crushing influence on the Courts in order to get the decisions against me. Thus I have had to fight all the time with my 6 lawyers against 2 governments. In consequence of that we shall henceforward again live in Paris, or perhaps in Naples; but first we have to finish Troy, where we cannot begin before 1 March. Perhaps you can come and see us there.

I have been sorry to hear of Mr Parson's sick hand, but I hope that it is long since convalescent.

I shall at all times be most delighted to hear of your good health and prosperity. Pray, inform me in your next also how Mrs Parson's sister is; my kindest regards to you all.

In England there is also a great enthusiasm for Troy. According to the Times Mr John Murray has at a dinner on the 13th ult sold 800 copies of my work which he has published in an English dress with engravings.
Believe me my dear friends yours most faithfully

HY SCHLIEMANN

~~~

Charles Parsons Esq St Louis
Athens, Greece, January 18, 1877

My Dear Mrs Parsons
I just received from the postoffice your most interesting letter of 20th ult, from which I am very proud to see that you still remember me and that you so highly appreciate my labours. But to my immense regret I am unable to send you any souvenir at all from Mycenae, because, as you will have seen from the London Times of 3d inst, I have presented to the Greek nation the one half of the treasures, which I could have claimed by the law, and I assure you on my honour that I have not even kept the slightest particle of the gold for myself. Regarding the other collection, it belongs to the state, Mycenae being national property, and the Greeks are so jealous of me that the Archaeological Society here refuses even to let me have 100 common Mycenaean potsherds out of the millions of beautiful fragments and thousands of splendid vases which I have gathered for them at the risk of my life and with large expenditure.

[Remainder of letter is cut off.]

~~~

5 Boulevard St Michel, Paris, April 26, 1878

My dear Mr Parsons
Please accept my warmest thanks for your kind letter of the 21st ult as well as for the window shutter, which has already arrived at London and will at once be forwarded to Athens. I shall be at Athens by the end of May, and after having examined the shutter with my architect I shall take the liberty to inform you of the exact number of shutters I require. The freight on this sample shutter amounts to more than the costing price, but I trust you can procure very cheap freights for a large parcel. I shall give you all particulars from Athens.

I shall have to return this summer to London, and shall then have much pleasure in giving to Messrs Smith Payne & Smith some little reminiscence from Troy for you. I have nothing from Mycenae myself; all my treasures are in the National Museum at Athens and belong to Greece.

Mrs Schliemann, who joins me in kindest regards to you, Mrs Parsons and Mrs Mackay, has been delivered here of a boy, who has got the name Agamemnon, [portion of letter is cut out.]

In recrossing the Alps a fortnight hence I shall remember the great pleasure I enjoyed 10 years ago in your and your ladies' charming company on our trip from Chambery to Susa.

~~~

5 Boulevard St Michel, Paris, June 14, 1878

My dear Mr Parsons
I just returned from Athens, and have the immense regret to inform you that the sample-shutter, which you kindly sent me, is certainly not fit for a mansion of that character as I am building. You will see it your self when you and Mrs Parsons come to see us at Athens. I have not the slightest doubt but your artist could, if he saw the edifice, make the inner shutters of perfectly the form and solidity required. But, to give exact instructions in that respect, is, with the distance which separates us, quite out of the question.

I am exceedingly sorry to have troubled you, and write Messrs Scribner Armstrong & Co in New York to send you a copy of Mycenae, which, pray, accept in kind remembrance of your fellow traveler across the Alps in 1868.

With kindest regards to you, Mrs Parsons and Mrs Macquay
yours very truly

HY SCHLIEMANN

~~~

Athens, Greece, February 9, 1882

My Dear Mr Parsons
I have hailed with very great joy your letter of the 2nd inst. As well as the splendid volume you sent me, and which Mrs Schliemann and I will read with the very greatest interest. In fact nothing could be more flattering to me than to see that you still so kindly remember your fellow traveller across the Mont Cenis in May 1868. To use reciprocity I send you a copy of my two last works Orchomenos and Journey in the Troas. I would have sent you also a copy of my Ilios if I did not feel sure that you already possess it.

With very great pleasure I have heard from American travellers of your growing prosperity; but with your iron will and the steadiness of your capacious mind that was of course to be expected. I think with a sigh of the happy time when I met you 14 years ago, for I had then but recently retired from commerce and had a great deal of leisure, whilst now I am continually overwhelmed with literary work and the older I become the more the burden which presses me becomes more heavy onerous. When you receive this letter I have again long since recommenced the exploration of ancient Troy, which bids fair to retain me on the shore of the Hellespont until August. It would be a great joy to Mrs Schliemann and us if you would honor us with your excellent Lady, either at Troy or here at Athens with your visit. In both places you will find a very warm welcome. My address at Troy is "D.H. Schliemann, Troy Near the Dardanelles." After this year's Trojan campaign we shall probably have to stay for two or three months at Paris to work up the French edition of

Ilios, which is to appear before the end of the year with Firmin Didot & Co. at Paris. Next winter we have an idea to do the Nile.

With heartiest wishes and kindest regards to you your good Lady and Mrs Mackay I remain truly your friend.

HY SCHLIEMANN

~~~

Troy near the Dardanelles, June 17, 1882

My dear Mr Parsons,
I read here your welcome letter of the 18th April and see from your remark that you possess "Troy and it Remains", but not my last child Ilios, of which I have great desire to present you a copy.

Should you happen to be in Europe you may perhaps take it with you from Mr Murray on your return. Otherwise please direct him how to send it.

You express the wish to be engaged in something that while giving you pleasure would confer benefit on the world. I can indeed propose you something which would render your name immortal and confer an immense benefit on the world; namely to excavate the great artificial mounds in the land of Goshen in Egypt and thus to bring light into the dark night of the history of the Jews before their emigration from Egypt.

If you will do it I shall probably excavate the mounds of the first Greek settlements in Egypt; but if you will not operate in Goshen I may do it myself; I shall, of course, not do it conjointly with you for if you do the work you must have all the glory of it. Mr Maspero, the director general of Egyptian Antiquities, as well as the American Consulate Cairo would give you all possible advice.

Mrs Schliemann, who works here with me, joins me in kindest regards to you Mrs Parsons and Mrs Mackay.

Yours very truly

HY SCHLIEMANN

~~~

Athens, Greece, November 25, 1883

My dear Mr Parsons,

Mrs Schliemann and I we have had the very greatest pleasure in receiving your kind letter of October 14th with your amiable Lady's photograph to which we allot a place of honour in our album. I rejoice to see that a long time of fifteen and a half years have not brought on the slightest change in her appearance; in fact she looks now younger than in fall 1868, when I had last the good luck to meet you at Paris.

We are delighted to see that you had been pleased with Mrs Schliemann's photograph as well as with that of our house at which you both a standing invitation. We are much grieved to hear that Mrs Mackay has had the misfortune to sprain her ankle and has for six months been unable to walk. But it is a great consolation to us to think that with her enthusiasm for literature she will at least not have had time to feel tedious. We are very glad to learn that she is now quite well again. It has given me great pleasure to see that you have been pleased with my Ilios.

With kindest regards of Mrs Schliemann and myself to you, Mrs Parsons and Mrs Mackay, I remain, very truly yours

Hy Schliemann

I am now busy with the French editions of Ilios but as soon as that is finished I hope to explore Crete.

# NOTES

## Preface

1. *St. Louis Republic*, "Obituary of Charles Parsons."
2. Mildred Lane Kemper Art Museum, "About."
3. Morita, *Book of Incense*, 31.
4. Ibid.
5. Mildred Lane Kemper Art Museum, "Artwork Detail: Incense Burner."
6. Humane Society of Missouri, "Humane Society of Missouri History."
7. *Artforum*, "Expanded Kemper Art Museum to Reopen in September."

## Acknowledgements

8. Beal, *Charles Parsons Collection of Paintings*, 14.

## Chapter 1

9. Burt and Parsons, *Cornet Joseph Parsons*, 151–52.
10. *St. Louis Republic*, "Obituary of Charles Parsons."
11. Burt and Parsons, *Cornet Joseph Parsons*, 152–53.
12. Ibid., 152.
13. Ibid.
14. Yale University, *Obituary Record of Graduates of Yale College*, 278.
15. Reid, *Alton, Illinois*.
16. Burt and Parsons, *Cornet Joseph Parsons*, 152–53.

17. Ibid., 152.
18. Ibid., 153.
19. Ibid.
20. Ibid.
21. Ibid.
22. Ibid.
23. Ibid., 151.
24. Parsons, *Genealogy of the Family*, 33.
25. Ibid., 29.
26. Burt and Parsons, *Cornet Joseph Parsons*, 151.
27. Ibid.
28. Parsons, *Genealogy of the Family*, 27.
29. Ibid., 27.
30. Ibid., 38.
31. Ibid., 33.
32. Ibid., 29.
33. Ibid., 28.
34. Ibid., 30.
35. Ibid., 34.
36. Ibid., 33.
37. Ibid., 31.
38. Ibid., 29.
39. Ibid., 39.
40. Ibid., 29.
41. Ibid., 28.
42. Ibid.
43. Ibid., 29.
44. Ibid., 30.
45. Beal, *Charles Parsons Collection of Paintings*, 4.
46. Ibid.
47. Ibid.
48. Ibid.
49. Parsons, *Genealogy of the Family*, 28.
50. Beal, *Charles Parsons Collection of Paintings*, 4.
51. Ibid.
52. Ibid., 5.
53. Ibid.
54. Ibid.
55. Ibid.
56. Ibid.

# Chapter 2

57. Ibid., 6.
58. Internet Solutions Inc. and the Lee County Historical Society, "History of Keokuk."
59. Bartlett, *Dictionary of Americanisms*, 241.
60. Fairchild, *History of Medicine in Iowa*, 3–25.
61. Internet Solutions Inc. and the Lee County Historical Society, "History of Keokuk."
62. Ibid.
63. Atwater, *Remarks Made on a Tour*, 58–59.
64. Jung, *Black Hawk War of 1832*, 72.
65. Ibid., 55.
66. Ibid., 164–65.
67. Ibid., 79.
68. Black Hawk, *Life of Ma-Ka-Tai-Me-She-Kia-Kiak*.
69. Internet Solutions Inc. and the Lee County Historical Society, "History of Keokuk."
70. Beal, *Charles Parsons Collection of Paintings*, 6.
71. Jenson, *Encyclopedia History*, 398.
72. Ross, "Cases of Shattered Dreams," 201–39.
73. Beal, *Charles Parsons Collection of Paintings*, 6.
74. *New York Times*, "Gen. John W. Noble Is Dead."
75. Ross, "Cases of Shattered Dreams," 201–39.
76. Shea and Hess, *Pea Ridge*, 275–90.
77. United States Congress, "George W. McCrary," 179.
78. Twain, "Model Town."
79. Internet Solutions Inc. and the Lee County Historical Society, "History of Keokuk."
80. Longden, "Mark Twain."
81. Brooks, "Mark Twain's Civil War Experience."
82. Glasner, Cooley and Murphy, *Business Cycles and Depressions*, 131.
83. Marx and Engels, *Collected Works of Karl Marx and Frederick Engels*, 12:669–70.
84. Calomiris and Schweikart, "Panic of 1857," 807–34.
85. Ross, "Cases of Shattered Dreams," 45.
86. Glasner, Cooley and Murphy, *Business Cycles and Depressions*, 131.
87. Ross, "Cases of Shattered Dreams," 22.
88. Huston, "Western Grains and the Panic of 1857," 14–32.
89. Beal, *Charles Parsons Collection of Paintings*, 6.
90. Ibid.

91. Hyde and Conard, *Encyclopedia of the History of St. Louis*, 3, 2:1,721.
92. Dan Fuller, conversation with the author, August 14, 2018.
93. Beal, *Charles Parsons Collection of Paintings*, 6.
94. Ibid.
95. Ibid.
96. Ibid.
97. Ibid.
98. Ibid.
99. Ibid.
100. Ibid.
101. Ibid.
102. Calomiris and Schweikart, "Panic of 1857," 816.
103. Noble, "Address Before the Missouri Historical Society on Charles Parsons."
104. Ibid.
105. Ibid.
106. Heitman, *Historical Register and Dictionary of the United States Army*, 749.
107. Noble, "Address Before the Missouri Historical Society on Charles Parsons," 6.
108. Ibid., 4.

## Chapter 3

109. Noble, "Address Before the Missouri Historical Society on Charles Parsons," 5–6.
110. Heitman, *Historical Register and Dictionary of the United States Army*, 749.
111. Rines and Beach, "John Willock Noble," 480.
112. Malloy, "Charles Parsons, Quartermaster," 1.
113. Letter from S.F. Chalfin, Assistant Adjunct General, War Department, Washington, to Charles Parsons, June 6, 1864.
114. Malloy, "Charles Parsons, Quartermaster," 4.
115. Ibid., 1.
116. Parsons, *Lewis Baldwin Parsons*, 9.
117. Ibid., 10.
118. Ibid., 11.
119. Ibid., 12.
120. John Maurath, conversation with author, August 2018.
121. Sherman, "From the Battle of Bull Run."
122. Malloy, "Charles Parsons, Quartermaster," 3.
123. Sherman, "From the Battle of Bull Run," 192.
124. Burt and Parsons, *Cornet Joseph Parsons*, 151–54.
125. "Charles Parsons for Appointment as Assistant Quartermaster."

126. King, *Lincoln's Manager*, 314.
127. Parsons, *Genealogy of the Family*, 33.
128. Maurath, conversation.
129. Beal, *Charles Parsons Collection of Paintings*, 7.
130. Maurath, conversation.
131. Ibid.
132. Malloy, "Charles Parsons, Quartermaster," 3.
133. Ibid.
134. Ibid., 2.
135. Ibid., 3.
136. Ibid., 4.
137. Ibid., 2.
138. Ibid.
139. Ibid., 5.
140. Ibid.
141. Ibid., 6.
142. Ibid.
143. Beal, *Charles Parsons Collection of Paintings*, 7.
144. Malloy, "Charles Parsons, Quartermaster," 8.
145. Ibid.
146. Ibid., 9.
147. Ibid.
148. Ibid.
149. Ibid., 10.
150. Ibid.
151. Ibid., 11.
152. Ibid.
153. Ibid., 19.
154. Ibid., 20–21.
155. Ibid., 20.
156. Ibid.
157. Ibid.
158. Ibid., 21.
159. Ibid.
160. "Envelope," Charles Parsons Papers, 1808–1940 (Bulk 1862–1864), Collection A1185, Box 44, Missouri Historical Society, St. Louis.
161. Malloy, "Charles Parsons, Quartermaster," 22, Charles Parsons Papers, 1808–1940 (Bulk 1862–1864), Collection A1185, Box 44, Missouri Historical Society, St. Louis.
162. Rule, "Tucker's War."
163. Malloy, "Charles Parsons, Quartermaster," 20.

164. Parsons, *Lewis Baldwin Parsons*, 11.
165. Ibid., 12.

## Chapter 4

166. Burt and Parsons, *Cornet Joseph Parsons*, 164.
167. White, "World's Fair City," 734.
168. Hyde and Conard, *Encyclopedia of the History of St. Louis*, 1:397.
169. Compton and Dry, *Pictorial St. Louis*, pl. 71, no. 14.
170. Ibid., pl. 71.
171. Hyde and Conard, *Encyclopedia of the History of St. Louis*, 1:397.
172. Ibid., 1398.
173. Stevens, *St. Louis, the Fourth City*, 1:323–24.
174. Hyde and Conard, *Encyclopedia of the History of St. Louis*, 1:398.
175. Ibid.
176. American Bankers Association, *Proceedings of the Convention*, 50, 127.
177. *St. Louis Post-Dispatch*, "St. Louis and Missouri."
178. Gage, *World's Congress of Bankers and Financiers*, 31.
179. Losses, "Early St. Louis Hotels."
180. Beal, *Charles Parsons Collection of Paintings*, 4.
181. Losses, "Early St. Louis Hotels."
182. Ibid.
183. Tower Grove Park, "Ruin/Fountain Pond, Tower Grove Park."
184. Sharoff, *American City*, xi.
185. Ibid.
186. Treacy, *Grand Hotels of St. Louis*, 8.
187. Tebbe, "Fate of Flames."
188. Parsons, *Notes of a Trip*, dedication.
189. Zimmerman, "General Sherman's St. Louis Home."
190. Depew and Champlin, *Orations and Memorial Addresses*, 140.
191. *St. Louis Post-Dispatch*, "Dead Warrior."
192. O'Connell, *Fierce Patriot*, 32.
193. Ibid., 46.
194. Ibid., 23.
195. Ibid., 24.
196. Charles Parsons Papers, 1808–1940 (Bulk 1862–1864), Collection A1185, Box 44, Missouri Historical Society, St. Louis.
197. Ibid.
198. Ibid.
199. *St. Louis Post-Dispatch*, "Dead Warrior."

200. Ibid.

201. Ibid.

202. Ibid.

203. Parsons, *Genealogy of the Family*, 33.

204. *St. Louis Post-Dispatch*, "Nephew Chief Parsons Heir."

205. *St. Louis Post-Dispatch*, "Buried This Morning."

206. O'Connor, *Hope and Healing*, 23.

207. *St. Louis Post-Dispatch*, "Humane Society Annual Meeting."

208. Burt and Parsons, *Cornet Joseph Parsons*, 151–52.

209. Parsons, *Fifty Years of Parsons College*, 35.

210. C. Parsons, "Last Will and Testament," in *St. Louis Post-Dispatch*, "Nephew Chief Parsons Heir."

211. *St. Louis Post-Dispatch*, "M'Kinley and His Cabinet."

212. The following account is described in *St. Louis Post-Dispatch*, "Took His Life."

213. American Bankers Association, *Proceedings of the Convention*, 4, 120.

214. *St. Louis Post-Dispatch*, "Views of Charles Parsons."

215. Parsons, *Silver Question*.

216. American Bankers Association, *Proceedings of the Convention*, 4, 120.

217. Parsons, *Silver Question*.

218. Ibid.

219. Nugent, *Money and American Society*.

220. Friedman, "Bimetallism Revisited," 85–104.

221. Birch, "World's Silver 'Dumping Ground.'"

222. The following summary and excerpts are from Parsons, *Silver Question*.

223. Williams, *Realigning America*.

224. *St. Louis Post-Dispatch*, "The Parade."

225. Ibid. The following excerpts are all from this article.

226. *St. Louis Post-Dispatch*, "Bankers' Dole to Mark Hanna."

227. Parsons, "Mr. Parsons Denies."

228. *St. Louis Post-Dispatch*, "Elected Director."

229. *St. Louis Post-Dispatch*, "Nicaragua Canal."

230. *St. Louis Post-Dispatch*, "Noonan's Menace."

231. *St. Louis Post-Dispatch*, "St. Louis Mayors."

232. Ibid.

233. *St. Louis Post-Dispatch*, "Noonan's Menace."

## Chapter 5

234. Beal, *Charles Parsons Collection of Paintings*, 9.

235. Payne, *Gold of Troy*.

236. Schliemann, *Ilios*, 6.

237. Ibid., 12.
238. Ibid.
239. Ibid., 815.
240. Ibid., 41.
241. Ibid., 17.
242. Heuck, *Finding the Walls of Troy*, 112.
243. Schliemann, *Ilios*, 769.
244. Riley, *Divorce*, 66.
245. Taylor, "So She Went."
246. Ibid.
247. Ibid.
248. Ibid.
249. Ibid.
250. Ibid.
251. Ibid.
252. Letter from Heinrich Schliemann, May 10, 1869, from Indianapolis, Indiana. This and all subsequent letters quoted here are in the Charles Parsons Papers, 1808–1940 (Bulk 1862–1864), Missouri Historical Society, St. Louis.
253. Schliemann, *Ilios*, 21.
254. Ibid.
255. Ibid., 44.
256. Ibid., 41.
257. Ibid., 45.
258. Ibid., 20.
259. Parsons, *Notes of a Trip*, 140.
260. Schliemann, *Ilios*, 603.
261. Calder, "Schliemann on Schliemann," 335–53.
262. McGovern, "Operation and Death of Henry Schliemann," 1:726–30.
263. *Complete Dictionary of Scientific Biography*, "Heinrich Schliemann."
264. New World Encyclopedia, "Heinrich Schliemann."

## Chapter 6

265. City of St. Louis, "Brief History of St. Louis."
266. Mulkey, "History of the St. Louis School of Fine Arts," 9.
267. Ibid., 10.
268. Ibid.
269. Ibid.
270. Ibid., 11.
271. Ibid.

272. Ibid.
273. Ibid.
274. Ibid., 12.
275. Ibid.
276. Ibid., 19.
277. Ibid., 22.
278. Ibid., 7–8.
279. Ibid., 1.
280. Ibid., Appendix B.
281. Ibid., 60.
282. Ibid.
283. Ibid.
284. Ibid., 61.
285. Ibid., 67.
286. Ibid., 71.
287. Ibid.
288. Ibid., 76–77.
289. Ibid., 77.
290. Wisbey, "Halsey C. Ives."
291. Mulkey, "History of the St. Louis School of Fine Arts," 83.
292. Ibid., 83–84.
293. Ibid., 83.
294. Ibid., 84.
295. *Missouri Republican*, April 13, 1879.
296. Mulkey, "History of the St. Louis School of Fine Arts," 87.
297. Ibid.
298. Ibid., 88.
299. Ibid., 92.
300. Ibid., 116.
301. Ibid.
302. Ibid., 117.
303. Ibid.
304. *St. Louis Post-Dispatch*, "St. Louis and Missouri."
305. Larson, *Devil in the White City*.
306. Mulkey, "History of the St. Louis School of Fine Arts," 136–37.
307. Ibid., 138.
308. Ibid., 150.
309. Ibid., 152.
310. Ibid., 166.
311. Ibid., 180.
312. Ibid.

313. Ibid., 188.
314. Ibid.
315. Ibid., 189.
316. Ibid., 190.
317. Ibid.
318. Ibid., 191.
319. Ibid.
320. Ibid., 192.
321. Ibid., 193.
322. Ibid., 192.
323. Ibid.
324. Ibid.
325. Ibid., 195.
326. Ibid.
327. Ibid., 210.
328. Ibid., 164.

## *Chapter 7*

329. Culkin, *Harriet Hosmer*, 13.
330. Ibid.
331. Ibid.
332. Ibid.
333. Mulkey, "History of the St. Louis School of Fine Arts," 7–8.
334. Beal, *Charles Parsons Collection of Paintings*, 13.
335. Ibid.
336. Ibid.
337. Mulkey, "History of the St. Louis School of Fine Arts," 210.
338. Hunter, *Westmoreland and Portland Places*, 195.
339. Administrative Board of Control, minutes of meeting, 89.
340. A search with the term "Parsons" will bring up objects from his collection. See https://www.kemperartmuseum.wustl.edu/collection/explore.
341. Ibid., 135.
342. Craven, *American Art*, 332.
343. Inv. no. WU2106; see Washington University, "Charles Parsons Collection Inventory, 1923," 134–41.
344. Paulson, "Spotlight Essay."
345. Mildred Lane Kemper Art Museum, "Permanent Collection Label: *Twilight: Mount Desert Island, Maine*."
346. Champlin and Perkins, *Cyclopedia of Painters and Painting*, 295.
347. Inv. no. WU2175; see Mildred Lane Kemper Art Museum, "Permanent Collection Label: *Twilight: Mount Desert Island, Maine*."

348. Inv. no. WU 2174; see Beal, *Charles Parsons Collection of Paintings*, 12; Mildred Lane Kemper Art Museum, "Permanent Collection Label: *Sierra Nevada de Santa Marta.*"

349. Beal, *Charles Parsons Collection of Paintings*, 12.

350. Ibid., 13.

351. Ibid.

352. Ibid., 14.

353. See King, "Parsons Collection Shown."

354. Washington University, "Charles Parsons Collection Inventory," 136.

355. Avery, "Sanford Robinson Gifford."

356. Ibid.

357. Ibid.

358. Inv. nos. WU4064, WU2182 and WU2183; see Washington University, "Charles Parsons Collection Inventory," 136.

359. *Christian Register* 83, "Meetings," 193.

360. *Encyclopedia Britannica*, "Swedenborg, Emanuel."

361. Ibid.

362. Bell, *George Inness and the Visionary Landscape*, 151.

363. Inv. no. WU2189; see Washington University, "Charles Parsons Collection Inventory," 136.

364. Strahan, *Art Treasures of America*, 59.

365. Inv. no. WU2141; see Champlin and Perkins, *Cyclopedia of Painters and Painting*, 33.

366. Champlin and Perkins, *Cyclopedia of Painters and Painting*, 33.

367. Inv. no. WU2110; see Keith, "Spotlight Essay."

368. Keith, "Spotlight Essay."

369. Rehs Galleries Inc., "Biography—Jules Breton."

370. Jules Breton, letter to Charles Parsons, translated by Marc Felix, Charles Parsons Papers, 1808–1940 (Bulk 1862–1864), Collection A1185, Box 44, Missouri Historical Society, St. Louis.

371. Inv. no. WU2101; see Washington University, "Charles Parsons Collection Inventory," 136.

372. Quoted in Beal, *Charles Parsons Collection of Paintings*, 14.

373. Ibid.

374. Ibid.

375. Culkin, *Harriet Hosmer*, 14.

## *Chapter 8*

376. Sherwood, *Harriet Hosmer*.

377. Beal, *Charles Parsons Collection of Paintings*, 6.

378. Carr, *Harriet Hosmer*, 4.

379. Stevens, *St. Louis, the Fourth City*, 682.

380. Culkin, *Harriet Hosmer*, 20.

381. Ibid., 21.

382. Ibid.

383. Ibid., 10.

384. Ibid., 12.

385. Ibid., 9–10.

386. Ibid., 10.

387. Bolton, *Lives of Girls Who Became Famous*, 144.

388. Culkin, *Harriet Hosmer*, 10.

389. Ibid.

390. Ibid., 12.

391. Ibid.

392. Ibid.

393. Ibid., 8.

394. Ibid., 9.

395. Ibid.

396. Ibid., 16.

397. Cosner and Shannon, *Missouri's Mad Doctor McDowell*, 5.

398. Culkin, *Harriet Hosmer*, 16.

399. Sherwood, *Harriet Hosmer*, 24.

400. Culkin, *Harriet Hosmer*, 16.

401. Cosner and Shannon, *Missouri's Mad Doctor McDowell*, 16, 52.

402. Ibid., 53.

403. Bolton, *Lives of Girls Who Became Famous*, 143.

404. Culkin, *Harriet Hosmer*, 15.

405. Cosner and Shannon, *Missouri's Mad Doctor McDowell*, 109.

406. Ibid., 112.

407. Culkin, *Harriet Hosmer*, 25.

408. Cosner and Shannon, *Missouri's Mad Doctor McDowell*, 42.

409. Ibid., 119.

410. Ibid., 42.

411. Ibid., 46.

412. Ibid.

413. Ibid., 43.

414. Ibid., 43–45.

415. Carr, *Harriet Hosmer*, 12.

416. Culkin, *Harriet Hosmer*, 20.

417. Carr, *Harriet Hosmer*, 20.

418. Sherwood, *Harriet Hosmer*, 26.

419. Cosner and Shannon, *Missouri's Mad Doctor McDowell*, 55.

420. Stevens, *St. Louis, the Fourth City*, 682.

421. Ibid., 47.

422. Ibid.

423. Ibid., 51.

424. Ibid., 54.

425. Ibid., 84.

426. Ibid., 92.

427. Ibid., 4.

428. Ibid., 29.

429. Vicinus, "Laocoöning in Rome," 354.

430. Culkin, *Harriet Hosmer*, 3.

431. Vicinus, "Laocoöning in Rome," 355.

432. Ibid., 354.

433. Ibid., 356.

434. Ibid.

435. Ibid.

436. Culkin, *Harriet Hosmer*, 22.

437. Vicinus, "Laocoöning in Rome," 355.

438. Ibid., 358.

439. Ibid.

440. Ibid., 359.

441. Ibid.

442. Culkin, *Harriet Hosmer*, 4.

443. Heinrich Schliemann, letter to Charles Parsons, 1883, Charles Parsons Papers, 1808–1940 (Bulk 1862–1864), Collection A1185, Box 44, Folder 13–17, Missouri Historical Society, St. Louis.

444. *St. Louis Post-Dispatch*, "In Society."

445. *St. Louis Post-Dispatch*, "At Lake and Sea."

446. *St. Louis Post-Dispatch*, "Patriotic Ladies."

447. *St. Louis Post-Dispatch*, "Loan Exhibition."

448. Vicinus, "Laocoöning in Rome," 362.

449. Carr, *Harriet Hosmer*, 263.

450. Ibid.

451. Sherwood, *Harriet Hosmer*, 322.

452. *School Journal* 75, "Present Day Biography: A Great Little Woman," 733.

## Chapter 9

453. Beal, *Charles Parsons Collection of Paintings*, 1.

454. Hunter, *Westmoreland and Portland Places*, 195.

455. Accession record, inv. no. WU99, Mildred Lane Kemper Art Museum, Washington University, St. Louis.

456. Deaccession records for 1969, Mildred Lane Kemper Art Museum, Washington University, St. Louis.

457. Polo, Yule and Cordier, *Travels of Marco Polo*, 80.

458. Morita, *Book of Incense*, 80.

459. Ibid., 43.

460. Sensei Drda, conversations with author, 1987–94.

461. Sandfield, *Ultimate Netsuke Bibliography*, 1:413.

462. Azusa Tanaka, interview with the author, St. Louis, Missouri, September 21, 2010.

463. Van Norden, "Mencius."

464. Tanaka, interview.

465. Mencius, *Mengzi*.

466. Morita, *Book of Incense*, 46.

467. Bedini, *Trail of Time*, 35.

468. Sensei Drda, conversations.

469. Beal, *Charles Parsons Collection of Paintings*, 11.

470. Parsons, *Notes of Travel*, 27

471. Ibid., 11.

472. Ibid., 9.

473. Huntington, "Sixteen Buddhist Arhats," 62.

474. Krasno, *Floating Lanterns and Golden Shrines*, 9.

475. Tanaka, interview.

476. Shinmura, *Japanese Etymological Dictionary*, 115.

477. Sasama, *Fukugen*, 79.

478. Michener, *Hokusai Sketchbooks*, 163.

479. Ibid.

480. Ibid., 14.

481. Ibid., 11.

482. Deguchi, "One Hundred Demons and One Hundred Supernatural Tales," 21.

483. Dunn, *Everyday Life in Traditional Japan*, 21.

484. Michener, *Hokusai Sketchbooks*, 174.

485. Bedini, *Trail of Time*, 26.

486. Nicoloff, *Sacred Kōyasan*, 46.

487. Bedini, *Trail of Time*, 25.

488. Ibid.

489. Ibid., 33.

490. Ibid.

491. Ibid., 34.

492. Ibid., 35.

493. Morita, *Book of Incense*, 36.

494. Ng, Chang and Kadir, "Review on Agar (Gaharu) Producing Aquilaria Species," 272–85.

495. Bedini, *Trail of Time*, 76.

496. Ibid., 72.

497. Ibid.

498. Casal, "Incense," 47.

499. Morita, *Book of Incense*, 18–19.

500. Casal, "Incense," 50.

501. Bedini, *Trail of Time*, 45.

502. Casal, "Incense," 52.

503. Ibid.

504. Huntington, "Sixteen Buddhist Arhats," 62.

505. Ibid., 64.

506. Groner, *Saicho*, 47.

507. Bedini, *Trail of Time*, 75.

508. Ibid., 75–76.

509. Ibid.

510. Ibid., 77.

## Chapter 10

511. Parsons, *Notes of a Trip*, 144.

512. C.A. Wellington, letter to Charles Parsons, Boston, September 15, 1879, transcription of letters of Heinrich Schliemann to Charles Parsons, 1869–83, Charles Parsons Papers, 1808–1940 (Bulk 1862–1864), Collection A1185, Box 44, Folder 13–17, Missouri Historical Society, St. Louis.

513. O'Connor and Cline, *Amenhotep III*, 120.

514. Forbes, "Giants of Egyptology," 14–16.

515. Rawnsley, *Notes for the Nile*, 200.

516. Forbes, "Giants of Egyptology," 14–16.

517. Ibid.

518. Rawnsley, *Notes for the Nile*, 136.

519. O'Connor and Cline, *Amenhotep III*, 119.

520. Forbes, "Giants of Egyptology," 14–16.

521. Ibid.

522. Ibid.

523. Ibid.

524. Ibid.

525. Ibid.

526. Ibid.
527. Ibid.
528. St. Louis Art Museum, exhibition and exhibition label.
529. Ibid.
530. Ibid.
531. Capel and Markoe, *Mistress of the House, Mistress of Heaven*, 168–69.
532. O'Connor and Cline, *Amenhotep III*, 113.
533. Ibid.
534. Capel and Markoe, *Mistress of the House, Mistress of Heaven*, 168–69.
535. Ibid.
536. Ibid.
537. Ibid.
538. O'Connor and Cline, *Amenhotep III*, 119.
539. Capel and Markoe, *Mistress of the House, Mistress of Heaven*, 168–69.
540. O'Connor and Cline, *Amenhotep III*, 119–20.
541. Ibid.
542. Kosloff and Bryan, *Egypt's Dazzling Sun*, 312–17.

## *Chapter 11*

543. Parsons, *Fifty Years of Parsons College*, 21.
544. Ibid., 20.
545. Ibid., 21.
546. Ibid.
547. Ibid., 17.
548. Ibid., 19.
549. Ibid., 20.
550. Ibid., 21–22.
551. Ibid., 22.
552. Ibid., 24.
553. Ibid.
554. Ibid.
555. Ibid.
556. Ibid.
557. Ibid.
558. Ibid., 26.
559. Ibid.
560. Ibid., 27.
561. Ibid., 29.
562. Ibid.

563. Ibid., 36.
564. Ibid., 95.
565. Ibid., 36.
566. Ibid., 30.
567. Gabbert, "Parsons."
568. Engel, "Maharishi International University," 19.

## Chapter 12

569. Beal, *Charles Parsons Collection of Paintings*, 11.
570. Parsons, *Notes of a Trip*, 1.
571. King, "Parsons Collection Shown."
572. Parsons, *Notes of a Trip*, 2.
573. Ibid.
574. Ibid., 12.
575. Ibid.
576. Ibid., 12–13.
577. Ibid., 15.
578. Ibid., 19.
579. Ibid., 27.
580. Cockington, "Land of the Rising Sum."
581. Pollard, *Master Potter of Meiji Japan*, 99.
582. Olson, "New York Surpasses World Record Price."
583. Parsons, *Notes of a Trip*, 13.
584. Ibid., 20.
585. Ibid., 14.
586. Ibid., 36–37.
587. Ibid., 41.
588. Ibid., 43.
589. Ibid., prologue.
590. Ibid., 177.

## Chapter 13

591. *St. Louis Post-Dispatch*, "Simplicity at the Funeral of Mr. Parsons."
592. Paul Anderson and Annette Carr, Christ Church Cathedral, e-mail correspondence with author, March 5, 2014.
593. Ibid.
594. *St. Louis Post-Dispatch*, "Simplicity at the Funeral of Mr. Parsons."
595. Ibid.

596. The sarcophagus of Lucius Cornelius Scipio Barbatus is well known and is in the collection of the Museo Pio Clementino, Musei Vaticani, Vatican City.

597. Burt and Parsons, *Cornet Joseph Parsons*, 165–68.

598. *St. Louis Post-Dispatch*, "St. Louis Helps Volcano Victims."

599. *St. Louis Post-Dispatch*, "Scenes in Hawaii."

600. *St. Louis Post-Dispatch*, "Nephew Chief Parsons Heir."

601. Ibid.

602. Ibid.

603. Ibid.

604. Ibid.

605. See https://www.kemperartmuseum.wustl.edu/collection/explore (use the search term "Parsons").

606. Ibid.

607. Ibid.

608. Shikibu, *Tale of Genji*, 739.

# *Appendix*

609. I owe a debt of gratitude to both the Missouri Historical Society, St. Louis, and the Indiana Historical Society, Indianapolis, for permission to publish the remaining letters between Charles Parsons and Heinrich Schliemann. Joanna Potenza transcribed the letters from the Missouri Historical Society and supplied the text in brackets. Where appropriate, I have made notes to connect known facts and other points.

610. Eli Lilly (1885–1977), Indianapolis industrialist, historian and archaeologist, became interested in Schliemann's Hoosier interlude because of his own interests in classical Greece and archaeology. With the help of professional scholars, he assembled Schliemann's letters written while in Indianapolis, had them translated, edited them and then published them in 1961 under the aegis of the Indiana Historical Society. See Lilly, *Schliemann in Indianapolis*, and Heinrich Schliemann Papers, 1869–1960, M0378, nos. 1961.1004 and 1962.1006. See also Yaggy and Haines, *Museum of Antiquity*, 385–422.

# BIBLIOGRAPHY

Administrative Board of Control. Minutes of meeting of the Administrative Board of Control of the City Art Museum of St. Louis, held at the museum on October 19, 1923, 3:00 p.m. St. Louis, MO: City Art Museum of St. Louis, 1923.

American Bankers Association. *Proceedings of the Convention of the American Bankers Association (1893–1894)*. New York: American Bankers Association, 1894.

*Artforum*. "Expanded Kemper Art Museum to Reopen in September." March 21, 2019. https://www.artforum.com/news/expanded-kemper-art-museum-to-reopen-in-september-79004.

Atwater, Caleb. *Remarks Made on a Tour to Prairie du Chien, thence to Washington City, in 1829*. Columbus, OH: Isaac Whiting, 1831.

Avery, Kevin J. "Sanford Robinson Gifford (1823–1880)." *Heilbrunn Timeline of Art History*. New York: Metropolitan Museum of Art, 2009. http://www.metmuseum.org/toah/hd/giff/hd_giff.htm.

Bartlett, John Russell. *Dictionary of Americanisms: A Glossary of Words and Phrases Usually Regarded as Peculiar to the United States*. Boston: Little, Brown, and Company, 1877.

Beal, Graham W.J. *Charles Parsons Collection of Paintings*. St. Louis, MO: Washington University, 1977.

Bedini, Silvio. *The Trail of Time: Time Measurement with Incense in East Asia*. Cambridge, UK: Cambridge University Press, 2005.

Bell, Adrienne Baxter. *George Inness and the Visionary Landscape*. New York: National Academy of Design, 2003.

Birch, Thomas. "The World's Silver 'Dumping Ground.'" *St. Louis Post-Dispatch*, October 23, 1896.

Black Hawk. *Life of Ma-Ka-Tai-Me-She-Kia-Kiak, or Black Hawk*. Cincinnati, OH, 1833.

Bolton, Sarah K. *Lives of Girls Who Became Famous*. New York: Thomas Y. Crowell, 1914.

Brooks, Rebecca Beatrice. "Mark Twain's Civil War Experience." Civil War Saga, October 5, 2011. http://civilwarsaga.com/mark-twains-civil-war-experience.

Burt, Henry M., and Albert Ross Parsons. *Cornet Joseph Parsons: One of the Founders of Springfield and Northampton, Massachusetts*. Garden City, NY: Albert Ross Parsons, 1898.

Calder, William M., III. "Schliemann on Schliemann: A Study in the Use of Sources." *Greek, Roman, and Byzantine Studies* 13, no. 3 (2003): 335–53.

Calomiris, Charles W., and Larry Schweikart. "The Panic of 1857: Origins, Transmission, and Containment." *Journal of Economic History* 51, no. 4 (1991): 807–34.

Capel, Anne K., and Glenn E. Markoe. *Mistress of the House, Mistress of Heaven: Women in Ancient Egypt*. New York: Hudson Hills Press, 1996.

Carr, Cornelia, ed. *Harriet Hosmer: Letters and Memories*. New York: Moffat, Yard and Company, 1912.

Casal, U.A. "Incense." *Transactions of the Asiatic Society of Japan* 3, no. 3 (1954).

Champlin, John Denison, and Charles Callahan Perkins. *Cyclopedia of Painters and Painting*. New York: C. Scribner's Sons, 1913.

"Charles Parsons for Appointment as Assistant Quartermaster." Washington, D.C.: Government Printing Office, 1862. Civil War, Military Records, U.S. National Archives, Washington, D.C.

*Christian Register* 83 "Meetings" (February 18, 1904): 192–93.

City of St. Louis. "A Brief History of St. Louis." https://www.stlouis-mo.gov/visit-play/stlouis-history.cfm.

Cockington, James. "Land of the Rising Sum." *Sydney Morning Herald*, February 4, 2009. https://www.smh.com.au/business/land-of-the-rising-sum-20090204-gdtc3p.html.

*Complete Dictionary of Scientific Biography*. "Heinrich Schliemann." New York: Charles Scribner's Sons, 2008. https://www.encyclopedia.com/people/social-sciences-and-law/archaeology-biographies/heinrich-schliemann.

Compton, Richard J., and Camille N. Dry. *Pictorial St. Louis, the Great Metropolis of the Mississippi Valley: A Topographical Survey Drawn in Perspective A.D. 1875*. St. Louis, MO: Compton and Company, 1876.

Cosner, Victoria, and Lorelei Shannon. *Missouri's Mad Doctor McDowell: Confederates, Cadavers, and Macabre Medicine*. Charleston, SC: The History Press, 2015.

Craven, Wayne. *American Art: History and Culture*. New York: Harry N. Abrams, 1994.

Culkin, Kate. *Harriet Hosmer, a Cultural Biography*. Amherst: University of Massachusetts Press, 2010.

Deguchi, Midori. "One Hundred Demons and One Hundred Supernatural Tales." In *Japanese Ghosts and Demons: Art of the Supernatural*. Edited by Stephen Addiss. New York: G. Braziller, 1985.

Depew, Chauncey Mitchell, and John Denison Champlin. *Orations and Memorial Addresses*. New York, 1910.

Dunn, Charles J. *Everyday Life in Traditional Japan*. Rutland, VT: Charles E. Tuttle, 1972.

*Encyclopedia Britannica.* "Swedenborg, Emanuel." 11th ed. N.p., 1911.

Engel, Allison. "Maharishi International University Mixes Meditation and Education." *Change* 7, no. 4 (1975): 19–22.

Fairchild, D.S. *History of Medicine in Iowa*. Des Moines: Iowa State Medical Society, 1927.

Forbes, Dennis C. "Giants of Egyptology: The Brothers Brugsch." *KMT: A Modern Journal on Ancient Egypt* 7, no. 3 (Fall 1996): 14–16.

Friedman, Milton. "Bimetallism Revisited." *Journal of Economic Perspectives* 4, no. 4 (Autumn 1990): 85–104.

Gabbert, Dean. "Parsons: 98 Years of Service, Life and Death of a College." *Fairfield Ledger*, June 1, 1973.

Gage, Lyman J. *World's Congress of Bankers and Financiers*. Chicago: Rand, McNally and Company, 1893.

Glasner, David, Thomas F. Cooley and Larry Murphy. *Business Cycles and Depressions: An Encyclopedia*. New York: Taylor and Francis, 1997.

Groner, Paul. *Saicho: The Establishment of the Japanese Tendai School*. Honolulu: University of Hawaii Press, 2000.

Heinrich Schliemann Papers, 1869–1960. M0378, nos. 1961.1004 and 1962.1006. Indiana Historical Society, Indianapolis.

Heitman, Francis B. *Historical Register and Dictionary of the United States Army: From Its Organization, September 29, 1789, to March 2, 1903*. Washington, D.C.: Government Printing Office, 1903.

Heuck, Susan Allen. *Finding the Walls of Troy: Frank Calvert and Heinrich Schliemann at Hisarlik*. Berkeley: University of California Press, 1999.

Humane Society of Missouri. "Humane Society of Missouri History." http://hsmo.org/history.

Hunter, Julius. *Westmoreland and Portland Places: The History of America's Premier Private Streets, 1888–1988*. Columbia: University of Missouri Press, 1988.

Huntington, Harriet E. "The Sixteen Buddhist Arhats." *Arts of Asia* 7 (1997): 62–89.

Huston, James L. "Western Grains and the Panic of 1857." *Agricultural History* 57, no. 1 (1983): 14–32.

Hyde, William, and Howard L. Conard, eds. *Encyclopedia of the History of St. Louis: A Compendium of History and Biography for Ready Reference*. New York: Southern History Company, 1899.

Internet Solutions Inc. and the Lee County Historical Society. "The History of Keokuk." http://www.keokuk.net/history/1820sto.htm#Top.

Jenson, Andrew. *Encyclopedia History of The Church of Jesus Christ of Latter-day Saints*. Salt Lake City, UT: Deseret News, 1941.

Jung, Patrick J. *The Black Hawk War of 1832*. Norman: University of Oklahoma Press, 2007.

Keith, Rachel. "Spotlight Essay: Narcisse Virgile Diaz de La Peña." Mildred Lane Kemper Art Museum. https://samfoxschool.wustl.edu/node/11281.

King, Mary. "Parsons Collection Shown at Steinberg Hall Gallery." *St. Louis Post-Dispatch*, December 24, 1976.

King, Willard L. *Lincoln's Manager: David Davis*. Cambridge, MA: Harvard University Press, 1960.

Kosloff, Arielle P., and Betsy Morrell Bryan. *Egypt's Dazzling Sun: Amenhotep III and His World*. Cleveland, OH: Cleveland Museum of Art, 1992.

Krasno, Rena. *Floating Lanterns and Golden Shrines: Celebrating Japanese Festivals*. Berkeley, CA: Pacific View Press, 2000.

Larson, Erik. *The Devil in the White City*. New York: Crown Publishers, 2003.

Lilly, Eli, ed. *Schliemann in Indianapolis*. Indianapolis: Indiana Historical Society, 1961.

Longden, Tom. "Mark Twain." *Des Moines Register Data Central*. https://data.desmoinesregister.com/famous-iowans/mark-twain.

Losses, David A. "Early St. Louis Hotels." Genealogy in St. Louis. https://stlouis.genealogyvillage.com/hotels.htm.

Malloy, George. "Charles Parsons, Quartermaster, 1861–1863." Unpublished manuscript, Missouri Historical Society, St. Louis.

Marx, Karl, and Frederick Engels. *Collected Works of Karl Marx and Frederick Engels*. Vol. 12, *Marx and Engels 1853–1854*. New York: International Publishers, 1979.

McGovern, Francis H. "The Operation and Death of Henry Schliemann." *Laryngoscope* 87 (October 1977): 1726–30. https://pdfs.semanticscholar.org/8bec/aab3749dad3646e37493026e18efece67e24.pdf.

Mencius. *Mengzi, with Selections from Traditional Commentaries*. Translated by Bryan W. Van Norden. Indianapolis, IN: Hackett, 2008.

Michener, James A. *The Hokusai Sketchbooks*. Rutland, VT: C.E. Tuttle Company, 1958.

Mildred Lane Kemper Art Museum. "About." https://www.kemperartmuseum.wustl.edu/about.

———. "Artwork Detail: Incense Burner." https://www.kemperartmuseum.wustl.edu/collection/explore/artwork/1999.

———. "Permanent Collection Label: *Sierra Nevada de Santa Marta*." https://www.kemperartmuseum.wustl.edu/collection/explore/artwork/440.

———. "Permanent Collection Label: *Twilight: Mount Desert Island, Maine*." https://www.kemperartmuseum.wustl.edu/collection/explore/artwork/439.

Morita, Kiyoko. *The Book of Incense: Enjoying the Traditional Art of Japanese Scents*. Tokyo: Kodansha International, 1992.

Mulkey, Mab. "History of the St. Louis School of Fine Arts, 1879–1909: The Art Department of Washington University." MA thesis, Washington University in St. Louis, 1944.

New World Encyclopedia. "Heinrich Schliemann." https://www.newworldencyclopedia. org/entry/Heinrich_Schliemann.

*New York Times.* "Gen. John W. Noble Is Dead; Secretary of the Interior in Harrison's Cabinet Dies at 80." March 23, 1912.

Ng, L.T., Y.S. Chang and A.A. Kadir. "A Review on Agar (Gaharu) Producing Aquilaria Species." *Journal of Tropical Forest Products* 2, no. 2 (1997): 272–85.

Nicoloff, Philip L. *Sacred Kōyasan: A Pilgrimage to the Mountain Temple of Saint Kōbō Daishi and the Great Sun Buddha.* Albany: State University of New York Press, 2008.

Noble, John. "Address Before the Missouri Historical Society on Charles Parsons." Charles Parsons Papers, 1808–1940 (Bulk 1862–1864), Collection A1185, Box 44, Missouri Historical Society, St. Louis.

Nugent, Walter T.K. *Money and American Society, 1865–1880.* New York: Free Press, 1968.

O'Connell, Robert L. *Fierce Patriot: The Tangled Lives of William Tecumseh Sherman.* New York: Random House, 2014.

O'Connor, Candace. *Hope and Healing St. Louis Children's Hospital: The First 125 Years.* St. Louis, MO: St. Louis Children's Hospital, 2006.

O'Connor, David, and Eric H. Cline. *Amenhotep III: Perspectives on His Reign.* Ann Arbor: University of Michigan Press, 1998.

Olson, Jeff. "New York Surpasses World Record Price for Yabu Meizan." Bonhams, September 16, 2014. https://www.bonhams.com/press_release/17459/#/ MR3_length=12&m3=3.

Parsons, Charles. "Mr. Parsons Denies." *St. Louis Post-Dispatch,* September 24, 1896.

———. *Notes of a Trip Around the World in 1894 and 1895.* St. Louis, MO: George D. Barnard and Company, 1896.

———. *The Silver Question.* St. Louis: Missouri Bankers Association, 1896.

Parsons, Julia E. *Lewis Baldwin Parsons.* N.p.: self-published, 1909.

Parsons, Lewis B., Jr. *Genealogy of the Family of Lewis B. Parsons.* St. Louis, MO: Perrin and Smith Printing Company, 1900.

Parsons, Willis Edwards. *Fifty Years of Parsons College 1875–1925.* Fairfield, IA: Parsons College, 1925.

Paulson, Noelle. "Spotlight Essay: Jean-Baptiste-Camille Corot." Mildred Lane Kemper Art Museum. https://www.kemperartmuseum.wustl.edu/node/11269.

Payne, Robert. *The Gold of Troy: The Story of Heinrich Schliemann and the Buried Cities of Ancient Greece.* New York: Funk and Wagnalls, 1959.

Pollard, Moyra Clare. *Master Potter of Meiji Japan: Makuza Kozan (1842–1916) and His Workshop.* Oxford, NY: Oxford University Press, 2002.

Polo, Marco, Henry Yule and Henri Cordier. *The Travels of Marco Polo: The Complete Yule-Cordier Edition.* New York: C. Scribner's Sons, 1920.

Rawnsley, Hardwicke D. *Notes for the Nile, Together with a Metrical Rendering of the Hymns of Ancient Egypt and of the Precepts of Ptah-Hotep (the Oldest Book in the World).* London: Heinemann and Balestier, 1892.

Rehs Galleries Inc. "Biography—Jules Breton (1827–1906)." https://rehs.com/Jules_Breton_Bio.html.

Reid, James Allan. *Alton, Illinois: A Graphic Sketch of a Picturesque and Busy City*. St. Louis, MO: J.A. Reid, 1912.

Riley, Glenda. *Divorce: An American Tradition*. Lincoln: University of Nebraska Press, 1997.

Rines, George Edwin, and Frederick Converse Beach. "John Willock Noble." In *The Encyclopedia Americana*. New York: Americana Company, 1903.

Ross, Michael A. "Cases of Shattered Dreams: Justice Samuel Freeman Miller and the Rise and Fall of a Mississippi River Town." *Annals of Iowa* 57, no. 3 (1998): 201–39.

Rule, G.E. "Tucker's War." Civil War St. Louis, February 19, 2003. http://www.civilwarstlouis.com/biographies/tuckers-war.

Sandfield, Norman L. *The Ultimate Netsuke Bibliography: An Annotated Guide to Miniature Japanese Carvings*. Chicago: Art Media Resources, 1999.

Sasama, Yoshihiko. *Fukugen: Edo seikatsu zukan (Restorations: Picture Book of Edo Era Life)*. Tokyo: Kashiwa Shobo, 1995.

Schliemann, Heinrich. *Ilios*. London: J. Murray, 1880.

*School Journal* 75. "Present Day Biography: A Great Little Woman" (May 1908): 733.

Sharoff, Robert. *American City: St. Louis Architecture, Three Centuries of Classic Design*. Mulgrave, AU: Images Publishing Group, 2010.

Shea, William, and Earl Hess. *Pea Ridge: Civil War Campaign in the West*. Chapel Hill: University of North Carolina Press, 1992.

Sherman, William T. "From the Battle of Bull Run to Paducah, Kentucky and Missouri, 1862–1862." In *The Memoirs of General W.T. Sherman*. 2nd ed. New York: D. Appleton and Company, 1889.

Sherwood, Dolly. *Harriet Hosmer, American Sculptor 1830–1908*. Columbia: University of Missouri Press, 1991.

Shikibu, Murasaki. *The Tale of Genji*. Translated by Edward G. Seidensticker. New York: Alfred A. Knopf, 1994.

Shinmura, Koujien Izuru. *Japanese Etymological Dictionary*. Tokyo: Iwanami Shoten, 1999.

Stevens, Walter Barlow. *St. Louis, the Fourth City, 1764–1909*. St. Louis, MO: S.J. Clarke, 1909.

*St. Louis Post-Dispatch*. "At Lake and Sea." August 18, 1886.

———. "Bankers' Dole to Mark Hanna." September 23, 1896.

———. "Buried This Morning." February 15, 1889.

———. "The Dead Warrior." February 20, 1891.

———. "Elected Director." November 28, 1896.

———. "Humane Society Annual Meeting." February 5, 1892.

———. "In Society." April 28, 1888.

———. "The Loan Exhibition." April 10, 1879.

———. "M'Kinley and His Cabinet." January 18, 1897.

———. "Nephew Chief Parsons Heir: Charles Parsons Pettus Gets Home, Art Collection, and Residue of Estate. $685,000 to Others Washington University Gets $75,000 and Parsons College $80,000—Other Bequests." September 27, 1905.

———. "The Nicaragua Canal." February 14, 1893.

———. "Noonan's Menace." June 5, 1890.

———. "The Parade." June 5, 1888.

———. "Patriotic Ladies." May 25, 1875.

———. "Scenes in Hawaii." April 2, 1893.

———. "Simplicity at the Funeral of Mr. Parsons." September 19, 1905.

———. "St. Louis and Missouri." June 22, 1893.

———. "St. Louis Helps Volcano Victims." May 14, 1902.

———. "St. Louis Mayors: Edward A. Noonan." September 24, 1927.

———. "Took His Life." December 19, 1892.

———. "Views of Charles Parsons." November 11, 1897.

*St. Louis Republic.* "Obituary of Charles Parsons." September 17, 1905.

Strahan, Edward. *The Art Treasures of America, Being the Choicest Works of Art in the Public and Private Collections of North America.* Philadelphia, PA: Gebbie and Barrie, 1880.

Taylor, Stephen J. "'So She Went': Heinrich Schliemann Came to Marion County for a 'Copper Bottom Divorce.'" *Hoosier State Chronicles,* March 11, 2015. https://blog.newspapers.library.in.gov/so-she-went-heinrich-schliemann-came-to-marion-county-for-a-copper-bottom-divorce.

Tebbe, Jen. "A Fate of Flames." Missouri Historical Society, March 30, 2017. https://mohistory.org/blog/a-fate-of-flames.

Tower Grove Park. "Ruin/Fountain Pond, Tower Grove Park." 2016. https://www.towergroveparkmap.org/fountain-pond-ruins.

Treacy, Patricia. *The Grand Hotels of St. Louis.* Charleston, SC: Arcadia Publishing, 2005.

Twain, Mark. "A Model Town." Chapter 57 of *Life on the Mississippi.* Boston: James R. Osgood and Company, 1883.

United States Congress. "George W. McCrary." In *Biographical Directory of the United States Congress, 1774–2005.* Edited by Andrew R. Dodge and Betty K. Koed. Washington, D.C.: Government Printing Office, 2005.

Van Norden, Bryan. "Mencius." *Stanford Encyclopedia of Philosophy,* December 3, 2014. https://plato.stanford.edu/entries/mencius.

Vicinus, Martha. "Laocoöning in Rome: Harriet Hosmer and Romantic Friendship." *Women's Writing* 10, no. 2 (2003): 353–66.

Washington University. "Charles Parsons Collection Inventory, 1923." St. Louis Art Museum Archives.

White, Edward. "The World's Fair City, 1903." *Banking Law Journal* 18, no. 10 (1901): 734.

Williams, R. Hal. *Realigning America: McKinley, Bryan, and the Remarkable Election of 1896*. Lawrence: University Press of Kansas, 2010.

Wisbey, Herbert A., Jr. "Halsey C. Ives." *Crooked Lake Review* 109 (Fall 1998). https://www.crookedlakereview.com/articles/101_135/109fall1998/109wisbey.html.

Yaggy, L.W., and T.L. Haines. *Museum of Antiquity: A Description of Ancient Life*. New York: Standard Publishing House, 1882.

Yale University. *Obituary Record of Graduates of Yale College, Deceased During the Academical Year Ending in July, 1868*. New Haven, CT: Yale University, 1868. https://catalog.hathitrust.org/Record/000525767.

Zimmerman, Ken, Jr. "General Sherman's St. Louis Home." September 18, 2013. https://kenzimmermanjr.com/shermans-house-lucas-heights.

# INDEX

# ABOUT THE AUTHOR

Andrew Shryock.

J ohn Launius is a media and technology executive based in St. Louis, Missouri, at Vidzu Media, part of the Nitrous Effect agency collective. He has provided leadership across governmental and educational sectors and has worked in all forms of media during his career. As a designated "Show Me Missouri" Historical Speaker, representing the Missouri Humanities Council and the Missouri State Historical Society, he enjoys research, writing and lecturing about nineteenth- and twentieth-century America. As a public speaker, he enjoys discussing leadership, management and other business-related topics. He is a Hillman Scholar and Venture for America (VFA) mentor and is engaged with nonprofits and charitable organizations focused on improving the quality of life for others. With thirty-eight years of martial arts training, he holds numerous black belts in several martial art styles. He has a BA from Webster University and studied at Washington University in St. Louis, DePaul University's Goodman School of Theatre and The Second City in Chicago.